NEW JERSEY
FOLK REVIVAL MUSIC

NEW JERSEY
FOLK REVIVAL MUSIC

HISTORY & TRADITION

MICHAEL C. GABRIELE

THE
History
PRESS

Published by The History Press
Charleston, SC
www.historypress.net

First published 2016

Manufactured in the United States

ISBN 978.1.62619.824.1

Library of Congress Control Number: 2016947531

THE THIRD NOTE

"Did you hear that?" a startled fourteen-year-old Merce Ridgway Jr. asked his friend Jack Fitzgerald while they were rabbit hunting in the woods of Lanoka Harbor during the fall of 1955. The boys by chance had whistled simultaneously, both calling for Merce's dog Streak. The two innocent whistles resonated and combined in the cool autumn breeze to create a magical third note.

Merce, a distinguished Garden State folk revival and traditional folk musician from the Pine Barrens, recounted the whistle incident, saying that no one ever plays the third note. He described it as a sonic phenomenon, an ethereal frequency that happens on its own, without warning.

The third note is a fleeting, melded tone—the closest thing to a sound from heaven. It's part of the harmonic alchemy that's possible when two or more people sing and play music. Listen closely.

Contents

Acknowledgements

Once again I would like to express gratitude to my colleagues at The History Press/Arcadia Publishing, especially my commissioning editor, Amanda Irle, for giving me an opportunity to write a book on New Jersey history.

I appreciate the help of my son, Charles, for scanning images. Special thanks go to Maura Grace Harrington Logue, PhD, also known as the "Graceful Grammarian." Thanks go to my Oklahoma friend Lauren West. Thank you Michael Byrnes, a mandolin player from Red Bank who served as a stage manager of the 2015 New Jersey Folk Festival, for giving me leads on New Grass music. I tip my hat to Jeff Smith for his help in gathering East Orange information on the long-lost Cave coffeehouse and the apartment of Bob and Sidsel Gleason. Special thanks go to Emilie and Ed Ahearn for their hospitality in welcoming me to Waretown and Albert Hall. Many thanks go to members of the Nanticoke Lenni-Lenape for inviting me to their facility in Bridgeton. Thanks Phil Grant, for sharing your memories and photos of the Homeplace. Thank you Catherine Cavallo, for finding information on the Lampell family of Paterson. Thank you Richard Veit, for turning me on to the paintings of William Sydney Mount. Thank you Christine Marzano, collections manager of the Long Island Museum, for providing images of Mount's paintings. Arzy Fogartaigh and Lynn Humphrey—I appreciate your assistance in uncovering information on the 1976 Perth Amboy/Sandy Hook music festivals.

Applause goes to my sources quoted in the book, all of whom were most generous in sharing their time, memories and materials. I'm grateful

to the libraries and librarians throughout the state, the Jewish Historical Society of New Jersey in Whippany and historical societies in other states. A long-distance shout out goes to the Vaughan Williams Memorial Library in London.

Author's note: All of the cities and towns mentioned in this book are located in New Jersey unless otherwise stated.

Introduction

A Sound That Catalyzes People

Ask any stouthearted New Jersey resident about the state's music history and most will proudly list the accomplishments of Frank Sinatra, Count Basie, Bruce Springsteen, Jon Bon Jovi, Bucky Pizzarelli, Dionne Warwick, Leslie Gore, Frankie Valli, Whitney Houston, the Shirelles, Mary Chapin Carpenter, Connie Francis, Sarah Vaughn, Wayne Shorter, the Roches and many others. The Garden State is acknowledged for its homegrown contributions to pop, rock and jazz and rightfully so.

But there's another story to tell: the story of the Garden State's folk revival music heritage. It begins in the colonial era with local musicians singing bawdy tunes in taverns and continues to the magical sounds heard throughout the Pine Barrens, the "Guitar Mania" phenomenon that unfolded in the 1800s, the first studio recording made by Woody Guthrie, early concert performances by Bob Dylan and Joan Baez, thirty-nine installments of a public television show featuring Pete Seeger, the flourishing of music festivals, the outreach efforts and cultural programs sponsored by community organizations and the romance of open-mic nights at village coffeehouses.

New Jersey has been home to numerous milestones that have shaped folk revival music as an art form. It's a circuitous journey that stretches through the Pine Barrens, Camden, Gloucester, Princeton, New Brunswick, Perth Amboy, Morristown, East Orange, Stillwater and all points in between. This book will examine the evolution of folk revival music in New Jersey and its

effects on local history and culture, as well as how it has changed lives—those on stage and those in the audience. As musician Roger Deitz explains in Part III of this book, the folk revival sound "catalyzes" people. Sources interviewed for this book spoke passionately about how they were enchanted by the sound of a guitar, banjo, dulcimer or a singer's voice and how those triggered their involvement in the folk revival tradition.

Growing up in East Orange during the early 1960s, singer/songwriter Janis Ian wrote, in her 2008 book, *Society's Child: My Autobiography*, about how her life was transformed by attending a concert at Rutgers University that featured eminent civil rights activist and singer Odetta. Ian also recalled the inspiration she drew from other folk revival musicians, which sparked her own prolific career:

> There was a "folk show" broadcast out of Newark once a week. It didn't begin until ten o'clock, past my bedtime. My Zaddy [grandfather] had given me a transistor radio, still an astonishing thing in 1962, and I'd hide under the blanket with my bedroom door shut tight, a towel shoved under it to muffle the noise. With the radio pressed against my ear, I would lay [sic] there and listen, discovering Phil Ochs, Eric Andersen and Judy Henske. I worshiped them and each time I managed to save $1.99, I'd buy one of their albums.

The sound catalyzed the prolific musical output of New Jersey's rock troubadour Bruce Springsteen. Among his numerous recordings, he released *The Ghost of Tom Joad*, which won the 1997 Grammy Award for Best Contemporary Folk Album, and *We Shall Overcome: The Seeger Sessions*, which won the 2007 Grammy for Best Traditional Folk Album.

New Jersey's folk revival music continues to evolve as a living history of new sounds and voices. Established folk revival musicians embrace a tradition of opening doors for the next generation of practitioners in order to sustain the music. This is a noble act of stewardship to help cultivate the songs that have yet to be written and sung.

Two Different Aesthetics

There is an important distinction to make between traditional folk music and folk revival music. Much like clothing, food, language, art, architecture

and dance, traditional folk music—defined as an element of cultural anthropology—helps identify a distinct ethnic population or region. This is the realm of study for academic folklorists, a scholarly discipline that requires extensive field research. By contrast, folk revival is the commercial, popular music tradition that draws inspiration and structure from traditional folk music.

Author and folklorist David Steven Cohen, PhD, who served as the coordinator of the folk-life program at the New Jersey Historical Commission, offered his thoughts on the definition of folk songs in his 1983 book, *The Folklore and Folklife of New Jersey*:

> *Folklore may be defined simply as oral tradition. For a story or song to be "folk," it must have been communicated by word of mouth. Folklorists use the term "traditional" as a synonym for "folk." Purists argue that to be traditional, the story or song must be communicated from one person to another, without the intervention of mass media. Thus...a folk song is learned from another person, rather than from sheet music, a record or the radio. Of course, there is little that is pure oral tradition. Most traditions are a mixture of folk and popular. A song that may have originated as a folk song will be sung in a different style when it is performed by a popular singer. The difference is not between a good singer or a bad singer, but between two different aesthetics.*

Angus Kress Gillespie, professor of American studies at Rutgers University, New Brunswick, and a folklorist who is the founder and executive director of the annual New Jersey Folk Festival, said there are several specific points a tune must meet in order to be considered a "traditional" folk song: it represents an oral tradition, passed down from generation to generation; its origins come from an anonymous source; it has a formulaic structure as a poem with simple imagery and clichés that makes it recognizable and easy to recite and remember; it exists in various iterations with alternate verses and titles; and it deals with "legendary" subject matter.

Jim Albertson, celebrated in New Jersey folk and folk revival music circles as a performer, teacher, recording artist, author, historian and radio show host, fortified Gillespie's definition, saying that a traditional folk tune also makes references to the lives and situations of common people and has a utilitarian quality, easing the drudgery of repetitive tasks—like sea shanties sung by sailors on tall ships or songs set to the rhythm of a weaver's loom.

Stephen Winick, a former New Jersey folklorist who works at the American Folklife Center at the Library of Congress in Washington, D.C., and is a writer,

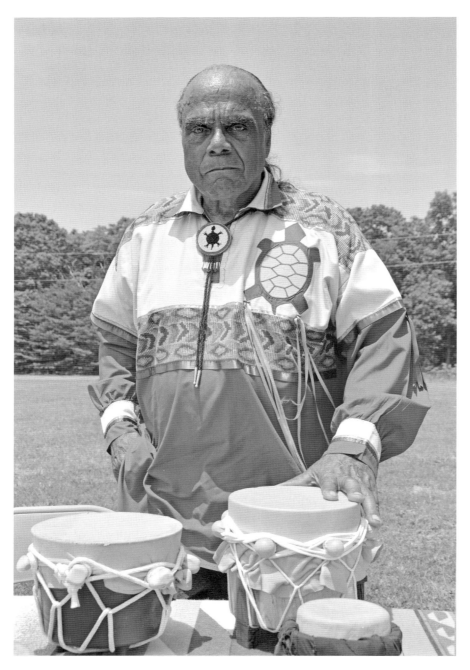

Mark Gould, chief of the Nanticoke Lenni-Lenape, Bridgeton, May 2015. *Photo by M. Gabriele.*

teacher and singer, said the concept of identifying the importance of folk songs can be traced to eighteenth-century German scholar Johann Gottfried von Herder. *Romancing the Folk: Public Memory and American Roots Music*, a book by Benjamin Filene, explained the significance of von Herder's work:

> *Once scorned as ignorant and illiterate, ordinary people began to be glorified as the creators of cultural expression with a richness and depth lacking in elite creations. German philosopher Johann Gottfried von Herder (1744–1803), the most influential proponent of the new cultural outlook, contrasted the* Kultur des Volkes *("culture of the people") with* Kultur der Gelehrten *("learned culture") and made clear which of the two he favored: "Unless our literature is founded on our Volk, we (writers) shall write eternally for closet sages and disgusting critics out of whose mouths and stomachs we shall get back what we have given." To Herder, folk culture offered a way to escape the Enlightenment's stifling emphasis on reason, planning, and universalism in cultural expression. Folk forms could cleanse culture of the artificiality that, he felt, was poisoning modern life.*
>
> *Herder's ideas inspired a generation of intellectuals that came of age in the late eighteenth and early nineteenth centuries, initiating a flurry of efforts to identify and understand folk cultures. In 1778 Herder himself published a collection of song lyrics he had gathered and transcribed in the German border region of Riga (present-day Latvia). In titling the work, Herder used a newly emerging word,* Volkslieder—*folk song. Herder was certainly not the first to collect traditional music. In seventeenth-century England, old ballads were published in numerous collections, tapping into a fad among both the middle class and aristocratic for things "country."*

New Jersey's earliest music dates back thousands of years to the ancestral origins of the Lenni-Lenape people. Lenni-Lenape music satisfies the academic "folk" definition, as it has anonymous, ancient cultural roots that have been handed down over the centuries through an oral tradition. It also has a utilitarian purpose: providing music for dancing and tribal ceremonies. This tradition was on display during a May 2015 gathering of students, teachers and friends in Bridgeton. Mark Gould, the chief of the Nanticoke Lenni-Lenape, assisted by Brett Paddles Up Stream, gave a demonstration on Lenni-Lenape folk dancing and instruments. Gould, a carpenter, showed examples of drum and rattle construction and discussed social, friendship and spiritual dances. He explained that many drumming patterns are based on a "heartbeat" rhythm.

This book is dedicated to Jim Albertson and Angus Gillespie, two faithful stalwarts and scholars who have given New Jersey a vast musical endowment to be savored for years to come.

MICHAEL C. GABRIELE
June 1, 2016

A Silvery Sound, an Unseen Thread

FOR THE ENTERTAINMENT OF TRAVELERS AND STRANGERS

More than three hundred years ago, as colonial life in New Jersey was taking shape, music was in the air. Hymns were sung in churches, families and friends gathered at home and entertained themselves by singing traditional songs and fifes and drums would inspire the Continental army during the Revolutionary War. "Vernacular" music filled tavern halls as drinks flowed merrily to the sound of the fiddle. Tavern patrons sang spirited, traditional folk songs from their homelands and frequently reworked familiar melodies with new words to fit a given occasion.

Throughout its history, New Jersey has been a corridor and a crossroads (hence its nickname Crossroads of the American Revolution). Saints and scoundrels have traversed the highways and byways of New Jersey, pollinating the state with their music, culture, language, politics and ideas. Much like today's roadside diners, colonial taverns served as inviting hospitality stops for travelers and friendly gathering places for local residents. Taverns were an important waystation in the eighteenth and nineteenth centuries for stagecoach passengers who ventured along the "post roads" (mail routes) and colonial turnpikes, such as the old King's Highway, which passed through Trenton, Princeton, Rahway and Newark. Today's Route 27 follows some of the old King's Highway.

John McPhee, in a feature article on the Pine Barrens published in the January 1974 edition of *National Geographic* magazine, wrote that taverns

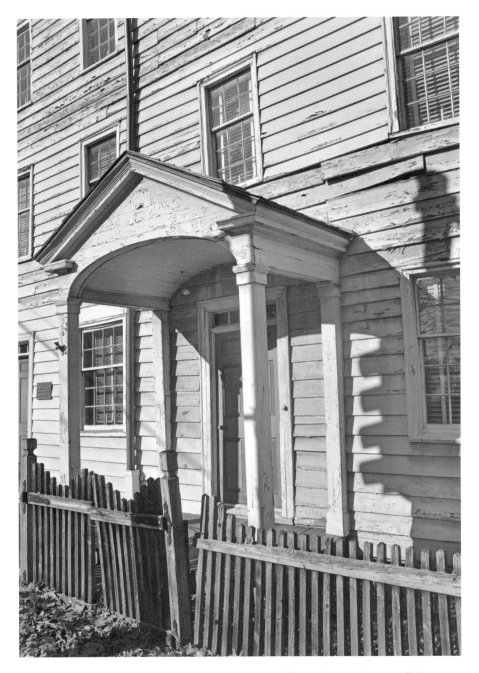

Merchants and Drovers Tavern Museum, Westfield and Saint Georges Avenues, Rahway. The building dates back to the late 1700s and was a stagecoach stop on the old King's Highway. *Photo by M. Gabriele.*

lined the route of the old Philadelphia-to-Tuckerton stagecoach run, which opened in the early 1800s. McPhee said taverns on this thoroughfare offered "potent fluids" with names like Mimbo (rum and muscovado sugar).

Charles S. Boyer, in his book *Old Inns and Taverns in West Jersey*, said there were two classes of taverns in New Jersey during the pre– and post–Revolutionary War years: one for "the accommodation of stagecoach and private travelers; and the other class where wagoners, teamsters and drivers 'put up' (for the night)." Based on Boyer's citation of information from a historian named John Omwake, it sounds like the fun spot was the latter class of taverns:

> *The wagoners were a noisy, jolly crew who loved to frolic and dance. At the end of the day, when the horses stood eating contentedly under the stars, and their bells were silent, the music of the violin usually was heard inside the tavern, and the wagoners, who had walked probably the greater part of the twenty miles that their teams had traveled that day, danced to whatever tune the fiddle sang.*

The Genealogy of the Bonnell Family, a privately published book from the late 1800s, describes the Old Revolutionary Inn in the village of Hunt's Mills (present-day Clinton), which was established in 1767 by Colonel Abraham Bonnell, a Revolutionary War hero. Stagecoaches stopped at the tavern three or four times a day, and mail was delivered once a week by a sulky (a two-wheeled, horse-drawn carriage). Tavern regulars who gathered around the hearth during the evening hours included "the usual group of uncouth figures…famed gossips that smoked, drank and sang many a good song, which made the walls ring on these genial, convivial occasions." The historic structure, today known as Bonnell's Tavern, still stands in Hunterdon County.

Early Taverns and Stagecoach Days in New Jersey, a book by Walter H. Van Hoesen, documents the oldest records of tavern culture in the Garden State. Van Hoesen wrote that the first mention of an "ordinary"—a hostelry that was a precursor to a tavern—is found in "Records of the Town of Newark, 1666–1836," a compendium preserved by the New Jersey Historical Society. The minutes of a meeting of Newark citizens held on May 16, 1666, included a business item: "The town hath chosen Henry Lyon to keep an ordinary for the entertainment of travelers and strangers, and desires him to prepare for it as soon as he can."

Van Hoesen said traces of this ordinary mentioned in the minutes have been lost to time, but he speculates that most likely it was a simple log

structure located on Broad Street, which was Newark's first thoroughfare. The word "entertainment" in the business item is intriguing, perhaps suggesting musical performances, but in those days, entertainment also could have referred to meals, alcoholic drinks or games of chance.

Given the social codes and cultural taboos of the day, there were laws enacted to forbid or restrain the conduct of those who might indulge in merriment in public or in taverns, especially on the Sabbath. Music, in particular, was singled out as an activity that inspired rowdiness. The laws attempted to enforce strict moral discipline as a way to regulate public behavior. Charles H. Kaufman, in his book *Music in New Jersey, 1655–1860*, stated that the General Assembly of East New Jersey met in Elizabethtown (present-day Elizabeth) and Woodbridge between October 10 and 13, 1677, to produce an edict stating:

> *Be it enacted by this Assembly that…any person or persons misbehaving themselves, namely staggering, drinking, cursing, swearing, quarreling or singing any vain songs or tunes of the same, shall cause the said person or persons so offending to be set in the stocks for two whole hours without relief.*

Kaufman wrote that the New Jersey Immorality Act (March 16, 1798) "strictly forbade interludes or plays, dancing, singing, fiddling or other music for the sake of merriment…on the Christian Sabbath." He also cited a passage from a private Philadelphia Quaker publication from 1801, which told of the Quaker conversion of a rambunctious fiddle player named Edward Andrews. Andrews was described as "a resident in the Jersey, near the seashore, among a wild sort of people, Indians and others, vain and loose in their conversation; fond of frolicking, music and dancing—among these he acted the part of fiddler." The publication wrote that Andrew's conversion to the Quaker faith "became complete when he resolved to break the fiddle in pieces, which, when done, his heart rejoiced and he felt a strength of hope rising in him—that God would give him further power over all his vanities."

William Paterson (1745–1806), according to an online biography posted by William Paterson University, was a 1763 graduate of Princeton (then known as the College of New Jersey). He served as secretary of the New Jersey Provincial Congress, the first attorney general of New Jersey, head of the New Jersey delegation to the federal Constitutional Convention and governor of New Jersey. In addition to these governmental responsibilities, Paterson apparently knew how to have a good time. Kate Van Winkle Keller, in her book *Dance and Its Music in America, 1528–1789*, indicated that Paterson

was well acquainted with Princeton social circuits. Van Winkle Keller wrote that, in 1772, Paterson penned a letter to Aaron Burr—the Newark-born third vice president of the United States and the man who shot Alexander Hamilton in their infamous July 11, 1804 duel in Weehawken—to inform him about happy days in Princeton:

> *I have been at a Dutch wedding and expect to be at one or two more shortly. There was drinking and singing, and fiddling and dancing. I was pleased extremely; everyone seemed to be in good humor with himself and this naturally led them to be in good humor with one another.*

Van Winkle Keller also wrote of a dinner/dance in Princeton, held on April 12, 1779—a gathering that included "nineteen ladies, twenty gentlemen and four servants." The bill for the night, $2,840, included payment to fiddler Jerry ($100) and fiddler Bob ($50).

Contrary Wind and Godless Company

What was it like to be surrounded by a crowd of eighteenth-century tavern revelers? Henry Melchior Muhlenberg (1711–1787), a missionary bishop known as the patriarch of the Lutheran Church in America, journeyed to German settlements in the New World from 1742 to 1787. His travels, documented in the book *The Journals of Henry Melchior Muhlenberg*, Volume 1, included stops in New Jersey, and his journals, translated into English from their original German, were published in 1942. Two entries—May 6 and 7, 1752—provide a rare eyewitness account of the boisterous activities.

Muhlenberg, on May 6, described sailing on a packet boat from Philadelphia. (A packet boat is a medium-sized ship designed to carry "packets" of mail on rivers and canals.):

> *We had contrary wind and godless company on board. During the night, we had to cast anchor and lie still because the tide had gone out. The company* [on board the boat] *began to sing obscene songs and to pour out all manner of curses and godless utterances. I protested and warned them somewhat, but it only encouraged their wantonness. I therefore asked the shipmaster to put me ashore together with an Englishman who was not participating with the others. Hardly had we*

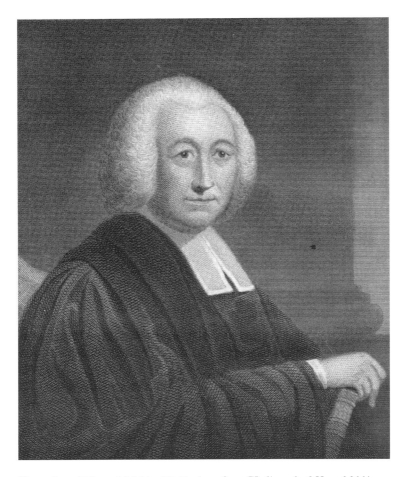

Illustration of Henry Melchior Muhlenberg from *The Journals of Henry Melchior Muhlenberg*, Volume 1. *Courtesy of the Lutheran Archives Center at Philadelphia.*

reached the shore and entered a house when the whole company followed us and carried on their frivolous proceedings.

The next day, the group arrived in Bordentown. Muhlenberg's entry on May 7 describes the scene:

At twelve o'clock noon we reached Bourdentown [Bordentown]. As far as I was able to observe, people of all sorts of nationalities live here. At one o'clock in the afternoon we left [by stagecoach]...covering thirty miles amid continuous shouting and singing on the part of the

company. That night at the inn, several apologized to me for the tumult they had made. I said that they could not do otherwise as long as they were Satan's servants and were not in fellowship with God. They were put out by this. Among them was a young Quaker whose flat hat and plain coat were symbols of his profession, but did not prevent him from behaving as wildly as the others. God help us, how vanity has ruined us mortals! The English people have songs which are set to melodic music and describe all sorts of heroes and feats of arms on land and sea. Respectable people sing them as a pastime and regard it as a serious invasion of their liberty if one protests against these songs. Now, if one rebukes them on account of their amorous songs, they believe that they can justify themselves by referring to these songs about heroes. The musical settings and melodies of these songs of heroic deeds are very similar to those which our Germans use for church music.

Let's Fathom the Bowl

Consumption of alcohol in colonial America was pervasive and considered a routine part of daily life. Alcohol helped to fuel the merriment at taverns and inspired music, dance and singing to complement the festivities. Ed Crews, writing in the 2007 holiday edition of the *Colonial Williamsburg Journal* ("Drinking in Colonial America"), said colonial Americans believed that "alcohol could cure the sick, strengthen the weak, enliven the aged, and generally make the world a better place. They tippled, toasted, sipped, slurped, quaffed, and guzzled from dawn to dark." While people enjoyed beer and ciders, Crews wrote that "rum was king of the colonies" before the Revolutionary War. It was made from molasses imported from Caribbean sugar plantations. By 1770, the colonies had more than one hundred and forty rum distilleries.

Richard Patterson, the executive director of the Old Barracks Museum in Trenton, said rum punch was the beverage of choice and "drink of abuse" in the early eighteenth century. The punch was a mixture of rum, fruit juices, perhaps some wine and lots of sugar. Patterson said that, in a tavern setting, punch consumption often involved lighthearted drinking songs, where a table of gentlemen would take turns singing a verse and drinking from a communal vessel to "fathom the bowl" (in other words, get to the bottom of it). This expression is celebrated in a traditional tune:

I'll fathom the bowl, I'll fathom the bowl
Give me the punch ladle, I'll fathom the bowl

Come all you bold heroes, give an ear to my song
And we'll sing in the praise of good brandy and rum
There's a clear crystal fountain near England shall roll
Give me the punch ladle, I'll fathom the bowl

From France we do get brandy, from Jamaica comes rum
Sweet oranges and apples from Portugal come
But stout and strong cider are England's control
Give me the punch ladle, I'll fathom the bowl

THE DEVIL AND THE OLD WOMAN

Tom and Marianne Tucker, who reside in Abington, Pennsylvania, have performed as eighteenth-century musicians for more than thirty years. Together with New Jersey residents David Emerson and Stacy F. Roth they make up the quartet Spiced Punch. Given his detailed study of the period, Tom Tucker said that twenty-first-century folk revival musicians should feel a special kinship with the tavern musicians of the eighteenth century. "Music was common in tavern halls," he said. "Only wealthy people went to 'formal' concerts."

Tucker explained that, in taverns, you would find people singing about everyday issues, just like the topical songs of today's folk revival singers. "The music you would have heard in the taverns was whatever the patrons knew. You would hear ballads as well as bawdy and humorous songs; probably a few hymns, love songs and songs about social issues." Tucker said most of the music at taverns would have been supplied by the patrons. "People went to taverns for the social atmosphere, and that included music and dancing," he said. "The patrons would frequently sing or play music to entertain themselves and their friends. Professional traveling musicians were not common in eighteenth-century New Jersey taverns. Traveling musicians would have been hired to perform at upper-class social functions, recitals or balls. They also would follow the fairs and festivals in an attempt to earn a living." Kaufman wrote that "since New Jersey was a corridor through which a mobile population traveled, the many itinerant music teachers and

Spiced Punch—(*left to right*) David Emerson, Marianne Tucker, Stacy F. Roth and Tom Tucker—performing as eighteenth-century musicians. *Courtesy of the Old Barracks Museum, Trenton.*

performers did not remain in one location long enough to be recorded in public archives."

"The most common instruments you would have encountered in an eighteenth-century tavern would have been fiddles and flutes, since they are portable and loud," Tucker continued. "Dancing was a highly valued social

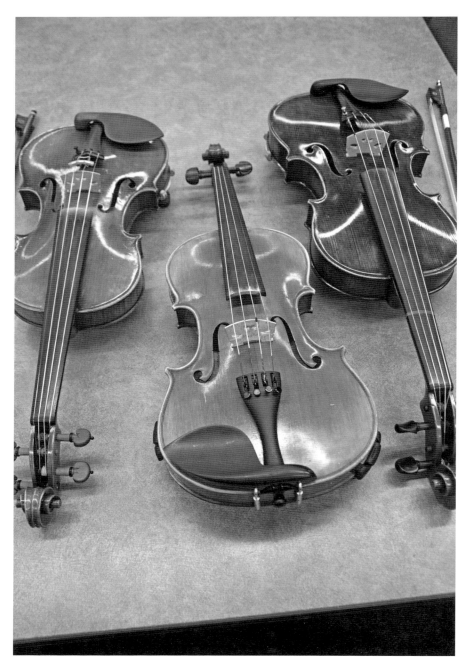

Two fiddles and a viola. Instruments courtesy of Clifton High School students. *Photo by M. Gabriele.*

skill in colonial days and dances were held in the larger taverns and inns. It was an important part of the social structure. Dancing in the 1700s was more popular than Disco in the 1970s." In her book, Van Winkle Keller said English and French country dances—the cotillion, the hornpipe, jigs and Scottish reels—were the best-known dance forms of the eighteenth century.

Van Winkle Keller provides some insight into the extent of musicians and dancers seeking employment in various New Jersey towns with a listing of advertisements, similar to classified ads. These postings from 1729 to 1786 appeared in newspapers and periodicals of the day, such as the *New Jersey Gazette*, the *New York Gazette*, the *New York Journal* and the *Pennsylvania Chronicle*. All of the musicians listed were men, and virtually all were fiddle players. In Perth Amboy, September 8–15, 1729, Michael Kearny "plays on the bagpipes and has a pair of pretty little bagpipes with him"; in Sussex County, October 1, 1741, William Selthridge "can sing well and says he can play on the violin"; and in Trenton, April 17, 1782, Jonathan Richmond "plays on the fiddle and uses the bow with his left hand."

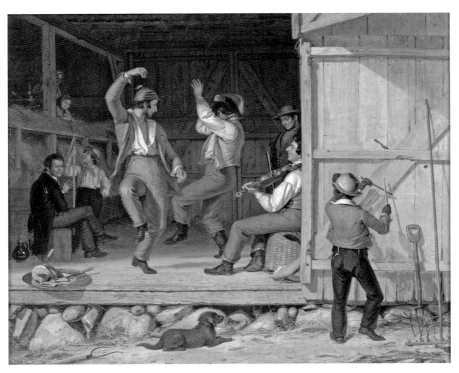

Dance of the Haymakers, painting by American artist William Sydney Mount (1807–1868). *Courtesy of Long Island Museum, Stony Brook, New York.*

What type of music would have been played in the taverns? "Since we were an English colony, most of the music would have originated in England, Scotland, Ireland and Wales," Tucker said. "Songs from Germany, the Netherlands and France also would be heard in areas with concentrations of those ethnic groups. During the eighteenth century, there was a rise in the number of songs composed by American musicians, but most of the music heard in taverns would have originated in Europe."

Victorian Songhunters: The Recovery of English Vernacular, a book by E. David Gregory, described "A Collection of Old Ballads," a three-volume compendium published in London between 1723 and 1725 that has been identified by folklore scholars as one of the earliest collections of British folk songs. Gregory wrote that the compilation of songs, put together by an anonymous editor, "had been presumably taken from broadsides [lyrics printed on handbills] and they may have been sung when hawked on the streets. A Collection of Old Ballads thus included quite a large number of folk songs, including the texts of several ballads. [The collection] held sway as the most useful and influential gathering of folk ballads and folk songs. It marked a first step toward the systematic collection of English folk songs."

Stephanie P. Ledgin, in her book *Discovering Folk Music*, noted that along with white European colonists introducing their music to the New World, "African slaves brought with them strong and stirring musical sensibilities and traditions, among them the banjo." Ledgin explained that "call and response" was a major characteristic of African song. "Often heard in work songs, this feature carried over into sacred music, when slaves, who were typically converted to Christianity, began to both adopt and contribute to the body of hymns being sung by both whites and blacks," Ledgin wrote. "Popular music of the white colonists and that of the slaves eventually began to meet and merge outside the church."

Tucker said another common practice during the eighteenth century was to "borrow" melodies from well-known songs and add new lyrics. Many of the surviving broadsheets from the period have the verse printed with instructions to "sing to the tune of…," using some popular song as the melody. Paper was expensive, but printing techniques had improved greatly, making printed sheet music more common. "If you were of means, your musical training would include how to read printed sheet music, so sheet music must have been used occasionally in the taverns," Tucker said. "I imagine that most proficient musicians could quickly pick up [by ear] whatever tunes and songs were being presented, as most musicians can do today."

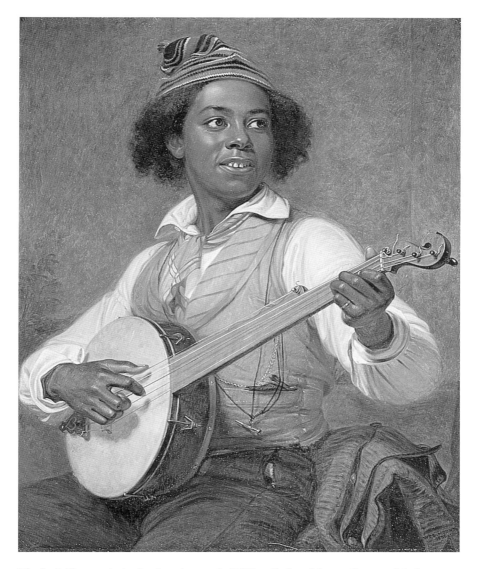

The Banjo Player, painting by American artist William Sydney Mount. *Courtesy of the Long Island Museum, Stony Brook, New York.*

He pointed to a popular tune that spread throughout the colonies known as "The Devil and the Old Woman," sung as a quick-moving poem in six/eight time. There are many versions of the traditional song (some dating back to the late seventeenth century), including one called "The Devil and the Farmer's Wife," but Tucker said the basic lyrics and story line have remained intact.

The Devil and the Old Woman (Traditional)

There once was a family that lived on a hill
If they haven't moved, they're living there still
The Devil came down to the man at the plow
"I've come for one of your family now"
Fie die diddle i fie, diddle i day.

"Oh, please don't take my eldest son
There's work on the farm that's got to be done.
"Take my wife, with all of my heart
With luck the two of you never need part."
Fie die diddle i fie, diddle i day.

The Devil he hoisted her onto his back.
No peddler was ever so proud of his pack.
And when they got to the fork of the road
He says, "Old woman, you're a hell of a load"
Fie die diddle i fie, diddle i day.

He dumped her out at the gates of hell
Said, "Stoke up the flames, and roast her well."
Then stepped up a demon with ball and chain
She upped with her foot and kicked out his brain
Fie die diddle i fie, diddle i day.

Some demons came down to put her in a sack
She up with her boot and broke all their backs
Three demons cried out from up on the wall
"Take her back, Daddy, she'll murder us all"
Fie die diddle i fie, diddle i day.

The old man heard the clickety-clack
When he seen the old Devil a-bringing her back.
The Devil said "If you would be so kind
Take her back farmer, I've changed my mind"
Fie die diddle i fie, diddle i day.

"What will you give me for taking her in?"
"I promise no more than the wages of sin.
I've been a Devil for all of my life,
But I never knew hell 'til I met with your wife."
Fie die diddle i fie, diddle i day.

"If you want to be rid of this feisty old hen
You'll never bedevil my family again."
The Devil did cry, the Devil did howl,
But he never returned to the man at the plow.
Fie die diddle i fie, diddle i day.

The old man gave his wife a kiss.
For who could get him a deal like this?
This proves that women are better than men,
They can go down to hell and come back again.
Fie die diddle i fie, diddle i day.

A LITTLE DRUNK AND IN VERY GOOD SPIRITS

Dennis Bertland, the founder and director of Dennis Bertland Associates, a Stockton-based historic preservation consulting firm, in an unpublished research paper, captured images of New Jersey tavern life in the 1700s and 1800s. Bertland conveyed notes written by Polish patriot Julian Ursyn Niemcewicz (1758–1841). According to online biographies, Niemcewicz, a statesman and author, was elected to the Polish parliament in 1788. He was an associate of Polish general Thaddeus Kosciuszko. Niemcewicz came to the United States in 1797 and settled in Elizabeth. He kept journals that describe his encounters with famous Americans, such as George Washington, Thomas Jefferson, John Adams and Alexander Hamilton. Niemcewicz, passing through Hoboken in 1797, "spent the night at an inn filled with sailors and other gentlemen, vagabonds—all a little drunk and in very good spirits." It's a safe bet that buoyant fiddling and sloppy singing were part of the raucous atmosphere.

In an online article for the Sonneck Society for American Music Bulletin, Van Winkle Keller traced the career of George Bush, a fiddle player from Delaware. Bush was born in Wilmington, Delaware, around 1753, and in

1776, he joined the Continental army as a lieutenant and spent time in New Jersey. "He evidently carried a fiddle with him as he traveled, and in 1779 began a collection of music in a pocket notebook made of paper from a Pennsylvania mill," she wrote. This collection of thirty-two songs included dances and marches. "Most of the songs, tunes, and dances are of British origin, and most were copied from fairly accurate sources. Several were transcribed by ear, but there is no evidence that Bush composed any of the music or songs." Bush died in 1797, and his manuscripts were donated to the Delaware Historical Society. Among the papers, he had a title page in handwritten script: "A new collection of songs by George Bush," dated September 28, 1779. Van Winkle Keller said that the dances collected by Bush may have been in use during the Continental army's winter encampments of 1778–79 near Morristown.

THE DANCING PRIVATEER

The Pine Barrens, occupying nearly one million acres in the southern half of the Garden State, encompass much of New Jersey's most colorful folklore. John McPhee, in his 1967 book, *The Pine Barrens*, detailed the early history of the region. In addition to the Native Americans who lived there, seventeenth-century woodcutters were among the first European inhabitants. During the Revolutionary War years, Tories, Hessians and Quakers—branded as deserters and rejected members of their respective communities—found a sanctuary in the recesses of the Pine Barrens. There also was mystery and mischief associated with the area during the eighteenth century. "One thing that attracted people to the pines was good money in smuggling—a respectable business in colonial America," McPhee wrote. "The Pine Barrens were a smuggler's El Dorado, for all that wilderness so close to New York and Philadelphia was extraordinary…and through the inlets from the sea up the Pine Barren rivers went hundreds of thousands of tons of sugar, molasses, tea and coffee."

It was in this shadowy land of intrigue that folklore and folk songs took root. McPhee described the Pine Barrens as "a kind of middle ground, where regional traditions overlap." He then cited the work of folklorist Herbert Halpert (1911–2000), who wrote in his dissertation that "this region is the meeting place for Northern and Southern folk song traditions. Certain songs and ballads are found in New England and other Northern states.

Pine Barrens, June 2015. *Photo by M. Gabriele.*

Others are encountered only in Southern states." The music from these different regions, brought by those traveling on the New Jersey corridor, seeped into Pine Barrens' culture.

One legendary figure who provides a glimpse into the musical environment of the Pine Barrens during the late 1700s is Joe Mulliner, a British privateer and outlaw. Oral history suggests that Mulliner was a scalawag who enjoyed the secular pleasures of music, drink and dance at Pine Barrens taverns. Mulliner reputedly had a habit of barging into a tavern, taking the hand of the prettiest woman and dancing with her. As such and by extension, the anecdotes regarding Mulliner's indulgences help to outline the existence of musical activities in the Pine Barrens during the colonial era.

Gabe Coia, a Pine Barrens historian and musician based in Valley Township, wrote that "beginning in 1779, in an effort to compensate for economic loss caused by the Rebel privateers, the British encouraged Loyalists to engage in privateering, a common wartime occupation for mariners." Coia said that Mulliner allegedly was a Loyalist privateer.

David J. Fowler, PhD, in his book *Egregious Villains, Wood Rangers and London Traders: The Pine Robber Phenomenon in New Jersey During the Revolutionary War*, wrote that Mulliner was captured in either June or July 1781. Fowler said that Mulliner, apparently because of his notorious reputation, was taken

into custody by the local militia due to his "favorite pastime of crashing local dances once too often."

One primary source that documents the end of Mulliner's life is a short news item published in an online version of the August 8, 1781 edition of the *New Jersey Gazette*:

> *At a special court lately held in Burlington, a certain Joseph Mulliner, of Egg Harbour, was convicted of high treason, and is sentenced to be hanged this very day. This fellow had become the terror of that part of the country. He had made a practice of burning houses, robbing and plundering all who fell in his way, so that when he came to trial it appeared the whole country, both Whigs and Tories, were his enemy.*

HOT NIGHTS AT THE STUMP TAVERN

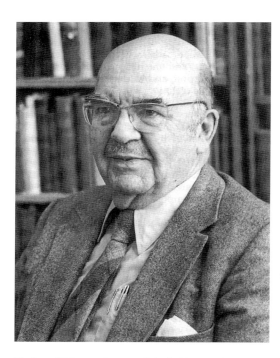

Herbert Halpert. *Courtesy of the Archives and Special Collections, Memorial University of Newfoundland, St. John's, Newfoundland, Canada.*

Herbert Halpert, beginning in the summer of 1936, traveled throughout the Pine Barrens, gathering details of folklore and making field recordings of folk songs. The result was his unpublished 1947 paper, "Folktales and Legends from the New Jersey Pines: A Collection and Study." Halpert's research also appears in the book *Folk Tales, Tall Tales, Trickster Tales and Legends of the Supernatural for the Pinelands of New Jersey*, edited by J.D.A. Widdowson. The most vivid stories Halpert encountered during those years involved tales of a wayfaring fiddle player, Samuel Gorden Giberson (GUY-ber-son), also known

as Sammy Buck. He was born on September 16, 1808, and died in the town of Hanover, Burlington County, on August 21, 1884, according to family records uncovered by Halpert. Giberson married Ann Wiseman in 1830, and she died on January 9, 1880.

Transcribing oral histories, Halpert provided a description of Giberson's appearance: about five feet, six inches tall; weighing between 140 and 160 sixty pounds; brown/gray hair; distinctive features and a medium complexion; plump hands and short fingers; a thick neck, square shoulders; and a full chest. As with any legendary figure, there are discrepancies on the precise dates of his birth, death and life events. Regarding Giberson's birthplace, Halpert suggested his information pointed to

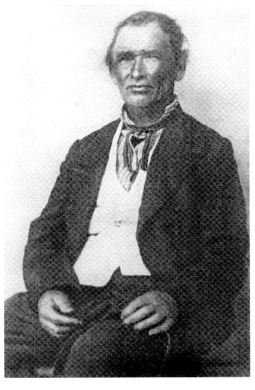

Sammy Giberson, circa 1875. *Courtesy of John D.A. Widdowson, Edwin Mellen Press Ltd., Lampeter, Ceredigion, Wales, United Kingdom.*

either Ocean or Burlington Counties, as county lines shifted over the years.

Accounts of Giberson's travels illuminate the folklore and music of the Pine Barrens during the 1800s. Family descendants and old-timers shared their handed-down tales of Giberson, who was revered as an extraordinary fiddle player and acrobatic dancer. Apparently, Giberson was in demand at dances, parties and taverns, receiving invitations via a word-of-mouth network. The oral histories gathered by Halpert indicate that Giberson was constantly in motion, walking throughout the Pine Barrens carrying his fiddle in a muslin sack.

> *Fiddler Sammy—he used to go out a-fiddlin' for the women and men to dance. He was never at home, always on the road. They'd tell him what night they wanted him to play the fiddle…He traveled from town to town,*

Street sign, Hornerstown, June 2015. *Photo by M. Gabriele.*

walked. Then he stopped in this place and that place: Stump Tavern,
Goshen (that's called Cassville now); New Egypt; and Whitings.

Halpert made note of performances in Hornerstown that mentioned
Giberson and a banjo-playing friend named Powell Evans, with information
that came from a book (*More Forgotten Towns of Southern New Jersey*) written
by Henry Carlton Beck. "Evans and Giberson were often in demand at
Hornerstown," Beck wrote. "[Giberson] could play a fiddle behind his back
and dance the hornpipe at the same time."

Today, Hornerstown is a wooded hamlet in Monmouth County, at the
intersection of Routes 539 and 537. Beck wrote that Hornerstown, in the
1860s and 1870s, had a train station, country store, farms, a post office
and a tavern at its crossroads. Hornerstown was a stop on the old Union
Transportation railroad line. Beck said the Stump Tavern was considered
the "real social center" for the Hornerstown/New Egypt area. "At the hotel
(presumably part of the tavern), travelers found room and board, billiards,
all-night dancing and other entertainment." Halpert also mentioned that
Giberson frequently performed at Saturday night dances held at a hotel in
Woodmansie. As for favorite tunes in Giberson's set list, Halpert's sources
rattled off titles such as "Fisher's Reel," "Devil's Dream," "Arkansas

Traveler," "Turkey in the Straw," "Nelly Gray," "Butcher Boy," "Oats and Beans and Barley Grow," "Jack on the Green," "Rag Baby," and an assortment of reels and waltzes. Giberson rarely sang and enjoyed hard liquor, according to Halpert's sources.

SAMMY BUCK'S AIR TUNE

The "Air Tune" is a central story in the Giberson legend ("air" was the Pine Barren pronunciation of the word "ear," Halpert explained). Giberson was considered an "air," or "ear," fiddler; in other words, he was self-taught and played naturally "by ear" rather than reading music. The most common version of the Air Tune yarn involves a mystical confrontation between a boastful, perhaps slightly intoxicated Giberson and the treacherous devil, also known as the "Old 'Un." It's said that one night, the two had a fiddling and dancing competition, and Giberson lost. The devil was set to enslave Giberson unless Sammy Buck could play a song that the devil had never heard. The magical Air Tune melody came to Giberson just in time via a supernatural source. The devil, to his credit, honorably admitted he never before had heard the enchanting song, so he released Giberson from his clutches.

As a folklorist, Halpert studied this story and compared it with similar tales from Ireland, Scotland, Norway and Sweden, where musicians are said to have learned songs "out of the air" from mystical beings like fairies and banshees. Halpert also uncovered lesser-known versions of the Air Tune story—one from Sammy Buck's descendants, who said Giberson heard the melody one day while "walking along the road and then he started right in and played it. He'd always play it after that." A Pine Barrens folk singer named Charles Grant claimed he was told that the tune came to Giberson one night in a dream. "He got up and practiced on it all night to get it down perfect." Several sources interviewed by Halpert shared stories that the Air Tune was a "sweet" song that "would bring tears to your eyes." Grant characterized it as an intricate song with extremely high and low notes.

During Giberson's era, inhabitants of the Pine Barrens considered the devil to be a major figure in life and folklore, according to Halpert. The Old 'Un was always lurking in the shadows, waiting for an opportunity to disrupt daily events, create mischief or cause tragedy. "It is extremely important to realize that…the Giberson legends were not looked upon as made-up stories, but as reports of actual occurrences. From our detached viewpoint,

we can say that many of them are obvious adaptations from the large stock of European legends imported to America, but such information was not in 'Piney' hands." Halpert wrote that Giberson's "seriousness" regarding the Air Tune was evidence that it had "a strong emotional importance for him. His attitude seems to have been based upon some deeply moving experience. The tune may well have been composed in some dream situation." Halpert also mentioned that, to understand the Giberson legend, "we must realize that fiddle playing and dancing, by long tradition, were linked with the devil or evil."

> *Dances* [in the Pine Barrens] *took place on Saturday night, and might well last past midnight into Sunday. For religious folk, this desecration of the holy day, combined with their disapproval of the drinking and probable immorality that accompanied dances, demanded some retaliation. We must notice also another powerful factor: the anomalous character of the fiddler's way of life in the* [Pine Barrens] *community. In a society which lived by hard, lonely labor, and regarded labor as one of its highest virtues, here was a man who refused to be tied to the rock; who made his living—even a good living—in a way that looked very much like amusement. A community will not tolerate for long a weakening of its sanctions. It enjoyed Giberson's fiddle playing, his dancing, his showmanship and his stories. It could not forget that his every action contravened the sanctions of its way of life. Its retaliation was to foster the growth of the tales which showed the devil's close connection with the fiddle and the man who played it.*

THE BALLAD OF JENNIE DEVLIN

Outside the Pine Barrens, a contemporary of Giberson was folk singer Jennie Devlin. Author Katharine "Kay" D. Newman, in her book *Never Without a Song: The Years and Songs of Jennie Devlin, 1865–1952*, profiled Devlin's life.

Newman wrote that she came to know Devlin through a mutual friend. Newman, who lived in Philadelphia, started visiting Gloucester, just across the Delaware River, and became aware of Devlin's vast knowledge of folk songs. It was a list that included old English ballads, bawdy melodies and rural American tunes. Newman, an English literature scholar and the founder of the Society for the Study of the Multi-Ethnic Literature of the United States, was astonished and curious: how was it that Devlin, a

seventy-two-year-old woman living in Gloucester, knew these folk songs? "Wherever did you learn these pieces?" Newman asked her. "I growed [*sic*] up with them," Devlin answered. "Whether it was this year or that year, I jus' couldn't tell you. I've known 'em all my life."

Born on February 8, 1865, Devlin was an orphan and became an "outbound" girl, obliged to work for families for her keep, without wages. Her earliest years were spent on a farm near Athens, Pennsylvania. Newman wrote that Devlin was placed with the Stevensons, a loving family of basket makers.

> *This was her* [Devlin's] *time of education through folksong. Basket makers…were the Johnny Appleseeds of American folksongs. As these itinerant workers carried their wares and their skills from town to town, they also carried songs.…The Stevensons were very effective song bearers because they accompanied themselves on musical instruments. Jennie danced and sang…The little girl was a true folksinger with an audience that applauded her enthusiastically.*

Early in 1906, Devlin moved to 25 North Broadway in Gloucester, then a shipbuilding town. She lived there for fifteen years and established the location as a boardinghouse and small restaurant. In 1921, Devlin and her family relocated to 312 Market Street. Newman wrote that Devlin was persuaded to join a local lodge chapter known as the Shepherds of Bethlehem and became a noteworthy member. During the weekly lodge programs, Devlin sang what she considered "an appropriate song. Thus, once again, she was a folksinger, with a reputation for it in her own community. Her message always was clear: people should live in dignity and harmony." Newman indicated that Devlin's lodge sisters held her in high esteem, not only locally but also throughout the state of New Jersey.

Newman went to the Library of Congress and petitioned Alan Lomax, the famed ethnomusicologist and folklorist, to record Devlin. As detailed in an online item from the American Folklife Center ("New Jersey Collections in the Archive of Folk Culture"), Devlin, on June 20, 1938, recorded thirty-five songs and three poems at her home in Gloucester, a session that yielded tunes such as "The False Lover" and "The Frog and the Mouse."

Devlin died in 1952. In her book, Newman shared her thoughts on Devlin's life journey as a folk singer:

> [Devlin] *selected many songs and passed them on to others—her audiences from her childhood to her own old age. But she had not collected songs for*

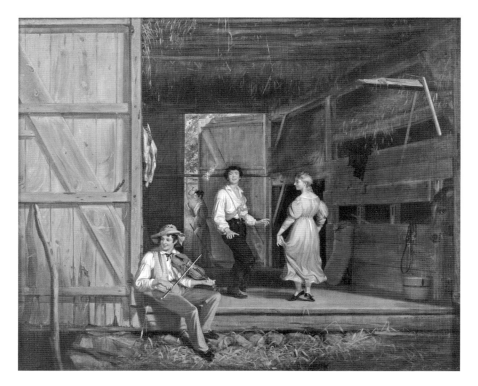

Dancing on the Barn Floor, painting by American artist William Sydney Mount. *Courtesy of the Long Island Museum, Stony Brook, New York.*

others; she had needed them herself. They were an integral part of her self-definition. So she was never without a song. She learned about life from the songs; she brought her own experiences to interpreting the songs…she used her repertoire as a vocabulary with which to comment on the moment as well as on the human condition.

Like Devlin, Everett Pitt (1886–1954) also was a keeper of folk ballads that were handed down to him through his family's tradition of singing and storytelling. Pitt's neck of the woods was northern Bergen County and the Ramapo Mountains. Folklorist Anne Lutz (1905–1996) did field recordings of Pitt in the 1940s that were issued in 1987 by Marimac Recordings, Little Ferry, under the title *Up Agin the Mountain: Traditional Ballads and Songs from the Eastern Ramapos.*

Lutz, in a booklet of notes that describe the recordings, wrote that she met Pitt through his daughter, who was a student at Ramsey High School. Pitt,

at the time, was living in Upper Saddle River. She felt the old songs sung by Pitt were "enjoyed as if they were heirlooms," relics of a culture shared by families and friends for more than two hundred years.

> *In the middle of the twentieth century, some people only forty miles or so from New York City were singing traditional versions of old English and Scottish ballads handed down in their families. These were not folks in isolated cabins in the hills. They were living in small towns in…Bergen County. They were farm workers, masons, mechanics, woodsmen, factory workers, housewives and school children. The man who may have had the largest store of those songs in his memory was Everett Pitt. Pitt recalled a family tradition of descent from a British soldier who had escaped when the* [Continental army] *stormed Stony Point* [New York] *in July 1779. The man took to the hills, found some friendly local folks, and simply became one more settler in the woods until the* [Revolutionary War] *was over. His descendants have been woodsmen, builders of stone walls, farm workers…and makers of traditional splint baskets and wooden ladles.*

The field recordings of Pitt included "The Tinker's Story," "The Butcher Boy" and "The Backwoodsman." As for identifying the source of folk songs in the Ramapo Mountains, Lutz surmised that local families most likely had learned the tunes "from songsters or broadsides, perhaps on trips to New York City." Similarities she found in ballads from the Ramapo and Catskill Mountains suggest that songs may have been carried by woodsmen traveling between the neighboring regions in search of work.

Guitar Mania

Today's folk revival musicians also can trace their roots to the advent of "Guitar Mania" in America, which began in Europe. Philip F. Gura, in his book *C.F. Martin and His Guitars, 1796–1873*, wrote that guitar craftsman Christian Frederick (C.F.) Martin arrived in New York City as the United States was "in the throes of Guitar Mania." Martin was born on January 31, 1796, in the German kingdom of Saxony, and according to information posted on the Martin Guitar Company's website, Martin and his family left Saxony on September 9, 1833. They arrived in New York on November 6,

1833. The family resided at 196 Hudson Street, and in early 1834, Martin opened his first shop at that address.

Gura summarized the rise of *"la guitaromanie,"* or Guitar Mania:

> *Martin's initial success as a guitar maker depended on the culture-wide interest in the guitar and its music that had begun in Europe about 1800 and reached the United States a few decades later. By these years the instrument had acquired its modern, six-stringed form, and widely published "tutors" for the guitar promulgated a sophisticated technique congruent to the music of the European classical tradition. Americans, stricken by the transatlantic strain of "la guitaromanie," adapted it to their own needs and interests. Less expensive and more portable than the piano, requiring different facility than wind instruments, the guitar proved a welcome accompaniment to the parlor songs, ballads, and popular operatic music that proliferated in Victorian America. By the 1840s the guitar, like the piano, violin, and flute, was a fixture in homes in which the performance of music marked a family's engagement with emergent middle-class culture.*

By the 1830s, "germs of Guitar Mania had spread across the Atlantic, where the instrument was just as eagerly embraced and, given America's unique social and economic conditions, further democratized," Gura wrote. Guitar music was heard throughout antebellum America, and concerts were held in cities like New York, Philadelphia, Boston and Charleston. He quoted American music historian Vera Brodsky Lawrence, who wrote that "the American parlor rang with home-generated music…sentimental ballads, hit tunes from the operas, hymns and folk songs of varying ethnicity." Gura also cited the writing of historian Nicholas Tawa, who said that by the 1840s "most Americans could sing and a surprising number could play a little; that is to say, perform popular song melodies, traditional ballads, airs, dance tunes and hymns."

In his book, Kaufman indicated that, in the second quarter of the nineteenth century, popular music tastes were taking shape in the Garden State. "[In Trenton and Newark] musical life in New Jersey became most active and varied," Kaufman wrote. "Vocal and instrumental soloists, family groups, vocal ensembles, ethnic musicians and minstrel shows constituted the range of performers who played to New Jersey audiences." Guitar Mania coincided with this period of burgeoning appreciation for popular music.

"Part of the guitar's growing appeal was related to its reasonable cost, for a fine instrument could be had for $25…while a piano might cost several

hundred dollars," Gura wrote. "Portability and convenience also were factors, for like the violin and flute, the guitar could be easily carried to wherever a musician was asked to perform and, compared to a piano or harp, was no trouble to tune or maintain." Martin moved his business to Nazareth, Pennsylvania, in 1839, and "by the late 1840s he was making guitars, now of his own design, on a full-time basis and marketing them throughout the United States." Martin died in Nazareth on February 16, 1873.

Dick Boak, Martin Guitar's museum director, historian and archivist, explained that the guitar initially was considered a "parlor" instrument, and many of Martin's early customers in the United States were women. He said guitars in the mid-1800s utilized "Sebastopol," or Open D tuning, while lamb-gut strings gave the guitar a soft, subdued sound (steel strings came into vogue around 1900).

According to Boak, there's an unseen thread that connects the Guitar Mania era to today's folk revival tradition and other forms of roots music. Guitar Mania also included the growing popularity of other fretted instruments such as the mandolin and the banjo. Boak said the "purely" American guitar produced by Martin combined two distinct elements: the Viennese concept brought from Europe by Martin and the Spanish design, which was influenced through a partnership with John Coupa, a guitarist who served as Martin's New York sales agent.

William Foden, a resident of Englewood who was born in St. Louis, Missouri, on March 23, 1860, was a Guitar Mania hero. *William Foden (1860–1947) Grand Sonata*, a booklet that contains the score of his masterpiece composition ("Grand Sonata"), also outlines his career. Foden was America's premier guitarist during the 1890s and the first decades of the twentieth century. He fell in love with the guitar when he was sixteen years old and embarked on his career as a professional musician at the age of twenty, gaining considerable fame while playing and endorsing his Martin guitar. He was classically trained and performed in concert halls throughout North America.

Foden was not a folk musician, but he did transcribe popular music as part of his repertoire. He serves as an important early influence—a maestro who defined the performance standards of the acoustic guitar for future generations. According to the notes in the foreword of the Grand Sonata publication, penned by Douglas Back, Foden was invited to perform at the convention of the American Guild of Banjoists, Mandolinists and Guitarists (AGBMG), with a concert held on January 29, 1904, at Carnegie Hall, New York. According to information on the Carnegie Hall website, Foden played three solos of pieces by classical composers at the Friday night show.

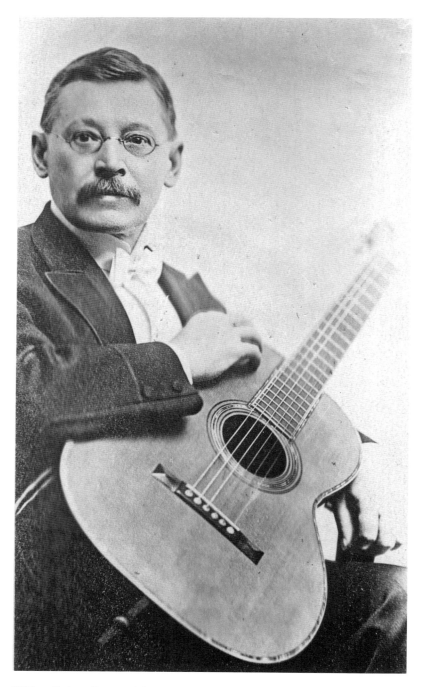

William Foden. *Courtesy of C.F. Martin Archives, Nazareth, Pennsylvania.*

"One is at a loss to find words adequately to describe Mr. Foden's playing," a review of the concert in the February 1904 edition of *The Cadenza* magazine stated. "He is more than a virtuoso. He has invented and mastered effects unknown to other guitarists. He executes trills, runs, tremolo passages, intricate chord combinations and sustained passages with a clearness of technique and fullness of tone usually associated with the harp or piano."

Following his appearance at Carnegie Hall, Foden continued to perform and teach in St. Louis until 1911, when he moved his family to Englewood and opened a music studio in New York City on Forty-Second Street. The AGBMG, at its tenth annual convention held in Philadelphia, decided to assemble a "dream team" of three world-class musicians. The guild staged a "Grand Festival Concert" at Witherspoon Hall on April 25, 1911, which featured Foden, Giuseppe Pettine ("Italy's greatest mandolinist") and Frederick Bacon ("America's greatest banjo player"). Backed by a string ensemble and the George C. Krick Plectrum Quartet, the three headliners took turns as soloists. Two nights later, on April 27, 1911, they played at Mealey's Auditorium in Allentown, Pennsylvania.

The performances received high praise from critics and fans, and the press dubbed Foden, Pettine and Bacon as the "Big Trio." The concerts put a spotlight on these fretted instruments, all of which would become staples of folk revival, bluegrass and roots music. *Music Publishing in St. Louis*, a book by Ernst C. Krohn and completed and edited by J. Bunker Clark, said that the Big Trio, from the fall of 1911 to the spring of 1912, embarked on a concert tour of forty-six North American cities that included Boston, Vancouver, Los Angeles, Denver, St. Louis, Chicago and New York. In 1939, Foden left New Jersey and returned to St. Louis, where he died on April 9, 1947.

Foreword writer Back, a teacher at Baldwin Arts Academic Magnet School in Montgomery, Alabama, and a fretted-instrument virtuoso himself, also identified exceptional New Jersey "black-tie" banjo players from Foden's era: Alfred A. Farland (1864–1954), who lived in Jersey City and Plainfield; Albert J. Weidt (1866–1945) of Newark; and Somerville's Fred Van Eps (1878–1960). Capsule biographies of these men are posted on the websites Classic Banjo Resource and Classic-Banjo. Back explained that, as black-tie performers, they played the banjo not in a folk revival or bluegrass style, but rather in what is now referred to as the "classic" banjo tradition—a technique that utilized gut-strings instead of steel strings and whose music included "society" ballroom dance music, ragtime and popular classical pieces transcribed for the instrument.

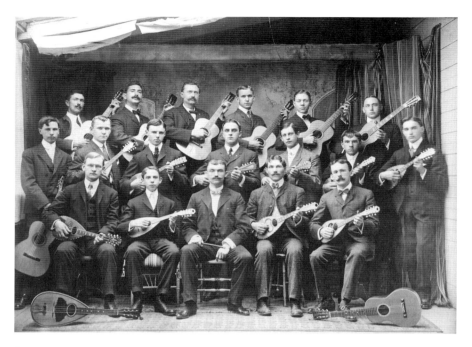

Henry Spahr's mandolin and guitar orchestra, Jersey City. *Courtesy of C.F. Martin Archives, Nazareth, Pennsylvania.*

Another Garden State Guitar Mania hero was Henry Spahr of Jersey City, who, like Foden, was a teacher, performer and Martin guitar aficionado. In the early years of the twentieth century, Spahr had a music studio at various locations on Central Avenue in the Heights section of the city and led the Spahr Mandolin and Guitar Club. Business directories for Jersey City, beginning in 1896, list Spahr as a music teacher and a provider of instruments and sheet music. He maintained a business address in Jersey City at least until 1926.

Spahr's club performed popular music from the 1900s: European operettas, Tin Pan Alley and vaudeville tunes and American ballads. Mandolin and guitar orchestras were well established throughout the United States during this period. The *New York Times*, in a May 9, 2004 story, said that "before garage bands, before swing orchestras, even before [John Philip] Sousa marches sounded in town gazebos, there was the mandolin orchestra. With the instrument's distinctive, shimmering sound, the mandolin orchestra was a fixture of amateur music-making across the United States during the late nineteenth and early twentieth

centuries." One surviving example of this tradition is the Bloomfield Mandolin Orchestra, which was founded in 1941.

Articles from the *Jersey Journal* newspaper document that Spahr and his guitar and mandolin orchestra performed at benefit concerts throughout Jersey City. A story dated April 25, 1898, reported the Spahr group played at the closing night (April 24) of an eight-day fair held as a fundraiser for the German-American School on Sherman Avenue. On September 28, 1901, the Anchor Athletic Club held a gala housewarming party to mark the opening of a new headquarters at Central Avenue and Thorne Street. The article stated that "musical selections were rendered" by Spahr's orchestra, among others. Spahr's ensemble, on November 22, 1906, performed popular music at the Thanksgiving festival at the Hudson City branch of the YMCA. The orchestra appeared at Saint Trinitatis Church on June 18, 1907, for a "Women's Rights" program. The article previewing this event said Spahr's club, made up of sixteen young men (most likely students of Spahr), had planned to perform selections such as "Swiss March," "Flower Song," "Serenade," "Queen of the Valley" and "Rocked in the Cradle of the Deep."

Like Foden, Spahr was not a folk musician, but these two pioneers are part of the unseen thread described by Boak. As teachers and performers, they set the stage for a new era and played music that was commercial and accessible. Their students went off in many directions, eager to explore a host of musical possibilities. Innovative technologies, like the phonograph and radio broadcasts, would spark new opportunities for musical expression. As the nineteenth century drew to a close, the Garden State's musical landscape glistened with the silvery sounds of guitars, fiddles, banjos and mandolins. The time for a folk music revival was rapidly approaching.

Revival

CAMDEN'S TALKING MACHINES

The sound of traditional folk and folk revival music came to life in Camden during the early years of the twentieth century. This was the place where Cecil Sharp, Paul Robeson, Carl Sandburg, the Carter Family, Jimmie Rodgers and Woody Guthrie all had important recording sessions at the Victor studios. Taken as a whole, the Camden sessions form a foundation for American folk revival music and created waves of music traditions. In the ensuing years, other internationally renowned artists passed through New Jersey to perform and record, touching lives along the way. Their efforts reverberated inside and outside the Garden State, as they crafted lyrical songs and addressed social and political issues that guided the folk revival movement.

As detailed in two online essays—"Victor Talking Machine Company, Eldridge Johnson and the Development of the Acoustic Recording Process" and the David Sarnoff Library's "The Victor Talking Machine Company"—Eldridge Reeves Johnson, on October 3, 1901, merged his Consolidated Talking Machine Company with the Berliner Gramophone Company to create the Victor Talking Machine Company. Six years later, Victor's main studio opened in Camden, at the southwest corner of Front and Cooper Streets. In February 1916, Victor christened a new executive building at Front and Cooper Streets. Two years later, the company purchased the Camden Trinity Church at 114 North Fifth Street and converted it to a studio. Recording sessions began at the church studio on February

Postcard photo of Camden, circa 1929 (RCA building is in bottom-center foreground with tower). *Courtesy of Frederick O. Barnum III, author of* His Master's Voice in America.

27, 1918. Fred Barnum, who wrote a history of the Victor Company, *His Master's Voice in America*, said Trinity Church quickly became the preferred studio because of its superior acoustics.

Eldridge Johnson sold his company to RCA in 1927. Barnum said the Camden facility had phased out studio recordings by the mid-1940s. Johnson was born on February 6, 1867, and died on November 14, 1945. An online research paper by Paul D. Fischer, "The Sooy Dynasty of Camden, New Jersey: Victor's First Family of Recording," describes the work of three brothers, Harry, Raymond and Charles Sooy, employees of the Victor Talking Machine Company, "as the unsung pioneers of popular music production."

Author and historian Leonard DeGraaf, an archivist at Thomas Edison National Historical Park in West Orange, said the famed New Jersey inventor, working at his Menlo Park lab in Middlesex County, received a patent for the ingenious tinfoil phonograph on February 19, 1878. Edison did envision the device as a source of entertainment, although DeGraaf pointed out that this early version of the phonograph "would require numerous technological improvements before it could provide a decent musical experience."

Gathering Songs, Sowing Seeds

British folklorist Cecil J. Sharp (1859–1924), a scholarly collector of ballads and folk dances, arrived in New York City on January 1, 1915. An entry in his diary on that date, transcribed by the London-based Vaughan Williams Memorial Library (part of the English Folk Dance and Song Society), states that Sharp "greeted the New Year in bed, being unable to sleep for the pandemonium in the streets. All New York seemed to be blowing tin horns, letting off explosives, rattling, etc."

The first folk music revival emerged as a result of Sharp's efforts in documenting folk songs in the United States and England. Maud Karpeles was his loyal assistant. Sharp is a key figure in the English folk revival, along with other British folklorists who preceded him, such as Lucy Broadwood, Frank Kidson and Sabine Baring Gould, all of whom were collecting and publishing folk songs during the late 1800s, as pointed out by a representative from the Vaughan Williams Memorial Library. Sharp's accomplishments included establishing the English Folk Dance Society in 1911; compiling the book *English Folk Songs from the Southern Appalachians*, published in 1917, as a joint effort with American folklorist Olive Dame Campbell; and producing recordings at the Victor studios in Camden.

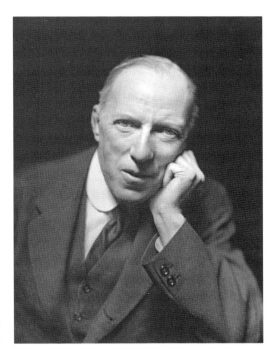

Sharp's work gathering folk songs in the United States took place during three visits, from 1915 to 1918. "In all, he collected 1,625 items. Sharp's aim was to collect songs of English origin [in America] and he did this very successfully," the Williams representative stated. He added that, generally speaking, Sharp was less interested in collecting songs and tunes of American origin, although he may have picked up some by accident.

Cecil Sharp. *Courtesy of the Vaughan Williams Memorial Library, English Folk Dance and Song Society, Cecil Sharp House, London.*

On April 15, 1915, an apprehensive Sharp wrote that he had taken the train from Philadelphia to Camden to supervise the Victor recordings. "Great fiasco—scores badly written." Despite Sharp's concerns, the session produced ten recordings by the Victor band, a "light orchestra" composed of "19 men personally supervised by Cecil J. Sharp," according to information provided by the Discography of American Historical Recordings, a database of master recordings made by American record companies during the 78 rpm era and part of the American Discography Project—an initiative of the University of California–Santa Barbara and the Packard Humanities Institute. The list of songs from the session included titles such as "The Butterfly," "Row Well, Ye Mariners" and "Goddesses."

Sharp traveled to Lincoln, Massachusetts, in June 1915 to meet with his main benefactor, Helen O. Storrow. In his June 19 diary entry, Sharp wrote that, while at the Storrow home, he met with folklorist Mrs. John (Olive Dame) Campbell of Asheville, North Carolina, "who showed me her collection of ballads, which I found most interesting." Three books—*Folk Dancing* by Erica Nielsen; *Hoedowns, Reels and Frolics: Roots and Branches of Southern Appalachian Dance* by Phil Jamison; and *Cecil Sharp: His Life and Work* by Karpeles—describe the meeting at the Storrow home. Campbell invited Sharp and Karpeles to visit Asheville. They arrived by train in July 1916, and this collaboration with Campbell became an extended project for which Sharp and Karpeles spent weeks doing field research in remote southern Appalachian communities, all of which led to Sharp's 1917 book.

According to an online essay by Digital Heritage, Campbell believed that the inhabitants of the Southern Appalachians were still singing the traditional songs and ballads handed down by their English and Scottish ancestors—tunes they brought with them to America. Sharp's research demonstrated how people tenaciously cling to their beloved folk songs, even when it means crossing an ocean to find a new home. The nostalgic tunes, embedded in the hearts of these immigrants, helped to ease their transition and fashion a new culture in a foreign land.

Sharp's efforts would have a lasting effect on American music. He influenced a generation of social historians, encouraging them to become more active in researching their respective folk cultures. The Digital Heritage essay stated that, in the wake of Sharp's work, "modern country music was borne of traditional ballad recordings produced in the heart of southern Appalachia. Music festivals, concert performances, and competitions began appearing nationally and throughout the region."

Prior to his initial journey to Asheville, Sharp made arrangements for another recording session at the Victor studios in Camden. His March 7, 1916 diary entry states that he caught the 8:00 a.m. train in Philadelphia and arrived at the Victor studios at 10:30 a.m. "Thank heavens I had another conductor, one Mr. Rogers, who really was a musician and knew his work. Consequently I was able to finish off all the records."

The Williams representative indicated Sharp oversaw three recording sessions at the Victor studios in 1915 and 1916, which included the arrangements of folk dance tunes that he had collected. "We know from the letters and diaries that Cecil Sharp had plenty of meetings with people at Victor and that he had worked on choosing and arranging material for the sessions." The Camden sessions took place on April 15, 1915; November, 26, 1915; and March, 7 1916.

Sharp left many legacies, one of which was his belief that folk music should be part of public education curriculum. For Sharp, this was a priority, and he championed the cause. He was sowing seeds that would take root in the later years of the twentieth century, providing a foundation for the folk revival music phenomenon (and market) in America. Young students exposed to the joys of folk music would become receptive consumers and participants in the genre in their adult years.

A Ragbag of Strips, Stripes and Streaks

President Lyndon Baines Johnson, in September 1967, during a memorial service for American poet Carl A. Sandburg (1878–1967) held at the Lincoln Memorial in Washington, D.C., said Sandburg "was more than the voice of America; more than the poet of its strength and genius. He was America."

Sandburg rose to national prominence in 1919, when his collection of poems, *Cornhuskers*, won the Pulitzer Prize. In addition to being a poet, Sandburg was a dedicated collector of American folk songs, which led to recording sessions at Victor studios in Camden. The Discography of American Historical Recordings documented two recording dates for Sandburg: a trial session of two songs on December 9, 1925, and a follow-up session on March 4, 1926. He sang and played guitar. The list of Sandburg's tunes included a "Classical Guitar Song," "The Boll Weevil Song," "Negro Spiritual," "Two Old Timers," "Two Cowboy Songs" and "Two Hobo

Songs." Victor issued two selections, "Boll Weevil" and "Negro Spiritual," on a single 78 disk.

Ronald D. Cohen, in his book *Rainbow Quest: The Folk Music Revival and American Society, 1940–1970*, described Sandburg as an "influential outsider." Sandburg, Cohen said, "made an early contribution to folk music through his publications, records and public performances. His leftist politics and search for heroic, common themes in U.S. history led, perhaps naturally, to a love of folk music. He collected folk songs most of his life and…frequently performed during public lectures the spirituals and hobo, cowboy and jail songs he had zealously collected." Sandburg's major contribution to folk music, according to Cohen, was his 1927 book, *The American Songbag*. In the book's introduction, Sandburg described his compendium, a collection of 280 songs:

> *The American Songbag is a ragbag of strips, stripes, and streaks of color from nearly all ends of the earth. The melodies and verses presented here are from diverse regions, from varied human characters and communities, and each is sung differently in different places.* [The songbag] *comes from the hearts and voices of thousands of men and women. They made new songs, they changed old songs, they carried songs from place to place, they resurrected and kept alive dying and forgotten songs.*

A PEERLESS A&R MAN

Victor artist and repertoire (A&R) man Ralph Peer (1892–1960) traveled to Bristol, Tennessee, during the summer of 1927, in search of new folk and country music talent—a now-legendary excursion in the annals of American music. Peer set up a temporary recording studio on State Street in downtown Bristol, the boulevard that was directly on the Tennessee/ Virginia state line. An online essay by Ted Olsen, written for the Library of Congress, and the book *Encyclopedia of American Gospel Music*, edited by W.K. McNeil, recount how these audition sessions, which ran from July 25 to August 5, led to Peer's discovery of the Carter Family and Jimmie Rodgers and how he brought them to record in Camden.

The Carter Family—Alvin Pleasant (AP) Delaney, his wife, the former Sara Dougherty and Maybelle (Addington) Carter, the wife of AP's brother Ezra—through their Victor recordings, emerged as pioneers of

American roots music. They became a standard for aspiring artists such as Woody Guthrie, Doc Watson, Johnny Cash, Joan Baez and Bob Dylan. Decades after their first recordings, they were inducted into the Country Music Hall of Fame, the Grammy Hall of Fame and the International Bluegrass Hall of Fame.

Sara, Maybelle and AP recorded six tunes for Peer on August 1 and 2, 1927, during the Bristol audition. The songs, according to a listing by the Discography of American Historical Recordings, were "Little Log Cabin by the Sea," "Bury Me Under the Weeping Willow," "Poor Orphan Child" and "The Storms Are on the Ocean" on August 1 and "Single Girl, Married Girl" and "The Wandering Boy" on August 2. McNeil wrote that, on November 4, 1927, Victor released the first Carter Family record, *Poor Orphan Child*, which became a hit. "Peer wasted no time in getting the Carters back into the studio," and paid the expenses for them to come to Camden, according to McNeil. Sessions in Camden on May 9 and 10, 1928, yielded twelve tunes, including "John Hardy Was a Desperate Little Man," "Anchored in Love" and "Wildwood Flower." The songs and their arrangements, instrumentation and vocal harmonies would become benchmarks for the twentieth-century folk revival sound.

The family returned to Camden on February 14 and 15, 1929, to record twelve more songs, including "Diamonds in the Rough," "My Clinch Mountain Home," "I'm Thinking Tonight of My Blue Eyes" and "Sweet Fern." Information on the American Experience website stated that Peer "had hit pay dirt" with the Carter Family. By 1930, they had several national hits and had sold more than 700,000 records. "By 1930 the Carters had broadened their repertoire to include modern-sounding songs…as well as African-American church music."

Peer, a champion of American roots music, knew the lay of the land in the Garden State, having resided in East Orange during most of his years as an A&R man, from 1919 through the 1930s. He joined Victor in 1926 and originally was employed at the Otto Heineman Phonograph Supply Company, which became General Phonograph, with a record label named Okeh, according to the book *Ralph Peer and the Making of Popular Roots Music* by Barry Mazor. Mazor wrote that General Phonograph had a manufacturing operation in Newark. "Peer's leisure time, limited as it was, tended to involve the close-knit family of General Phonograph and Okeh employees around East Orange."

"In the course of his career, Peer singled out a historic list of musical jewels and placed them in settings that got our attention," Mazor continued.

"Ralph Peer developed and executed a business strategy that bordered on an aesthetic. At its core was a simple idea: untapped roots music—music that evidences rich history, that has moved a specific people of some distinctive place and culture and reflects their lives and rhythms—could appeal to much broader audiences by far, if handled properly as a commercial musical proposition."

THE FATHER OF COUNTRY MUSIC

On November 30, 1927, Jimmie Rodgers arrived at the Victor studios in Camden, having accepted an invitation from Peer. Like the Carter Family, Rodgers had met Peer in August of that year in Bristol for an initial demo session. Rodgers recorded four tunes in the Camden studios, including "T for Texas," also known as "Blue Yodel Number 1," which went on to become a national hit and featured his signature country yodel.

Immortalized as "the Father of Country Music," Rodgers admittedly was not a folk revival singer, but his music would have a direct influence on important revival musicians like Woody Guthrie, Pete Seeger and Bob Dylan. In his book *Meeting Jimmie Rodgers: How America's Original Roots Music Hero Changed the Pop Sounds of a Century*, Mazor pondered the question of whether Rodgers should be considered a "hero" in the folk revival music genre. Mazor wrote that, with "little equivocation," Rodgers didn't want to be a folk singer. During Rodger's brief career as a professional musician, he demonstrated a

> pattern of choices…that steered him clear of the folk minstrel job description…and kept his music outside of the urban folk song bag. Yet it is not surprising, in view of the eventual emergence of folk revival heroes who owed him something, that Jimmie himself is sometimes claimed as a hero of American folk music. In the places where the makers and consumers of unmediated down-home music lived and struggled to get by, Jimmie Rodgers' music was out there, being played and adapted.

Rodgers was a dedicated Martin Guitar user. Dick Boak, the Martin Guitar historian, said Rodgers is part of the unseen thread that traces the development of folk revival music, as mentioned in Part I. According to Boak, the twelve-bar blues that Rodgers helped pioneer serves as a foundation for

folk revival music as well as rock-and-roll. "Jimmie's early records set the groundwork for everything that followed," Boak said. "All genres of music interconnect and influence each other."

The distinctive vocal style of Rodgers, molded by regional influences, much of it rooted in a blues tradition, is what set him apart from other performers in his day, according to Mazor. Rodgers's singing and phrasing "was loose and comfortable, closely akin to the way he spoke. At times it was nearly conversational. His style contrasted sharply with the old-school, declamatory style of vocalizing that was still

Jimmie Rodgers. *Courtesy of C.F. Martin Archives, Nazareth, Pennsylvania.*

holding on in pop operetta and early Broadway shows." Mazor wrote that record buyers and radio and sound-film audiences were seeking "something from the American vernacular that sounded more intimate, not designed to be boomed across a concert hall. Rodgers' performing style was about emotional immediacy. He sang the lyrics of a song...communicating the drama of the story as it unfolded."

Following that initial November 30, 1927 recording session with Victor, Rodgers had five more studio dates in Camden, the last being on August 15, 1932, according to information posted by the New World Encyclopedia website. Rodgers was born on September 8, 1897, in Meridian, Mississippi, and died in New York City on May 26, 1933.

THE DUSTIEST BALLADEER

Woody Guthrie landed in New York City during a winter storm on February 16, 1940. The book *Woody Guthrie: American Radical* by Will Kaufman chronicled Guthrie's arrival and early activities in the Big Apple.

Woody Guthrie on the New York City subway, circa 1943; photo by Eric Schaal. *Courtesy of Woody Guthrie Publications Inc. Used by permission.*

While living in California, Guthrie met Hollywood actor and left-wing activist Will Geer. (Geer is best known for playing Grampa Walton in the 1970s TV series *The Waltons*.) Geer invited Guthrie to join him in New York. Guthrie, who had been living in Pampa, Texas, sold his car, paid for a bus ticket to Pittsburgh and then hitchhiked the rest of the way. Geer, at the time, had the lead role of Jeeter Lester in the Broadway production *Tobacco Road*, which was playing at the Forrest Theater.

Ed Cray, in his book *Ramblin' Man: The Life and Times of Woody Guthrie*, described Geer as a prominent organizer of left-wing causes, traveling the country to support striking workers. Geer booked Guthrie to perform at Manhattan's Mecca Temple on February 25, 1940, a rally to benefit Spanish Civil War refugees. This rally was a prelude to Guthrie's involvement in a major concert one week later. Cray wrote that Geer had made arrangements with the producers of Tobacco Road to use the Forrest Theater (today known as the Eugene O'Neill Theater, located on West Forty-Ninth Street) for a concert to benefit the John Steinbeck Committee for Agricultural Workers.

The concert, dubbed "A Grapes of Wrath" evening (the name borrowed from Steinbeck's classic 1939 American novel), was held on March 3, 1940, presented by Geer and the Theatre Arts Committee of New York. In retrospect, the concert was a pivotal moment that helped to launch the American folk revival music movement of the twentieth century. "There had been other 'folk' music recitals, but this would be remembered as the first really important one, the first before a large, mainstream audience," Joe Klein wrote in his book *Woody Guthrie: A Life.*

The New York–based *Daily Worker* newspaper, in its March 1, 1940 edition, provided preview coverage of the show, a "ballad-sing benefit," with

the headline "Broadway Progressives Aid American Relief." The newspaper reported that proceeds for the benefit would go "entirely for the aid of the now-famed 'Okies'. They are the 'refugees' from the ravages of our native landlords and bankers, who are waging as merciless a war against these people as any battle taking place in Europe." The article went on to say that the concert, in the "true American tradition," would present

> some of the finest and most authentic folk and working class artists to be found in this country. Along with Geer on the Grapes of Wrath program, there will appear a veritable bumper crop of talent, including "Woody," a real Dust Bowl refugee and discovery of Geer's who was brought to New York recently, especially to appear on the program. Woody is a folk singer who chants not only the genuine songs of this region, but composes unique and moving ballads of social and topical nature.

Below the *Daily Worker* article was a two-column photo of a guitar-strumming Guthrie with this caption: "Woody—that's the name. Straight out of John Steinbeck's *The Grapes of Wrath*, this troubadour will sing ballads of the people at the Forrest Theater affair."

The concert also brought together Guthrie, Alan Lomax and Pete Seeger. Cohen, in his book *Rainbow Quest*, said Pete Seeger, born in New York City on May 3, 1919, "dropped out of Harvard at nineteen and hit the road. The [Grapes of Wrath] concert marked Seeger's inaugural public performance, a nervous rendition of one song." Cray and other sources identified the tune as "The Ballad of John Hardy." Seeger had left Harvard University in the spring of 1938 and a year later was hired by Lomax as an intern at the Library of Congress's Archive of American Folk Song. It was Lomax who urged Seeger to perform at the Forrest Theater show.

A copy of the Grapes of Wrath program, provided by the Woody Guthrie Center in Tulsa, Oklahoma, identified the lineup of performers. In addition to Guthrie and Seeger, the list included Geer, Aunt Molly Jackson, Lomax, the legendary blues singer Leadbelly, Burl Ives, the Pennsylvania Miners and the Golden Gate Quartet. Guthrie, as listed in the concert program, performed "Do Re Mi," an untitled blues tune and an antiwar song titled "Why Are You Standing in the Rain?"

Cray wrote that Alan Lomax was intrigued by Guthrie—both his music and persona. Alan, the son of pioneering folklorist John Avery Lomax, "was an enthusiastic promoter of American folk music. By March 1940, and the time of the Forrest Theater concert, Alan was a driving force in the

burgeoning revival of American folk song in big cities." He served as the "assistant in charge" of the Library of Congress's Archive of American Folk Song. According to Cray, Lomax collaborated with Geer and selected the performers for the Grapes of Wrath event, except for

> *Will Geer's friend from California, this bushy-haired Okie with the exaggerated drawl* [meaning Guthrie]. *Lomax was overwhelmed. Guthrie was not only singing folk songs, he was writing his own; songs that reflected Lomax's own belief in a new America, a nation in which the working people expressed themselves through folk culture. In Guthrie, Lomax heard a real ballad maker, a man who wrote in the people's idiom. Guthrie was a natural genius.*

DUST BOWL BALLADS

In his book, Ronald Cohen observed that by 1940, folk and folk revival musical idioms had gained the attention of record labels. There was an expanding, diverse audience for the music, as demonstrated by the popularity of the Forrest Theater event. "Major record companies recognized the growing urban interest in native folk styles....The long-smoldering question of authenticity and style versus substance would continually engage folklorists, music critics and fans throughout the century."

The fast-paced sequence of events involving Guthrie in the span of three months—arriving in New York, performing at the Grapes of Wrath concert, connecting with Lomax and Seeger—propelled Guthrie's career as a recording artist. Cray's book and the blog *Woody Guthrie Dust Bowl Ballads* tell the story of how RCA Victor producer Robert P. Wetherald approached Lomax about doing a "folk" record. Lomax quickly nominated Guthrie for the opportunity, describing Woody "as our best contemporary ballad composer." During this early period of his career, Guthrie often was referred to as a "balladeer." Guthrie signed an "Artists Letter Agreement" with RCA Manufacturing Company Inc., dated April 24, 1940, a copy of which is on file in the archives at the Library of Congress. Two days later, Woody Guthrie arrived at the RCA studios in Camden to record his *Dust Bowl Ballads* album. Most likely, he traveled by train, toting his guitar case and a notebook full of tunes. This would be Guthrie's first commercial studio recording session.

O-44

RCA MANUFACTURING COMPANY, INC.

A RADIO CORPORATION OF AMERICA SUBSIDIARY

Camden, New Jersey

Mr. Woody Guthrie
203 W. Craven Ave.,
Pampa, Texas.

Date April 24, 1940

Dear Sir: ARTISTS LETTER AGREEMENT

1. This Letter Agreement will constitute an agreement between you and RCA Manufacturing Company, Inc. (herein called "the Company") for the rendering of personal services by you in connection with the production of phonograph records, containing Dust Bowl Songs of your own composition or arrangements.

2. This Agreement shall remain in effect for a period of one year from the date hereof, and during that period you will, at mutually convenient times, come to and perform at the Company's recording studios for the purpose of recording twelve (12) selections, or more than this number if the Company so desires.

In consideration of this agreement and without further payment than as herein provided, you grant to the Company, its associates, subsidiaries and nominees (1) the right to manufacture, advertise, sell, lease, license or otherwise use or dispose of in any or all fields of use, throughout the world, or to refrain therefrom, throughout the world or any part thereof, records embodying the performances to be recorded hereunder, upon such terms and conditions as the Company may approve; (2) the right to use your name and photograph, if desired, in connection with the exploitation of said records; and (3) all rights in and to the matrices and records, and the use and control thereof, upon which are reproduced the performances to be recorded hereunder.

3. The Company will pay you for the rights granted herein, and the services to be rendered hereunder, a royalty of 0 % of the retail list price of records in the country of manufacture, if pressed in North or South America, China or Japan, and a royalty of 0 % of the retail list price in England for all records sold elsewhere, for each double-faced record manufactured and sold by the Company on both faces of which are embodied any of the selections recorded hereunder. In case of records manufactured and sold by the Company on only one face of which is embodied a selection recorded hereunder, the amount of royalty shall be one-half the amount set forth above. Royalties are to be computed in the national currency of the country where the list prices above mentioned apply, and are payable in the dollar equivalent at the rate of exchange at the time of payment. Payment of royalties on records sold in foreign countries shall be made only if the Company itself receives payment thereof. This payment will also cover our use of your compositions or arrangements recorded hereunder.

The Company further agrees that within ten days after each master record recorded hereunder has been approved by an authorized representative of the Company, it will pay you the sum of Twenty-five Dollars , as an advance payment against the royalties to be earned under this contract and said payment shall be deducted from said royalties at the time of settlement therefor.

IPA-9
GO RCA ALL

Mr. Woody Guthrie -2- April 24, 1940

4. Payment of accrued royalties shall be made semi-annually, on the first day of May for the period ending March 31 and on the first day of November for the period ending September 30 of each year. The Company, however, shall have the right to deduct from the amount of any statements, or accounts of royalties due, the amount of royalties previously paid to you on records subsequently returned, either as defective or on exchange proposition.

5. You agree that during the period of this Agreement you will not perform for any other person, firm, or corporation, for the purpose of producing records, that after the expiration of this Agreement you will not record for anyone else any of the musical selections recorded hereunder, and that in the event of a breach of this covenant, the Company shall be entitled to an injunction to enforce same, in addition to any other remedies available to it.

6. If any instrumental musicians whose services are engaged hereunder are members of the American Federation of Musicians, the following provision shall be deemed to be a part of this agreement:

"As the musicians engaged under the stipulations of this contract are members of the American Federation of Musicians, nothing in this contract shall ever be construed as to interfere with any obligation which they owe to the American Federation of Musicians as members thereof."

7. It is mutually understood and agreed that in the event the license issued to the Company by the American Federation of Musicians, and pursuant to which the Company engages the services of Federation members as instrumental musicians, should be revoked or terminated, with or without cause, and in the event you or any of the members of the musical organization are members of the Federation, this agreement shall be suspended until such time as the Company's license is restored, and if it is not restored within six months, then this agreement shall be deemed terminated.

8. The Company shall have the privilege and option to extend this Agreement from the date of its expiration for a period equal to the term of this Agreement by giving to you notice in writing of its exercise of such option and its election to continue. Such notice shall be given to you personally or be mailed to your last known address not less than ten days prior to the expiration of this Agreement. Upon the giving of such notice this Agreement shall be continued and extended for such further period upon the same terms as those above set forth.

Kindly sign both copies of this letter, in the place provided to constitute this an agreement between us and return same for execution by the Company, whereupon one executed copy will be returned for your files.

Very truly yours,

RCA MANUFACTURING COMPANY, INC.

By
Vice President

ACCEPTED AND AGREED TO:

W. W. Guthrie
IPA-9-2

This is Woody Guthrie's two-page contract, dated April 24, 1940, for his first studio album, *Dust Bowl Ballads*, recorded at the RCA studios in Camden. *Courtesy of the American Folklife Center, Library of Congress, Washington, D.C. Used by permission.*

Guthrie's *Dust Bowl Ballads* album and the Grapes of Wrath concert are cornerstones in the American folk revival tradition. The recording sessions in Camden took place on April 26 (the primary session) and May 3. The list of tunes included "Talkin' Dust Bowl Blues," "Tom Joad," "The Great Dust Storm" and "I Ain't Got No Home in This World Anymore." The songs on the album were Guthrie's eyewitness accounts of Midwest dust storms during the depths of the Great Depression.

Released in July 1940, *Dust Bowl Ballads* inspired generations of musicians. However, authors Cray and Klein wrote that the album initially received little critical attention. According to Klein, "the most perceptive review came from Howard Taubman in *The New York Times*: These albums are not a summer sedative. They make you think; they may even make you uncomfortable."

During the 1940s, Guthrie was in demand to sing at labor rallies and union halls. Will Kaufman, in his book *Woody Guthrie: American Radical*, wrote that on February 9, 1947, Guthrie was invited to sing for the United Electrical Workers at the Phelps-Dodge Plant in Elizabeth. The workers had just concluded a bitter eight-month strike. Guthrie did perform, but this date tragically coincided with the death of his four-year-old daughter, Cathy Ann, who perished in an accidental fire at the Guthrie home in Coney Island, New York.

THE LIVE WIRE IN NEWARK

The October 21, 1949 edition of the *Jewish News* reported that Guthrie would present a song and lecture program on the development of American folk music at the Jewish Community Center in Newark, part of the center's "Meetings on Mondays" series. Years later, this concert would come to be known as the "Live Wire" performance. The event took place on October 24, 1949. The *Newark Evening News*, in its October 24, 1949 edition, previewed the event, saying Guthrie "would perform tonight at 8:15 p.m. in Fuld Hall" at the Newark center. The article described him as the "author of hundreds of folk songs" and mentioned his service during World War II as a merchant marine (and in the army). "Guthrie's wife, Marjorie Mazia, a dancer, will give a commentary on her husband's songs between his offerings." *The Live Wire* CD booklet indicates that "no more than fifty people" attended the Monday night program.

Marjorie was a dancer with the Martha Graham Dance Company and taught classes at the Newark center. One member of the audience on that Monday night was a Rutgers University student named Paul Braverman, who had brought with him a wire-recording device. According to the accompanying booklet for the 2007 *Live Wire* CD, Braverman, more than fifty years after attending the performance, discovered the wire recordings in a closet at his home in Florida. He donated them to the Woody Guthrie Archives in 2001. The CD was released in 2007, and it won the 2008 Grammy Award for Best Historical Album. The Newark performance represents the only known full-concert

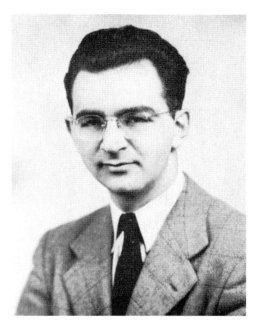

Rutgers student Paul Braverman, circa 1949. *Courtesy of Special Collections and University Archives, Rutgers University Libraries, New Brunswick.*

recording of Guthrie. Song titles on the CD performed that night in Newark include "Black Diamond," "The Great Dust Storm," "Talking Dust Bowl Blues" and "Tom Joad." Braverman died in 2003, according to a December 19, 2007 Associated Press story.

Kurt Sonnenfeld, a Queens, New York resident who worked at the Newark center and was a friend of Marjorie, recalled seeing Woody at the center on several occasions. Sonnenfeld, who, along with his family, came to the United States in 1940 to escape the growing Nazi threat spreading throughout Europe, was a resident of Manhattan in the late 1940s. He would take the bus to Newark three days a week, working as a supervisor for youth groups at the Jewish center. "My friends and I, we liked folk songs and we went to concerts and political rallies in New York City," Sonnenfeld said in a February 2015 phone interview. "We were sympathetic to progressive causes. Woody Guthrie, Pete Seeger and Paul Robeson—they were our heroes, musically and politically." Sonnenfeld confessed that he wasn't able to attend the Live Wire concert.

Throughout the 1950s, Guthrie's health deteriorated due to the effects of Huntington's disease. In the mid-1950s, he spent two years at Brooklyn

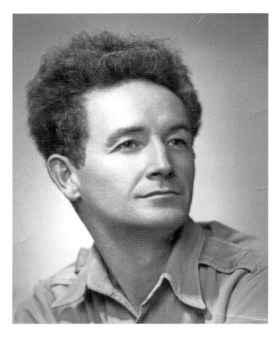

Woody Guthrie publicity photo. The picture is dated July 1948 and was taken at the studio of Oscar Stechbardt, which was located at 614 Central Avenue in East Orange. *Courtesy of the* People's World, *Chicago, via the Tamiment Library and Robert F. Wagner Labor Archives at New York University.*

State Hospital. Cray wrote that Guthrie was released from the hospital and made his way to New Jersey, where he was arrested in the Morristown area on May 28, 1956, "wandering aimlessly on a highway in a dazed condition." Guthrie was committed to the New Jersey Hospital at Greystone Park, a sanatorium in Morris Plains, on May 29, 1956, according to his summary medical report reproduced in the book *Woody Guthrie's Wardy Forty* by Phillip Buehler. During his days at Greystone, Guthrie was befriended by two devoted fans, Bob and Sidsel Gleason, and he spent weekends at their East Orange apartment.

Guthrie died at Creedmoor State Hospital in Queens, New York, on October 3, 1967 at the age of fifty-five. Author and historian Nat Hentoff, in a magazine article written three years before Guthrie's death, quoted John Steinbeck on the significance of the Dust Bowl balladeer's legacy. "There is nothing sweet about the songs [Guthrie] sings, but there is something more important for those who will listen. There is the will of the people to endure and fight against oppression. I think we call this the American spirit."

I SHOULDN'T HAVE BEEN SURPRISED

Josh White, the silky-voiced guitarist, arrived in the Big Apple in 1931. White's discography as a folk revival and blues singer began in 1929, and he recorded throughout the 1930s. In late 1939, White was cast in a supporting

role in the Broadway production *John Henry*, with Paul Robeson in the lead role. The production opened on January 10, 1940, at the Forty-Fourth Street Theater but lasted only seven performances, according to *The Complete Book of 1940s Broadway Musicals* by Dan Dietz.

Music historians point to "John Henry" as the most popular song in American folk music. John Henry is depicted as a powerful, brave, defiant figure. Several have attempted to identify the man behind the legend. One author believes he came from New Jersey. Scott Reynolds Nelson, in his 2006 book *Steel Drivin' Man: John Henry, the Untold Story of an American Legend*, did research at the Library of Virginia, examining records from the old Virginia Penitentiary, and discovered John William Henry, a "colored man" who was received at the prison (at age nineteen) on November 16, 1866. According to those files, he was born in Elizabeth and was serving a ten-year sentence for "housebreak and larceny." Nelson wrote that the prison register shows New Jersey's John Henry was contracted to join Virginia's Chesapeake & Ohio (C&O) Railroad in 1868. Records also indicate that convicts and steam drills worked side by side, as described in the folk song.

While the Broadway production of *John Henry* had a short run, this experience connected Josh White with other musicians in New York. Author Elijah Wald, in his book *Josh White: Society Blues*, wrote that "the New York Left was certainly heady company for black blues singers. In the 1930s, Josh's fans had been rural, southern blacks; in the 1940s they were white, urban and often quite wealthy café-goers." Wald wrote that this new audience "lionized and applauded" White's stance on racial and social justice issues.

In 1940, White came to New Jersey, a visit that would inspire a song. He went to see his brother Bill, who was in Fort Dix taking part in basic training for the army. Wald, during an August 2015 phone interview, said he learned about the story from notes given to him by White's manager. Wald said White also recounted the tale during an October 29, 1944 radio interview on the broadcast *New World A'Coming: Music at War*. White drove out to Fort Dix and was shocked to witness the segregated conditions that existed between white and black recruits. "Well, I shouldn't have been surprised," Wald quoted White, "but I wasn't thinking. I felt that once we were preparing to fight an enemy, we'd forget about all these things." White returned to New York, still disturbed by this experience. "I went home and couldn't sleep, so I wrote a song. It wasn't a good song, a good tune or a good lyric, but I said what I had to say, what I wanted to say about Uncle Sam."

Collaborating with Harlem Renaissance poet and composer William Waring Cuney, White wrote the tune "Uncle Sam Says," which appeared

This photo of Josh White Sr. was taken at a war bond rally in New York, circa 1942. *Courtesy of Douglas A. Yeager Productions, New York. Used by permission.*

on his 1941 recording *Southern Exposure: An Album of Jim Crow Blues*. The song also was released as a single. Wald, in an article he penned for *Living Blues* magazine ("Josh White and the Protest Blues"), said the album garnered reviews in mainstream media, including a story in the *New York Times*. "This coverage all concentrated on the political content of his music…the burden of

these songs is the bitter lot of the Negro seeking his meed of equality," Wald wrote, paraphrasing the *Times* review. Despite White's initial misgivings, Wald pointed out that "Uncle Sam Says" was "the most significant song on the album…a cutting 12-bar critique." The song's lyrics lament that, even when the United States was pulling together to fight the war in Europe, African Americans, serving honorably and courageously in the armed forces,

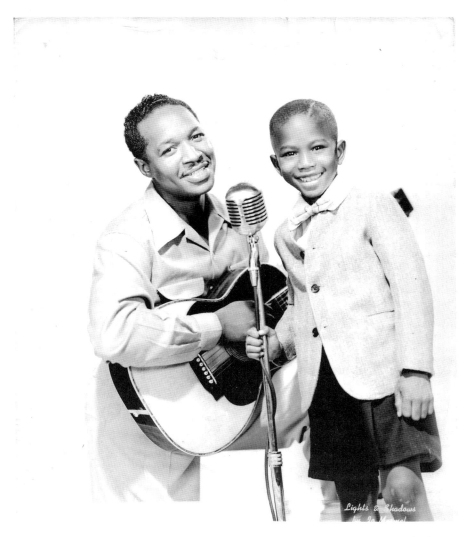

Beginning in 1944, Josh White Jr. and his dad began performing as a duo on New York radio broadcasts. In June 1998, the U.S. Postal Service issued a postage stamp in honor of Josh White Sr. *Courtesy of Douglas A. Yeager Productions, New York. Used by permission.*

still were forced to endure the segregated restrictions and bigotry imposed on them by the Jim Crow era.

Wald also discussed an obscure New Jersey episode for White—a recording session for a little-known studio, CES Recordings, located in Livingston, which purportedly took place on the evening of March 26, 1954. Though the story is somewhat murky, Wald said he culled together several sources, which indicated the session—eight songs—did take place and that the tunes were released by London Records in Europe and Period Records in the United States. The 1958 Period album *Josh White Comes A-Visiting* had White's tunes on the album's A side, paired with eight songs by Big Bill Broonzy on the B side.

The Period album notes described a session that started out with a degree of tension.

The night of the [recording] *date Josh was leaving for Hollywood....The first ten minutes were stretched as tight as a guitar string. Suddenly, Josh grinned. "This is going to be a good session," he said quietly with a deep chuckle. It was! Josh took over the session with the result that had the feeling he and his friends had just dropped in on us from the road to spend a few hours of folksy music. We like this record. We like it because we think it is an honest picture of Josh White at his finest and "folksiest."*

Josh White Jr. was the featured guest at the Hurdy Gurdy Folk Music Club in Fair Lawn at a concert held in December 2014 to celebrate the 100th anniversary of his dad's birth.
Courtesy of Douglas A. Yeager Productions, New York. Used by permission.

White, who was born on February 11, 1914, in Greenville, South Carolina, and died on September 5, 1969, in Manhasset, New York, recorded albums throughout the mid-1960s, although earlier in his career he was a "blacklisted" artist due to his views on politics and civil rights. Ron Olesko's "Folk Music Notebook," an online article

posted on December 1, 2014, by *Sing Out!*, reported that the Hurdy Gurdy Folk Music Club in Fair Lawn would honor White, marking the 100th anniversary of his birth, with a concert at the Fair Lawn Community Center on December 6, 2014. Josh White Jr., White's son, a professional folk revival and blues musician, was the guest of honor for the performance.

Paterson's Blacklisted Son

Writing in the July 14, 1942 edition of the *New Republic*, Paterson native Millard Lampell offered thoughts about the power and influence of music. "What makes good songs?" Lampell asked in his article.

> *The answer is in folk music. The Spanish loyalists sing folk songs. The Red Army is singing folk songs and so are the Chinese. Folk songs* [are] *in the people's language and in the people's tradition. Songs made up yesterday and this morning. It's about time for somebody to slap down the idea that folk music means archaic ballads and hill tunes. Folk music is a living art of working people, writing about their own lives. It means assembly lines, wives and kids, love, and the sound of machines. It means saying it straight, with no tricky rhymes, strained puns and tortured metaphors. It means writing simply, with the color and imagery of an ordinary working man's speech.*

Lampell's essay decried what he considered to be restrictions imposed by the American music industry on thoughtful songs. "The whole vast network of music distribution is a slick machine," he wrote. "Standards are set by the music publishers and the songwriters accept them meekly…and wonder what the hell rhymes with 'champagne.' Record companies turn out whatever songs the 'name' performers want to record, and 'name' performers use the songs music pluggers hand them." Despite the hurdles, Lampell wrote that there was reason to be hopeful, saying he was reassured by the graceful simplicity and good taste of everyday people. "Occasionally the good songs get through. And sometimes, when enough people sing them loud enough, they echo up into the chromium and leather offices of the radio chains and record companies."

Millard Lampell was born in Paterson on January 23, 1919. His parents, Bertha and Charles Lampell, had come to America from Austria and

Millard Lampell pictured with Hollywood actress Betty Garrett (1919–2011) at a 1946 Citizens to Abolish the Wood-Rankin Committee rally held in Manhattan. The Wood-Rankin Committee was associated with the U.S. House Committee on Un-American Activities. *Courtesy of the People's World, Chicago, via the Tamiment Library and Robert F. Wagner Labor Archives at New York University.*

operated a millinery shop in the Silk City. Lampell grew up in the aftermath of Paterson's 1913 silk millworkers' strike, a significant chapter in America's labor history. He attended School 20 and graduated from Eastside High School. He arrived at the University of West Virginia in the fall of 1936, going there on a football scholarship. A biography on Lampell, posted on the website Allmusic.com, stated that during his years as a student at West

Virginia, Lampell "became fascinated by the rural folk music that he heard, and his social conscience evolved as well in the mid-1930s, especially after he visited the home of a college roommate and discovered the conditions under which coal miners worked and lived. He also saw first-hand the battles waged between the United Mine Workers and the mine owners."

Beginning in 1940, Lampell wrote articles for the *New Republic* and became acquainted with another *New Republic* author named Lee Hays. Doris Willens, in her book *Lonesome Traveler: The Life of Lee Hays*, said that the two young writers connected through a series of letters of mutual admiration. It was through this correspondence that they decided to meet in New York. Willens wrote that they hit it off well and decided to become roommates, getting an apartment in the Chelsea section of Manhattan. Woody Guthrie and Pete Seeger also were in town during this period, and through a mutual friend, Lampell and Hays met Seeger and Guthrie, which led to the formation of the Almanac Singers.

Tender Comrades: The Backstory of the Hollywood Blacklist by Patrick McGillian and Paul Buhle includes a chapter on Lampell, in which he described himself as "a storyteller from an early age." During his university years, he said he became interested in "one particular subject—fascist movements in America." After graduating from the University of West Virginia, Lampell said he hitchhiked to New York with the aim of becoming a writer. Lampell, in an op-ed piece ("I Think I Ought to Mention I Was Blacklisted") that appeared in the August 21, 1966 *Sunday New York Times*, shared his experiences:

> *In 1940 I had come up from West Virginia and, with Pete Seeger, Woody Guthrie and Lee Hays, formed a folk singing group called the Almanacs.... There wasn't exactly a clamor for folk singers and we were grateful for any paid bookings we could get. Mostly we found ourselves performing at union meetings and left-wing benefits for Spanish refugees, striking Kentucky coal miners and starving Alabama sharecroppers. We were all children of the Depression, who had seen bone-aching poverty.... We had learned our songs from gaunt, unemployed Carolina cotton weavers and evicted Dust Bowl drifters.... We were for the working stiff, the underdog and the outcast and those were the passions we poured into our songs. We were all raw off the road and, to New York's left-wing intellectuals, we must have seemed the authentic voice of the working class. Singing at their benefits kept us in soup and guitar-string money.*

THE ALMANAC TRAIL

The Almanacs performed at Madison Square Garden on May 21, 1941, for twenty thousand members of the Transport Workers Union who were striking to protect their collective bargaining rights, according to a 2010 online article by Peter Dreier. Their appearance at the labor rally was a prelude to the Almanacs' fabled cross-country, union-hall tour. The tour began in July 1941 at a union hall in Pittsburgh and continued on to California. Seeger told his friend New Jersey banjo player Rik Palieri that Lampell was "the mover" who put together the tour concept and worked out the logistics and performance dates. Lampell even came up with the transportation: a 1932 midnight-blue Buick sedan he obtained from an alleged Paterson gangster. Seeger did most of the driving, and the four Almanacs wrote songs as they traveled between stops, Palieri said, relaying tales of the journey as divulged by Seeger. "These were four guys who were 'On the Road' before Jack Kerouac."

During the hurly burly of American political events in 1941 and the threat of world war on the horizon, the Almanacs received less-than-favorable notoriety for their antiwar album *Songs for John Doe*, released in May 1941. The recording was retracted when, on June 22, 1941, Germany attacked Communist Russia, breaking a nonaggression pact the two nations had formed in August 1939. Prior to December 7, 1941, there were many political factions—staunch isolationists, conservative Republicans and others—opposed to America's involvement in the escalating war in Europe. Cray wrote that the Almanacs, in the first months of 1941, "were avowedly activist, anti-war, pro-union and well left of center in their politics. Even if they were not members of the Communist Party, they took their cues from the *Daily Worker*, Seeger acknowledged. Their songs were topical, polemical and blunt; propaganda set to music."

As the four Almanacs were preparing for their westward tour, the June 1941 edition of the *Atlantic Monthly* published an article titled "The Poison in Our System." It was written by Carl Joachim Friedrich, who was a scholar, lecturer and professor of government at Harvard University. Most of the twelve-page essay dealt with Friedrich's observations on the turmoil in Europe and efforts to undermine American democracy through propaganda. He made mention of the John Doe album just once, midway through the article:

> *An outfit which calls itself the Almanac Music Company has recently brought out a series of phonograph records called "Songs for John Doe." These recordings are distributed under the innocuous appeal: "Sing Out*

for Peace." Yet they are strictly subversive and illegal....They ridicule the American defense effort, democracy and the Army.

Friedrich wrote that "whether Communist or Nazi financed," the general spirit of the album was indicated by the lyrics of antiwar protest songs such as "C for Conscription" and "Plow Under." He warned that "unless civic groups and individuals make a determined effort to counteract such appeals, democratic morale will decline."

Time magazine, in its June 16, 1941 issue, also made a brief mention of the John Doe album in a music review. "Honest U.S. isolationists last week got some help from recorded music that they would rather not have received....Professionally performed with new words to old folk tunes, John Doe's singing scrupulously echoed the mendacious Moscow tune: Franklin Roosevelt is leading an unwilling people into a J.P. Morgan war." The Almanacs returned to the studio and, in February 1942, released the album *Dear Mr. President*, with songs that supported the U.S. war effort.

Today, the John Doe episode still rankles a vocal segment in American politics. The lingering rub is the notion that, at the time, in order to advance their agendas, leaders in the left-wing progressive movement conveniently turned a blind eye to the brutal dictatorship of Joseph Stalin (1879–1953), secretary general of the Communist Party of the Soviet Union. *Star-Ledger* columnist Paul Mulshine expressed his opinion in a January 28, 2014 article:

> *As I've noted, most American conservatives were also anti-interventionist before Pearl Harbor. Like all good lefties, the Almanac Singers were trying to further the interests of Joe Stalin. And Stalin was at that moment in a nonaggression pact with Adolf Hitler. The* [John Doe] *album was full of songs that lampooned Franklin D. Roosevelt as a warmonger for wanting to help England. Oops! A few days after the album came out, Hitler invaded the Soviet Union. The album was quickly recalled and all but a few copies were destroyed.* [The Almanacs] *immediately cut another album, this time calling on the United States to jump into the war alongside Uncle Joe. The switcheroo worked. The incident was largely lost to history and I have seen little note of it anywhere.*

Lampell was drafted in 1943, served in the army air force and eventually dropped out of the music scene. In his profile in the book *Tender Comrades*, Lampell candidly admitted that he briefly was a member of the U.S. Communist Party in the early 1940s, "toward the end of the Almanac days.

Millard Lampell with Eleanor Roosevelt (1884–1962), circa 1960. *Courtesy of the Wisconsin Historical Society, Madison, Wisconsin.*

The functionaries were obviously delighted to have us out there singing peace songs, then anti-Fascist songs. We believed in what the party was for generally, especially on the home front, but when it came to international events, we didn't know much about them. I left the party automatically when I was drafted and I never rejoined."

After being discharged from the army, Lampell remained active in political causes and was drawing attention from right-wing, anti-Communist organizations, such as the Church League of America. These groups monitored his writings and affiliations. Many people in the arts came under similar scrutiny. All of this led to the tribunals in the late 1940s and early 1950s, established by the House Un-American Activities Committee, as well as the McCarthy era of Cold War suspicion and blacklists in the United States.

In the August 21, 1966 op-ed piece for the *Sunday New York Times*, Lampell revealed how, in 1950, he kept a journal, in which he recorded "the ironic, sometimes bizarre, sometimes ludicrous experience of the twilight world of the blacklist."

> *By 1950 I had been a professional writer for eight years, including the time spent as a sergeant in the Air Force that produced my first book,* The Long Way Home. *I had published poems, songs and short stories, written a novel and adapted it as a motion picture, authored a respectable number of films, radio plays and television dramas, collected various awards and seen my Lincoln cantata, "The Lonesome Train," premiere on a major network, issued as a record album and produced in nine foreign countries. Then, quietly, mysteriously and almost overnight, the job offers stopped coming....I began to have increasing difficulty in getting telephone calls through to producers I had known for years. It was about three months before my agent called me in, locked her door and announced in a tragic whisper, "You're on the list." What made it all so cryptic was the lack of accusations or charges. Fearing legal suits, the film companies and networks flatly denied that any blacklist existed. Through the next several years, bit by bit, the shadowy workings of the blacklist came into sharp focus.*

Lampell survived the blacklist era and in the early 1960s resumed his work as a successful writer, penning the scripts for popular TV programs such as *East Side, West Side*; *The Adams Chronicles*; *Rich Man, Poor Man*; and *The Orphan Train*. A highpoint in his career came when his screenplay *Eagle in a Cage*, broadcast on NBC's Hallmark Hall of Fame, won the 1966 Emmy Award for dramatic writing. The *Paterson Evening News*, in its May 23, 1966 edition, paid tribute to this son of Paterson: "Lampell created somewhat of a sensation at the generally placid proceedings of the Emmy presentations...by ending his 'thank you' for the award with a dramatic declaration: I was blacklisted for ten years. As Lampell walked off the stage...he drew the longest ovation of the night." Millard Lampell died on October 3, 1997, in Ashburn, Virginia.

THE SEMI–POPULAR FRONT

The international social/political movement known as the Popular Front was a major factor in the cultural divide in the United States during the

1930s, 1940s and 1950s. Michael Denning, in his book *The Cultural Front: The Laboring of American Culture in the Twentieth Century*, explained that the Popular Front, "born out of the social upheavals [of the mid-1930s] and coinciding with the Communist Party's period of greatest influence in U.S. society, became a radical historical bloc uniting industrial unionists, Communists, independent socialists, community activists, and émigré anti-fascists." In 1935, the seventh congress of the Comintern (Communist International) endorsed a "popular front" against the rising fascist powers in Europe.

Denning pointed out:

> *The latter-day success of the folk music revival—the music of Woody Guthrie, Huddie Ledbetter* [Lead Belly] *and Pete Seeger—has often led historians and cultural critics to assume that folk music was the soundtrack of the Popular Front. This is not true. The music of the young factory and office workers, who made up the social movement, was overwhelmingly jazz. The emergence of jazz as a mass commercial success...not only coincides with the beginning of the Popular Front, but it was in large part a sign of the cultural enfranchisement of the second-generation children of migrants from the Black Belt South and from Jewish, Italian and Slavic Europe.*

Daniel Sidorick, a lecturer in the Labor Studies Department of Rutgers University, said that folk revival music had connections to the labor movement segment of the Popular Front primarily because performers aligned themselves with striking workers on the picket line. Sidorick also stressed that the Popular Front movement in the United States was diverse and not monolithic; its members came from a wide spectrum of political viewpoints. "They worked together, nonetheless, on many political and cultural activities, though occasionally with some friction when particular agendas went in different directions and conflicted," he said. American musicians, actors, artists and writers floated in and out of the political circles associated with the Popular Front.

Sidorick said the Popular Front movement began to unravel during the anti-radical hysteria associated with McCarthyism in the early 1950s, which included the blacklisting of writers and performers, as well as the firing of Rutgers professors "for not adhering to the dominant political orthodoxy of the time." In December 1994, Rutgers compiled an internal report (*Academic Freedom Cases, 1942–1958*) on the dismissal of the professors.

THE VOICE

Paul Robeson, the legendary singer, scholar, actor and international political and social activist and a member of Rutgers' graduating class of 1919, returned to his alma mater for a concert at the Rutgers gymnasium on January 8, 1947. "Paul Robeson Music Warmly Received Here" was the headline on page one of the January 10, 1947 student newspaper, the *Daily Targum*. The newspaper reported that a capacity crowd was mesmerized by his powerful baritone/bass voice during the two-and-a-half-hour performance. This was a world-class artist at the height of his powers, and he generously acknowledged the appreciative audience with fifteen encores, including his signature tunes "Water Boy" and "Ol' Man River." Pianist Lawrence Brown accompanied Robeson and also harmonized with him on several spirituals.

Paul Robeson, a 1919 Rutgers graduate. *Courtesy of Special Collections and University Archives, Rutgers University Libraries, New Brunswick.*

"Mr. Robeson sang a varied program of songs in a half-dozen different languages, each of which received a purity of enunciation," the article stated. "Songs ranging from a seventeenth century English air, through German, Italian, French, Hebrew and Russian selections, were offered with telling effectiveness. The fascinating stage personality of Mr. Robeson was indeed refreshing. The wonderful spontaneity and color of his voice was heard throughout the evening."

In an interview that also ran on the front page of the January 10, 1947 *Targum*, Robeson told reporter Norman Ledgin that Rutgers students "have a lot of hard work ahead of them. When I was in my last year here, [World War I] had just ended and we had many of the same problems that you're faced with today. New developments like atomic energy came out of this war

and it's mainly the engineering and science students who will have to cope with them in the near future. A lot of sound judgment is going to have to enter diplomatic circles, too." Later that same year, on September 18, 1947, Robeson gave a benefit concert at Plainfield High School, as reported by the *Daily Home News*.

The diverse set list for his 1947 Rutgers concert demonstrated Robeson's respect for the value of folk music. Two years after the Rutgers concert, he proclaimed his high regard for ethnic folk music in an interview published by *Sovietskaia Muzyka* (Soviet Music) that was reprinted in the 1978 book *Paul Robeson Speaks; Writings Speeches Interviews 1918–1974*:

> *There is an old Spanish proverb that goes: sing me your folk songs and I'll tell you about the character, customs and history of your people. How true! Folk songs are, in fact, a poetic expression of a people's innermost nature, of the distinctive and multifaceted conditions of its life and culture, of the sublime wisdom that reflects that people's great historical journey and experience.*
>
> *I don't think I have to go into a detailed appraisal here of the great artistic merit of Negro folk music or of its unquestionable significance for all of mankind. This is universally acknowledged. Even in capitalist America, where there exists racial discrimination of revolting proportions, where many "cultured" whites refuse to recognize the Negro as a human being—even there our folk songs constitute, as strange as it may seem, an object of national pride for many Americans. These songs are striking in the noble beauty of their melodies, in the expressiveness and resourcefulness of their intonations, in the startling variety of their rhythms, in the sonority of their harmonies, and in the unusual distinctiveness and poetic nature of their forms.*

Martin Bauml Duberman, in his book *Paul Robeson: A Biography*, wrote that Robeson, born in Princeton on April 9, 1898, began his singing career by utilizing connections with members of the Harlem Renaissance movement. Robeson landed a recital date on April 19, 1925, a program of spirituals, accompanied by Lawrence Brown, at the Provincetown Playhouse in New York's Greenwich Village. "In stressing art as a solvent for racism, Robeson was articulating a characteristic position of the Harlem Renaissance intellectuals: racial advance would come primarily through individual achievement," Duberman wrote. As a result of his performance at the Provincetown Playhouse, Robeson signed a contract to record with

Victor. His Victor sessions in Camden began on July 16, 1925, and continued throughout that month, with additional sessions in January 1926, according to the Discography of American Historical Recordings. At the Victor studios, Robeson and pianist Brown recorded spirituals, such as "Were You There When They Crucified My Lord," "Water Boy," "Steal Away," "Joshua Fit de Battle ob Jerico," "Swing Low, Sweet Chariot" and "Motherless Child." These recordings, in turn, led to concert bookings in Europe and the United States. The duo also recorded music at Victor's New York studios at later dates.

Duberman quoted Robeson, who said that folk songs were "the music of basic realities, the spontaneous expression by the people for the people of elemental emotions." Duberman explained that Robeson felt folk songs of the Russian, Hebrew, Slavonic, Highland and Hebridean people "held the deepest affinity with the underlying spirit of Afro-American songs."

On June 3, 1941, Robeson opened the season for the Essex County Symphony Society as a soloist, performing with conductor Dr. Frank Black and the Eva Jessye Choir. The evening concert, billed as an "All-American program," was held outdoors at City Schools Stadium, located at the intersection of Roseville and Bloomfield Avenues in Newark. The June 4, 1941 edition of the *Newark Evening News* covered the event, reporting that an audience of over twenty thousand people enjoyed the show. "Much of the success of the occasion was due to Paul Robeson, the featured soloist. His deep, rich tones rolled over the field and into the stands with a telling effect rarely achieved by any other stadium soloists" (this was the sixth season of the Essex County Symphony Society's outdoor concert series).

The article said the "high spot" of the evening was "Ballad for Americans," a signature Robeson tune written in 1939 by John La Touche and Earl Robinson. "The expansive scope of the work seemed to fit the outdoor conditions unusually well," the story stated. "Its potent mingling of drama and comedy was voiced by Robeson with a clear diction that made it understandable to all." Though not a folk song, the composition does address grass-roots, "everyman" values of America's cultural diversity. The lyrics are an affirmation that people of all ethnicities, religions and racial backgrounds are members of the American family; that the country's future remains bright, and the nation's best songs have yet to be sung.

Robeson sang folk songs and spirituals during years of international concert tours, and he performed twelve concerts and recitals at Carnegie Hall, New York—the first on November 5, 1929, and the last on May 23, 1958, according to information posted on the Carnegie Hall website. In addition, Carnegie Hall staged a memorial tribute to Robeson on October

18, 1976, which included a performance by Pete Seeger. Outside of Robeson's music career, publications and pundits frequently critiqued him for his fight against racism, his support for world peace and human rights and his alleged membership in the Communist Party. Paul Robeson died in Philadelphia on January 23, 1976. His obituary appeared on page one of the January 24, 1976 edition of the *New York Times*. "One of the most influential performers and political figures to emerge from black America, Mr. Robeson was under a cloud in his native land during the Cold War as a political dissenter and an outspoken admirer of the Soviet Union," the *Times* obituary reported.

Improper Questions for Any American to be Asked

The *New York Times* reported on April 5, 1961, that forty-two-year-old Pete Seeger was sentenced by a New York federal court to one year in prison for refusing to provide information to the House Un-American Activities Committee. The charge, filed in July 1956, was "contempt of Congress." Seeger, accompanied by his counsel Paul L. Ross, had appeared before the committee on August 18, 1955, and declined to answer questions concerning his alleged involvement in the Communist Party. However, Seeger prevailed in the case, with his sentence overturned by the U.S. Court of Appeals on May 18, 1962.

During his 1955 testimony, Seeger sparred with House committee chairman Francis E. Walter and staff member Frank S. Tavenner Jr. (an online version of the testimony transcript is posted by Harvard College Library, "Investigation of Communist Activities, New York Area, Part VII"). The heated exchange focused on an appearance by Seeger during a 1948 May Day rally in Newark. The dialogue between Seeger and Tavenner began with Seeger answering questions about his service in the armed forces during World War II. Seeger was drafted into the army in July 1942 and was discharged in December 1945. Tavenner then introduced "Seeger Exhibit No. 1" to the committee. This exhibit was a photo copy of the April 30, 1948 issue of the *Daily Worker*, which printed an advertisement of a "May Day Rally: For Peace, Security and Democracy. Are you in a fighting mood? Then attend the May Day rally." The advertisement stated that the event, which was held on April 30 at the Graham Auditorium in the Prince Hall Masonic

Temple on Belmont Avenue in Newark, would include "entertainment by Pete Seeger." Tavenner pointed out that the ad said the rally was being held under the auspices of the Essex County Communist Party.

Seeger was asked directly to confirm whether he had lent his talent to "the Essex County Communist Party on the occasion indicated by this article from *The Daily Worker*." Seeger declined to respond. When pressed by Chairman Walter, Seeger again refused to answer the question directly or provide details. Walter again asked him: "What is your answer?" After consulting with Ross, Seeger addressed the House committee members:

> *I feel that in my whole life I have never done anything of any conspiratorial nature and I resent very much and very deeply the implication of being called before this committee that in some way because my opinions may be different from yours…I am any less of an American than anybody else. I love my country very deeply, sir. I have sung for Americans of every political persuasion, and I am proud that I never refuse to sing to an audience, no matter what religion or color of their skin, or situation of life. I am not going to answer any questions as to my associations, my philosophical or religious beliefs or my political beliefs, or how I voted in any election, or any of these private affairs. I think these are very improper questions for any American to be asked, especially under such compulsion as this.*

Many sources indicate that, from 1942 to 1949, Seeger was a member of the Communist Party. In the book *Pete Seeger: In His Own Words*, edited by Rob Rosenthal and Sam Rosenthal, a collection of writings by and about Seeger, he said he dropped out of Harvard University in 1938. "Got too interested in politics. Let my marks slip. Lost my scholarship. In the winter of 1939 I was a member of a young artists group in New York City. It was a branch of the Young Communists League." This also was the period when he worked with Alan Lomax at the Archive of the American Folk Song at the Library of Congress, a connection that led to his meeting Woody Guthrie at the Grapes of Wrath concert.

Amid the blacklisting controversies of the 1950s, Seeger emerged as a champion of folk revival music. He continued to record studio albums and receive concert bookings. On June 16, 1963, he appeared at the Music Circus in Lambertville. Twelve-year-old Peter Stone Brown and his dad, Joe, who was a devoted Seeger fan, were in the audience that day. Brown, in a blog post from April 25, 2012, wrote that this was the third time he had attended a Seeger show. Even at this early age, Brown knew there was "something

different" about the Lambertville concert. "Seeger was singing new material from young musicians like Bob Dylan and Tom Paxton," Brown said during a September 2015 phone interview. "You knew there was something going on in the lyrics of these songs. The words were very political."

Brown recalled that two tunes sung by Seeger at the Lambertville concert—Dylan's "A Hard Rain's A-Gonna Fall" and "Who Killed Davey Moore"—were especially thought provoking. In an April 27, 2012 blog post, Brown wrote that, at the end of Seeger's rendition of "Hard Rain," "my dad turned to me and asked: 'Do you know what that [song] was about?' 'The bomb,' I replied [meaning the atom bomb], but it was a question. I didn't know it at the time, but those two songs were the beginning of something that was going to change my life." Brown, who resided in Millburn during the 1960s and 1970s, went on to become a writer and touring performer of Americana roots music.

Created by actor and impresario St. John Terrell (1917–1998), Lambertville's Music Circus was an outdoor theater-in-the-round under a circus-like tent with over two thousand seats. It was located on old U.S. Route 202 and provided an assortment of entertainment from 1949 to 1970, according to the website "St. John Terrell's Music Circus."

HOOTENANNY

As detected by Brown's perceptive young ears during Seeger's Music Circus performance, a new wave of folk revival music was on the horizon. In the early 1960s, this music demonstrated its commercial viability, especially among college students. The American Broadcasting Company (ABC) picked up on this trend and unveiled an innovative TV program called *Hootenanny*, which presented selections of live music concerts at college campuses from the most popular folk revival bands and performers of this period. The show first aired on April 6, 1963. The *New York Times*, in its April 8, 1963 edition, reviewed *Hootenanny*, praising it as "a thoroughly pleasant and enterprising departure from the staid programming norm. Mark it down as the hit of the spring." The *Times* article also mentioned "one disquieting note": the conspicuous absence of Pete Seeger, who, during his career, had served as an inspiration and role model for many of the artists on the show. "Apparently, Pete Seeger's private political concerns continue to keep him off all network shows of folk singers," the article stated. "Since

he is at complete liberty to appear on stages and can be heard at home on recordings, why should TV prolong its blacklist?" Even though he won his legal battle with the House Un-American Activities Committee, Seeger still was considered a pariah by network television.

This "prolonged blacklisting" drama played out on the campus of Rutgers University, which was selected to be the site for the *Hootenanny* concert taping on Monday, April 15, 1963. The show was staged at the Ledge, the student center on the New Brunswick campus. The program's air date was April 27, 1963—the fourth installment of the first season, which included music by the Chad Mitchell Trio, the Smothers Brothers, Judy Henske and the Simon Sisters (Carly and Lucy), according to archival material posted on the blog for the *Hootenanny* TV show.

The *Daily Targum*, in its April 15, 1963 edition, ran a story at the top of page one: "Picket to Protest Seeger Blacklisting." The article's lead paragraph stated that "an ad hoc committee of students will picket the ABC Hootenanny tonight because Pete Seeger was not invited to participate in the television series." The Associated Press, in an April 15, 1963 wire story report, indicated that four hundred "singing, sign-carrying students" protested the concert outside of the Ledge while inside there was an audience of six hundred students. The lead story on the front page of the April 16, 1963 edition of the *Targum* reported the protest was peaceful as Rutgers students camped outside of the Ledge for nearly two hours.

But that night there was a counter demonstration. Students carried American flags and led a cheer of "G-O-L-D-W-A-T-E-R," a reference to Barry Goldwater, the U.S. senator from Arizona and conservative Republican candidate in the 1964 presidential election. The two demonstrations that night outside the Ledge were an early sign of the polarized, right-wing/left-wing, conservative/liberal ideologies that would take shape in American politics during the 1960s. A member of the student council who led the Goldwater rally submitted a letter to the editor, which the *Targum* ran in its April 18 edition:

> *My leading the Goldwater cheer was in protest against the picket. The purpose of the anti-picket demonstration was to affirm the right of the American Broadcasting Company and* Hootenanny *to exercise their constitutional prerogatives of freedom of choice and freedom of association in their employee policies. Contrary to the anti-ABC pickets, the right of free speech is not abridged when ABC does not hire Pete Seeger....The First Amendment prohibits the Congress from passing a law abridging freedom*

of speech, but it does not prohibit me to refuse to allow Seeger to sing in my home; likewise, [ABC] may decline to employ Seeger.

The jousting continued between Seeger and the TV networks. The *Times*, in a September 9, 1963 story, reported that Seeger had refused to sign a "loyalty oath" in order be considered for an appearance on *Hootenanny*. ABC also required him to furnish "a sworn affidavit as to his past and present affiliations." When Seeger refused, ABC said "the singer would not be considered for an appearance." Some musicians supported Seeger and boycotted the show. ABC canceled *Hootenanny* after two seasons.

ULTRA-HIGH FREQUENCY

Seeger no doubt had an appreciation for television's reach as a powerful medium to connect with an audience. Spurned by the three major TV networks, Seeger opened a new door: ultra-high frequency (UHF). A technology that dates back to the early 1950s, UHF went beyond the regular television dial (two to thirteen) to provide specialty, regional programming. It was a pioneering field of broadcasting that confronted a host of financial and technical difficulties, such as a constant search for adequate private funding and poor broadcast signal quality. Most TV sets needed to be fitted with special equipment, a tuner and an antenna, in order to receive the signal. One UHF venture in the New Jersey/New York TV market was station WNJU. The website www.wnjutv47.com, established for the station's alumni, posted that in April 1964 "the darkened studios of the old Channel 13, located in the upper floors of the Mosque Theater in Newark, New Jersey, came alive as the brand new WNJU-TV." (The theater today is known as Newark's Symphony Hall.)

Joe LoRe, a 1963 graduate of Bayonne High School who maintains the WNJU alumni website and works to preserve the memories of the old UHF station, said that, as a young man, he jumped at the opportunity to become involved in the effort. "It was an innovative atmosphere at the station, to say the least," LoRe said. "It was all new. We had big challenges. It was an uphill battle." He said the station was also known as Telemundo 47, a nod to the region's large Latin American population. Programs included professional wrestling, amateur boxing bouts, bullfights from Mexico, a jazz show with pianist Billy Taylor, Spanish-language movies and a live

WNJU-TV — CHANNEL 47 — PROGRAM SCHEDULE

TIME	SUNDAY	MONDAY	TUESDAY	WEDNESDAY	THURSDAY	FRIDAY	SATURDAY
1:15	SIGN ON						
1:20	COLORFUL WORLD						
1:30	ORAL ROBERTS						
2:00	PRESSURE COOKER Israeli Variety		TEST PATTERN 3:00 — Monday through Saturday / Color Slides until Sign-on				
2:30	JEWISH TV CHRONICLE Editor – Richard Cohen						
3:00	ITALIAN		SIGN ON 4:45 — Monday - Friday				
3:45	FILM						
3:50	GREATS						
	Full Length						SIGN ON 3:55
4:00	Movies		THE COLORFUL WORLD — Color Films — 4:50 Monday-Friday				COLORFUL WORLD Color Films
4:30	(In Italian)						
4:45	ITALY-LAND OF BEAUTY						MUSEUM PIECE Newark Museum
5:00	A TOUCH OF STARDOM Variety Program		HELEN MEYNER PROGRAM — Guests, Features — Monday-Friday				
5:30	(In Italian) ITALIAN						DISC-O-TEEN with Zacherley
5:45	INTERVIEW DRAMA		JUNIOR TOWN with FRED SAYLES — Cartoons, games — Monday-Friday				
6:00	MASTERPIECES FROM RAI-ITALY (In Italian)		DISC-O-TEEN with ZACHERLEY — Music, dancing, contests — Monday-Friday				THELMA OLIVER SHOW Variety
6:30	ITALIAN NEWS Erberto Landi						BILLY TAYLOR SHOW
6:45	ITALIAN SPORTS Filippo Crisafulli		NEW JERSEY TODAY — State-wide coverage — Monday-Friday Fred Sayles - Cal Louderback - Suzanne James				Jazz Groups and Soloists
7:00			CHILDREN'S CAROUSEL — Cartoons, Games, Educational features (In Spanish)				PETE SEEGER SHOW
7:30	FAVORITE NOVELAS		NOVELA — Continuing Dramatic Serial (In Spanish)				International Guest Stars
8:00	5 Episodes — Complete Dramatic Serial (In Spanish)	ACCUSED Dramatized Trials (In Spanish)	WHIPLASH Western (In Spanish)	COUNT OF MONTE CRISTO Action Drama (In Spanish)	HIGH ROAD Travel Adventure (In Spanish)	SPANISH FORUM Discussion Program (In Spanish)	BULLFIGHTS FROM MEXICO World's Greatest Matadors
8:30		THE THREE MUSKETEERS Action Adventure (In Spanish)	BOXING Amateur Bouts (In Spanish and English)	WRESTLING Professional Matches (In Spanish and English)	DISCOTECA 47 Music and Dance Program (In Spanish)	CINEMA HISPANO Full Length Movies (In Spanish)	
9:00		MISS SPANISH TELEVISION Talent & Beauty Contest (In Spanish)					
9:30	SUNDAY MOVIE			SPORTS QUIZ (In Spanish)	COMEDY TIME Variety (In Spanish)		
10:00	Full Length Movies (In Spanish)		NOVELA — Continuing Dramatic Serial (In Spanish)				BOXING
10:30			WORLD NEWS AT 10:30 — (In Spanish) Monday-Friday				AAU
10:40			LOCAL NEWS AT 10:40 — (In Spanish) — Monday - Friday				BOUTS
10:50			SPORTS AT 10:50 — (In Spanish) — Monday-Friday				

An original WNJU-TV Channel 47 program schedule. The *Pete Seeger Show* is listed at the far right, in the Saturday, 7:00 p.m. time slot. *Courtesy of Joe LoRe.*

dance show known as *Disc-O-Teen*, hosted by the inimitable TV and radio personality John Zacherle.

Interviewed on the Public Broadcasting TV series *American Masters*, Seeger confirmed that the inspiration for doing a TV show in Newark came about because he was banned from network television. LoRe said that, most likely, Ed Cooperstein, WNJU's general manager, reached out to Sholom Rubinstein, Seeger's manager, with the idea of doing a show that would feature live folk and folk revival music with special guests. The project moved forward, produced and funded by Seeger, Rubinstein and Seeger's wife,

Toshi Seeger, and on Saturday, November 13, 1965, at 7:00 p.m., *Rainbow Quest*, also known as the *Pete Seeger Show*, made its broadcast debut. An article in the November 15, 1965 edition of the *New York Times*, "TV: Pete Seeger Makes Belated Debut," took note of the event:

> *A night of television extremes took place Saturday evening over television station WNJU-TV in Newark. There was taped bullfighting from Mexico as the newest attraction for the family viewing group. More importantly, there was the long overdue TV debut of Pete Seeger, the folk singer, in a program that should stand as one of the gems of the local video scene. Channel 47's coup in obtaining the services of Mr. Seeger is reason enough to make sure that one's set can pick up UHF. The man who has played such a vital role in stimulating appreciation of folk music has a full 60 minutes to call his own. Characteristically, his premiere was blissfully free of the slightest trace of show business orientation. The hour with Mr. Seeger and his friends—the Clancy Brothers and Tommy Makem and Tom Paxton—was spent singing and playing around a plain wooden table. Theirs was the art of folk music as it has never really been seen on the big, rich television channels—performed for the sheer joy of doing it and rich in warm genuineness and sincerity. After all the aberrations of folk music on the networks, Channel 47 alone has the honest article.*

Taped in black and white, the first program began with Seeger standing, playing solo banjo and singing the song "Oh, Had I a Golden Thread." He then addressed the viewers directly. "You know, I'm like a blind man, looking out through this little magic screen, and I don't know if you can see me. I know I can't see you. But all the same, tonight and in weeks to come I'd like to invite you to come with me on a Rainbow Quest, to try and seek out all the different colors and kinds of human beings we have in our land."

The Clancy Brothers and Tommy Makem were Seeger's first guests, and they sang "The Little Beggar Man." They performed other tunes and enjoyed an engaging, informal banter with Seeger. Next, Seeger introduced "this young fellow over here," Greenwich Village bard Tom Paxton. Paxton told Seeger he had just written a brand-new song, "about an event that happened just the other night." Paxton was referring to the great metropolitan area blackout that occurred on Tuesday, November 9, 1965. A smiling Paxton, playing his guitar, began singing his topical, humorous composition, imagining what sort of mischief people were doing to entertain themselves during the infamous power outage.

Working as a camera man, LoRe had a front-row seat for the Seeger show and took part in the production work. "Pete Seeger was a sweetheart," LoRe recalled. "He was laid back, polite and very easy to work with. He didn't have a big ego like lots of other TV stars." LoRe said he worked on five or six of the *Rainbow Quest* programs, saying the show had no rehearsals and was "taped live." The show was shot with three RCA black-and-white TK-60 cameras and recorded on Quadra-Flex, two-inch video tape. He noted that, because the producers funded the production work and owned the tapes, many of the *Rainbow Quest* episodes survive and can be seen online or purchased as CDs from retail outlets. Looking back, LoRe marveled at the guests Seeger was able to attract to the program—obscure and well-established artists—people like Judy Collins, Johnny Cash, Reverend Gary Davis, Doc Watson, Donovan, Mississippi John Hurt and Roscoe Holcomb. They all performed with Seeger in the Newark studio, and their music reached New Jersey viewers. Thirty-nine shows were recorded and broadcast between 1965 and 1966. In subsequent years, the shows were repeated on Public Television stations.

Seeger offered his own critique of the *Rainbow Quest* show in an April 1968 letter to Bert Snow, the director of public relations at the public television station KCET in Los Angeles. The letter, marked "found in Seeger files," is part of the collection of material in the book *Pete Seeger: In His Own Words*. Written in a question-and-answer format, the letter was Seeger's brief feedback to specific inquiries posed by Snow. Seeger wrote that the *Rainbow Quest* series "reflects one man's curiosity about different kinds of people and their music, either old or new. That's why only a few of the performers are well known. The Rainbow Quest gives me a chance to swap songs with many different kinds of performers. And remember, the same songs can mean different things to different people. This is fun to explore."

Just one month after the debut of his show, Seeger performed a concert at Symphony Hall in Newark on Saturday, December 18, 1965. Seeger garnered a warm-hearted review in the *Star-Ledger* for his efforts on stage. The review made no mention of his songs but rather focused on Seeger—the man and his artistic sensibilities.

> He [Seeger] *is that rare and fortunate artist who has found in his art a medium for full expression. Pete is simple and unpretentious in his ways, and his views on music are presented in the same, straight-forward manner. The real folk singers, he believes, are to be found "around the fireplace and in the hills." These are people who retain their conservatism and limit their*

Pete Seeger made three appearances at Drew University in 1970. *Courtesy of Drew University Library Archives.*

songs to an expression of their personal views and way of life. "I am a professional on stage and a folk singer when around the fireplace," he says. But even when appearing in the "market place," Seeger retains his integrity as a folk singer. His art reflects his views and the demands of the market are always pressed into the background.

Pete Seeger (*left*) is pictured with California congressman Paul N. ("Pete") McCloskey Jr. (*center*) and Dr. Robert F. Oxnam (1915–1974), the eighth president of Drew University. Seeger and McCloskey were featured speakers at an environmental conference, "Action for the Environment," held at Drew in September 1970. *Courtesy of Drew University Library Archives.*

Seeger performed at Drew University–Madison and Seton Hall University–South Orange in the early 1970s. As reported by the *Drew Acorn* student newspaper, Seeger made three appearances at Drew. The first, at Baldwin Auditorium on April 14, 1970, was a benefit concert for the Hudson River Sloop Restoration Inc., Seeger's signature environmental project; for the second, on April 22, 1970, Seeger filled in as a speaker for Wisconsin senator Gaylord A. Nelson during the university's "Charter Day Conference on the Environment," which was part of a nationwide environmental "teach-in" campaign; and in the third, Seeger took part in another environmental gathering at Drew on September 26, 1970. That event included a keynote address by U.S. representative Paul McCloskey of California. On April 28, 1971, Seeger performed at Seton Hall's Theatre in the Round, according to the April 30, 1971 edition of the *Setonian* student newspaper. Pete Seeger died in Manhattan on January 27, 2014, at the age of ninety-four.

SHE DEMANDED A LOT FROM HER AUDIENCE

During the late 1950s and into the early 1960s, a new generation of folk revival music was in full swing. In 1958, the Kingston Trio's hit single "Tom Dooley" sold three million records. The Brothers Four's "Greenfields" reached number two on the pop charts in January 1960. The Highwaymen, in 1961, had a number-one hit with the haunting single "Michael" ("Michael, Row the Boat Ashore"). *Tonight in Person*, the debut album of the Limelighters, rose to number five on the *Billboard* chart. The self-titled first album by Peter, Paul and Mary, released in early 1962, was a number-one album on *Billboard*. The trio's single "Blowin' in the Wind," the signature cover of the Bob Dylan classic, climbed to the number-two slot on the *Billboard* pop chart during the summer of 1963.

These recordings and others carved out a commercial niche for folk revival music, and its appeal among millions of fans was demonstrated on the radio, in concert halls and at record stores. The tunes were well-produced, enjoyable entertainment that generated thoughtful conversations. Song lyrics were poetry that, sometimes directly and sometimes obliquely, framed political and social issues. It was against this backdrop that Joan Baez and Bob Dylan, in the respective early stages of their careers, performed together and separately at venues in New Jersey.

The *Newark Evening News*, in its Saturday, November 24, 1962 edition, printed a review of Baez's performance at Newark's Mosque Theater. "Joan Baez, the saddest and maybe the richest of the folk-singing set, chanted her melodious woes to an immense and affectionate audience last night at the Mosque Theater. The house was crowded to the legal limits…and it was obvious that the Baez cultists were having a grand old time." The review described Baez as a

> thin, frail slip of a thing who has made folk singing a national rage. Her hair, black as a villain's heart, falls down on each side. She has a guitar, which she spends a lot of time tuning. And she has a voice…it has a vibrato that sends the shiver coursing. Sometimes it is a rich mezzo, full of color. Again, it is a thin, sweet soprano, like a bird. And it is expressive and evocative, true to pitch, always in key, with an ear that would put some opera singers to shame.

As for the material she performed on stage, the reviewer lauded her singing of ballads such as "Portland Town" and "Silver Dagger." Her set

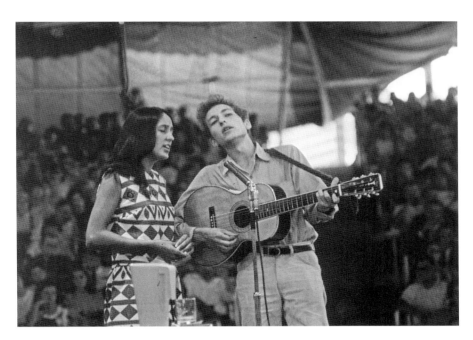

This page: Joan Baez and Bob Dylan, performing at the 1963 Camden Music Fair. *Photos by John Rudoff.*

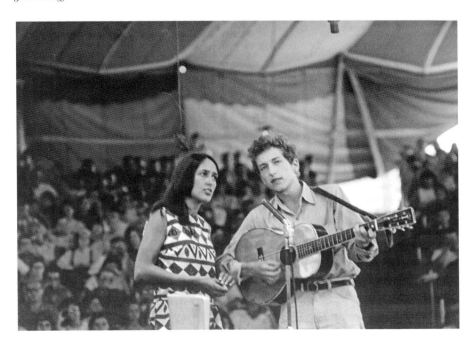

list also included songs of the sea, spirituals and a Calypso version of "The Lord's Prayer." Near the end of the night, Baez encouraged the audience to take part in a singalong of "Battle Hymn of the Republic." "Everything Miss Baez did at last night's hootenanny seemed to please her public. Miss Baez scored a personal triumph with her sweetness and purity," the *Evening News* review reported.

Coinciding with Baez's Newark concert, *Time* magazine, on the cover of its November 23, 1962 edition, had an illustration of Baez, depicted as a soulful, barefoot singer, embracing her guitar while sitting on a wicker chair. The magazine article referenced her all-business, no-frills approach as a singer. "In performance she comes on, walks straight to the microphone, and begins to sing. No patter. No show business. The purity of her voice suggests a purity of approach." The magazine story also revealed a significant New Jersey connection for Baez. Her mom, Joan Bridge, was from Scotland, the daughter of an Episcopal minister. Her dad, Alberto, born in Mexico, was a minister's son. "The two met at Drew University in Madison, New Jersey," the article stated. Joan Baez was born on Staten Island on January 9, 1941.

Baez returned to the Garden State in August 1963 for two concerts, but this time, she had a musical partner: Bob Dylan. The duo performed under a tent at the Camden Music Fair on August 3 and then sang at Asbury Park's Convention Hall on August 10. The *Asbury Park Press*, in its August 12, 1963 edition, covered the Convention Hall program. "Joan Baez demanded a lot from her audience Saturday night. She demanded respectful silence, understanding, and enthusiastic participation when requested. She got all three and, in return, captivated the capacity audience with a dynamic performance." The review characterized Baez as an "intense singer whose voice is a sweet, clear bell in a sea of commercialized confusion. Joan Baez stood Saturday night on an empty stage, a slight girl in a simple print dress, playing a guitar almost as big as she, and singing songs of love, fear and, above all, peace. When she left the stage after nearly two hours, the summer concert series had reached a high point, which will be hard to top."

The review stated that, during the show, Baez put down her guitar and "danced a little" during the performance by Dylan, "one of the country's rising young folk singers. He wrote 'Blowin' in the Wind,' Peter Paul and Mary's current hit. He and Miss Baez sang the song in its original form."

Shortly after these two New Jersey appearances, Baez and Dylan traveled to Washington, D.C., and performed on the steps of the Lincoln Memorial at the August 28, 1963 "March on Washington for Jobs and Freedom."

He Heard Honesty

John Rudoff was fifteen years old, living in the suburbs of Philadelphia, when he saw a newspaper article that said Joan Baez would appear at the 1963 Camden Music Fair. He knew this was a show he had to attend. "Joan Baez was the real deal," Rudoff said during a 2014 telephone interview. His father, Hyman Rudoff, whom John described as "an accommodating, supportive dad," offered to provide the transportation, so father and son bought tickets and went to the show. Just before they hit the road, the young John Rudoff, an aspiring photographer, remembered to bring his camera: a 35-millimeter Contax.

Rudoff said Baez was the headliner that day. She performed a set of songs, took a short break and then came back with Dylan at her side. Rudoff recalled that they performed "The Times They Are A-Changing," "A Hard Rain Is A-Gonna Fall" (two Dylan compositions) and other tunes. As they were singing, Rudoff, like any stealthy photographer on assignment, made himself invisible, crept down the aisle and shot fifteen frames of Kodak Ektachrome film.

While he trained his eye to capture detail and composition in his photos, Rudoff's ears were attuned to the sound of folk revival music. What was the magic that he heard that day in Camden? "Honesty," he answered. "This was thoughtful, sincere music. This was music that wasn't packaged." He said performances by Joan Baez and Bob Dylan "came out of a deeper connection with the real world. It wasn't 'commercial' and you could hear that in the songs. If you're a real artist, technique is just a means to an end. The music [played by Baez and Dylan] was something more than just a tune. Somehow this music connected with me fifty years ago, and today I still feel connected to the music." Rudoff said his dad was captivated by Joan but not impressed with Dylan. "He was put off by his voice and the lyrics to his songs." Rudoff went on to become a successful photographer, as well as a respected cardiologist in Oregon.

On July 29, 1964, Joan Baez performed at the Rutgers University gymnasium. The hot, humid Wednesday night didn't dampen the enthusiasm of the 3,500 "folk-singing" fans who turned out to see her, according to an article in the July 30, 1964 edition of the *Daily Home News*. She was greeted by "thunderous applause and cheers from the audience," which she gratefully acknowledged. The article made reference to another source of thunder—booming storms passing through central New Jersey that night, which provided Baez a cue to perform a

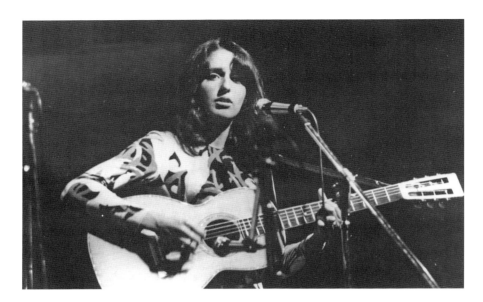

Joan Baez is pictured performing at the 1967 Newport Folk Festival. She gave a solo concert at Rutgers in July 1964 and sixteen years later received a doctor of humane letters degree from the university. *Photo by Dick Levine.*

traditional, singalong ballad "Somebody Got Lost in a Storm." Rutgers awarded Baez a doctor of humane letters degree on May 23, 1980, at the university's 214th commencement ceremonies.

TALKIN' NEW JERSEY

It's been widely documented that Bob Dylan arrived in New York City in late January 1961, looking to connect with the Greenwich Village folk revival scene. Numerous sources also have referenced the bus rides he made to East Orange during this period to visit Woody Guthrie. As mentioned earlier in this chapter, Bob and Sidsel Gleason, a couple living at 182 North Arlington Avenue, Apartment Number 32, in East Orange, had made arrangements to bring Guthrie to their home on weekends. Guthrie, at the time, was a patient at Greystone Park sanatorium in Morris Plains. (The East Orange Public Library provided the Gleason's address, listed in the 1959, 1961, 1963 and 1965 editions of the *New Jersey Directory of the Oranges, Including Orange, East Orange, South Orange, and Maplewood.*)

Main entrance, 182 North Arlington Avenue, East Orange. *Photo by M. Gabriele.*

Nora Guthrie, Woody's daughter, during a 2015 phone interview, said that before Dylan ventured out to East Orange, the first stop he made was to the Guthrie home in Queens to visit her mom, Marjorie Guthrie. Nora said Dylan found the family home in a New York City phone book and persistently came calling before he finally was invited in. Nora said it wasn't unusual for Greenwich Village musicians to occasionally visit the Guthrie home in Queens in search of Woody. "Woody's music was part of the Greenwich Village folk music repertoire. Bob just stood out from the rest of the guys that came to see us. He was very funny and very sweet. He played guitar for us and had dinner with us. My mom told him that he would be able to find Woody on weekends at the Gleasons' apartment. It had become a gathering place for musicians who wanted to see Woody." Marjorie also drove out to New Jersey to visit Woody.

Dylan, in "Talkin' New York," a street-poet rap on his 1962 self-titled first album, made a reference to his pilgrimages to see Guthrie, stating that he was leaving the Big Apple and heading west to East Orange. Sean Wilentz, in his book *Bob Dylan in America*, wrote about Dylan's mission to find Woody Guthrie:

> *Dylan got his wish at the end of January 1961, about five days after he arrived in Manhattan, at a Sunday gathering at the home of Guthrie's friends Bob and Sidsel Gleason in East Orange, New Jersey. Guthrie, ravaged by Huntington's chorea, was under permanent care at Greystone Park Hospital, but the hospital released him to the Gleasons' care on weekends, when old friends and young admirers from New York would hop on a bus to East Orange. In his successful search for Guthrie, Dylan had stumbled upon the surviving remnants of the original folk revival that [emerged out of] the left-wing music world in New York City at the depths of the Great Depression.*

Quoted in the book *Wardy Forty*, Sidsel recalled how she first met Woody in Arizona in the 1930s during the construction of the Hoover Dam. "I was baking bread and biscuits. I heard this guitar playing...and there was Woody. Woody traveled all over the country. I went over and started talking to him and he said, 'Well, right now I don't know which way I'm gonna go, but one of these days I'll probably end up at your front door'—and that is exactly was happened a number of years afterwards." The Gleasons got permission to take Woody off the Greystone grounds, "and we went up to get him every Sunday, just like clockwork...[Bob Dylan would] come out quite often. And sometimes he'd spend a week with us."

Greystone Park Psychiatric Hospital in Morris Plains. The building was demolished in October 2015. *Photo by M. Gabriele.*

Bob Gleason passed away in 1993, but Sidsel Gleason lived until 2006, according to a March 30, 2006 obituary in the *Star-Ledger*. The article reported that, in late 1959, the Gleasons learned that Guthrie was a patient at Greystone. During his visits to East Orange, Guthrie enjoyed Sidsel's cowboy stew, took long baths, got his clothes cleaned and enjoyed seeing his folk revival chums and young musicians.

I WAS YOUNG, BUT NOT NAÏVE

Dylan gave a solo performance at Princeton University's McCarter Theatre on November 16, 1963, and another at Newark's Mosque Theater on November 30, 1963, in the wake of the assassination of President John F. Kennedy. A display ad in the November 27, 1963 edition of the *Newark Evening News* labeled Dylan as "America's most compelling folk singer."

A front-page story in the February 8, 1965 edition of the *Daily Targum* reported that Dylan was giving a concert at the Rutgers University gym on February 10, 1965. The show took place five months before Dylan "went electric" at the 1965 Newport Folk Festival. Michael Perlin, at the time a junior at Rutgers, attended the performance. Perlin had seen Dylan at clubs in Greenwich Village and at the legendary Halloween Concert at Philharmonic Hall on October 31, 1964. Growing up in Perth Amboy in the early 1960s, Perlin was a big fan of jazz and rock-and-roll and enjoyed folk revival music. His connection with Bob Dylan came when Perlin attended the 1963 March on Washington, obtaining a ticket to the event through the office of New Jersey congressman Edward J. Patten, for whom he was interning. Watching Dylan perform that day in Washington was, Perlin recalled, a life-altering experience.

"Dylan's music and lyrics were like nothing I had ever heard," Perlin said during a 2014 interview at his office in New York. When asked to describe precisely what it was that struck him, Perlin said that "it was Dylan's power as a poet; his anger and depth. That was it. It was more than just music; it was magic. I know it sounds like a cliché, but ever since that day in Washington, Bob Dylan's music has been the soundtrack of my life." Perlin added that, along with the rough-hewn vocals and striking stage presence, he also was fascinated with the social and political commentary in Dylan's early compositions. "I was young, but I was not naïve," he declared. "I knew what he was trying to say in his songs. Politics and topical issues were discussed

Right: Michael Perlin at his office in New York, August 2014. *Photo by M. Gabriele.*

Below: Original button from the August 28, 1963 "March on Washington for Jobs and Freedom." *From the collection of M. Gabriele.*

Peter Stone Brown. *Photo by Jon Perlmutter; courtesy of Peter Stone Brown.*

at home. My dad [Jacob W. Perlin] was a journalist" (a managing editor of the *Perth Amboy Evening News*). Perlin graduated magna cum laude from Rutgers in 1966, graduated from Columbia University Law School in 1969 and went on to have a distinguished career in the field of law as an author and a professor at New York Law School.

After going electric at the Newport Folk Festival (on July 25, 1965), Dylan returned to Newark on October 2, 1965, for a concert at Symphony Hall, backed by members of a Canadian rockabilly band. Peter Stone Brown (at the time a self-described "long-haired, poetry reading and writing, anti-Vietnam war button wearing, folk-singing freak") had a front-row seat for the show, which began with an acoustic set by Dylan. Brown recorded his memories in a February 24, 2014 blog post:

> *When the band took the stage after intermission, the contrast between how they looked and how Dylan looked was somewhat astonishing. They were in suits and ties and had really short hair. I had no idea who they were and Dylan didn't introduce them. There was a line of huge Fender amps that ran across the stage. They started with "Tombstone Blues," and it was probably the loudest thing I ever heard in my life. Since Dylan was holding down the rhythm, along with Levon Helm on drums and Rich Danko on bass, it allowed remaining musicians, Richard Manuel on piano, Garth Hudson on organ and Robbie Robertson [on guitar] to kind of have a free for all throughout the show. The song that blew me away came early in the show when Dylan pulled out "Baby Let Me Follow You Down" from his first album. And though I've seen Dylan more than 100 times since, that night, that show in Newark remains kind of hard to beat.*

During the summer of 1965, Levon (Helm) and the Hawks were headliners "Down the Shore" at Tony Mart's club in Somers Point. In his book, *This Wheel's on Fire, Levon Helm and the Story of The Band*, Helm wrote that, in 1965, he and his mates headed for the Wildwood/Atlantic City summer circuit. "Tony's place was said to be the biggest teenage nightclub in the East: three stages, seven bars and fifteen cash registers. The capacity was supposedly three hundred, but twice as many college kids crammed into the place on weekends."

Dylan "had sent some of his people down to see us at Tony Mart's," Helm wrote. A mutual friend in the music business had recommended the Hawks to Dylan. A feature in the August 24, 1968 edition of *Rolling Stone* magazine recounted the New Jersey connection:

> *They* [the Hawks] *were playing at a night club in the seashore resort of Somers Point, New Jersey, when, in the summer of 1965, Dylan telephoned them. "We had never heard of Bob Dylan," says drummer Levon Helm, who, as a sharecropper's son from the South Arkansas Delta country, is the only American in the band. "But he had heard of us. He said, 'You wanna*

play the Hollywood Bowl [in Los Angeles]*?' So we asked him: Who else was gonna be on the show? 'Just us,' he said."*

Helm wrote that he and the other Hawks said goodbye and thank you to Tony Mart just before Labor Day 1965. "We'd been there since the Fourth of July and they were sad to see us go, but we headed back to Toronto. Bob Dylan showed up a few days later to hear the band for the first time." The Hawks toured with Dylan, and then, at the end of 1967, Helm and his partners decided to move off on their own. Renamed the Band, they scored a hit with their 1968 folk/rock album, *Music from Big Pink*. Among his various stops along the byways of New Jersey, Bob Dylan received an honorary doctorate of music degree from Princeton University on June 9, 1970.

CONFESSIONS OF A REHEARSAL HOUND

"I don't have a 'favorite' instrument. My favorite instrument is the one I'm playing right now; the one that fits the song. That's my job. I try to play what fits the song and play with taste." Paul Prestopino offered this modest assessment of his career as a professional musician that spans more than five decades—an in-demand banjo, guitar, harmonica and mandolin player who, indeed, "has fit the songs" of folk revival pioneers such as the Chad Mitchell Trio and Peter, Paul and Mary.

Born in Brooklyn, New York (September 20, 1938), Prestopino moved to the Monmouth County town of Roosevelt in 1949 and has resided there ever since. In the early 1960s, he did briefly relocate to Madison, Wisconsin, where he worked as a machinist for the High Energy Physics Department of the University of Wisconsin. While in Madison, Prestopino, in the winter of 1962, received a call from Frank Fried, the manager of the Chad Mitchell Trio. The Mitchell group was looking for a banjo player to complement the ensemble. A band known as the Tarriers, at the time performing in Chicago (where Fried was located), had recommended Prestopino. Members of the Tarriers had known Prestopino in the late 1950s during their carefree days of playing music at Washington Square Park in Greenwich Village. Prestopino, during that time, was a member of the bluegrass band known as the Greenbriar Boys.

Fried invited Prestopino to come to his Chicago office and chat with Milt Okun, the music director for the Chad Mitchell Trio. The meeting went

Paul Prestopino. *Courtesy of Paul Prestopino.*

well, and Prestopino was hired to play with the trio at a state fair in Jackson, Michigan. He went on to perform with the group for nearly six years. After returning to New Jersey, Prestopino became involved with recording production work at A&R Studios in New York. After working for a year at A&R, he spent twenty years at Record Plant Studios in New York and then became associated with Record Plant Remote, a mobile audio recording truck.

In 1969, Okun introduced Prestopino to Peter, Paul and Mary, and that association lasted for many years through recording sessions, TV shows and

concert tours. He has performed regularly with Peter Yarrow and Noel Paul Stookey since the death of Mary Travers in September 2009. Prestopino said he also has enjoyed his collaborations with singer/songwriter Tom Paxton.

As a professional musician, Prestopino has been an eyewitness to the flowering of folk revival music. Today, he is active in Princeton circles, focusing his efforts on the genre of English country dance. Since 1982, he has been a member of a quartet, Hold the Mustard, which includes Daniel Beerbohm (clarinet, flute and penny whistle), Barbara Greenberg (violin) and Kathy Talvitie (piano). He also performs at regional folk revival music festivals with the Jug Town Mountain String Band and the Magnolia Street String Band. "I'm a rehearsal hound," he confessed, regarding his love for and dedication to the process of music. "That's the creative time. That's when you interact with musicians and work up material and arrangements. The performance before a live audience happens 'in the moment.' But there's something about woodshedding—that's the creative process."

THE ROAD IS HIS MISTRESS

During his years growing up in East Brunswick in the late 1960s, Rik Palieri's favorite show was Pete Seeger's *Rainbow Quest* program. Seeger's banjo playing, singing and storytelling was the spark that kindled Palieri's lifelong love affair with folk revival music. "I enjoyed the feeling that Pete put into his songs," Palieri said. "There was a social commitment to his music. A lot of the songs had a sense of wanderlust, which appealed to me. These were things that you didn't hear in commercial music."

Palieri attended a Pete Seeger concert at Voorhees Chapel, Douglass College, on March 12, 1971. "When I saw Pete singing, I said to myself, 'This is what I want to do with my life.'" Palieri became a banjo player, doubling on twelve-string guitar, and began appearing at New Jersey coffeehouses, like Mine Street in New Brunswick. He also began making musical connections throughout the state, and he performed at the Hoboken River City Fair on July 26 and 27, 1975, which was a port of call for Seeger's Hudson River Clearwater Sloop. Stevens Institute of Technology and the Hoboken Environmental Committee sponsored the festival. Seeger, on July 25, 1975, had been across the Hudson River, performing a concert with Arlo Guthrie at Wollman Rink in Central Park. Following a brief introduction, Seeger asked Palieri to join him on stage at the Hoboken festival, which became the start of their friendship.

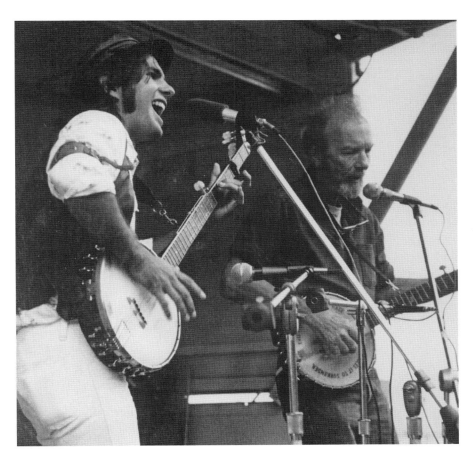

Rik Palieri (*left*) and Pete Seeger performing at the Festival of Blueberries in Perth Amboy, circa 1978. *Courtesy of Rik Palieri.*

In his 2004 book, *The Road Is My Mistress: Tales of a Roustabout Songster*, Palieri wrote that, following the Hoboken event, he and Seeger kept in touch via letters and phone calls, and Palieri was invited to be part of Seeger's Clearwater environmental movement. Palieri also became a regular member of the Hudson River Sloop Singers. It was through Clearwater that Palieri met an activist named Claire Dameo, who ran a coffeehouse in Jersey City called Not for Bread Alone. Palieri performed at this venue during the balance of 1975. One of Dameo's partners at the café was a charismatic guitar player known as Brother Kirk, whom Palieri described as "a giant of a man, with a raspy, strong voice and a heart of gold." Brother Kirk—Reverend Frederick Douglass Kirkpatrick—and Seeger performed on the public TV

program *Sesame Street*. In 1974, the two men recorded a *Sesame Street* folk music album for children.

Palieri said that Seeger, in early 1976, urged him to organize a Clearwater festival in New Jersey. Palieri contacted his high school art teacher and mentor, Bob Husth, to develop graphical concepts for an outdoor event. Palieri then approached Steve Bandola, the recreation director for Perth Amboy, with his idea for a festival. Palieri, through his network of music friends, had learned that Perth Amboy was interested in staging a summertime outdoor event. Palieri knew the Perth Amboy Harbor would be a perfect location to display the Clearwater sloop, and the city's Bayview Park was a natural, riverfront amphitheater. Bandola introduced Palieri to Perth Amboy mayor George John Otlowski, and the two shook hands on the arrangements for the festival. "Mayor Otlowski was a very dignified man and I was a hippie with long hair," Palieri recalled. "Somehow the two of us connected and made it work. I think he understood that we were trying to do something positive for the city."

Construction of the Hudson River Clearwater Sloop, a 106-foot riverboat launched in May 1969, was inspired by Seeger as a symbol for environmental awareness. A post on the Beacon, New York–based Clearwater organization's website states that the sloop was modeled after Dutch vessels that sailed on New York's Hudson River in the eighteenth and nineteenth centuries. It was due to arrive in New Jersey in late August 1976. The August 25, 1976 edition of the *Daily Register* and the September 1, 1976 edition of the *Asbury Park Press* reported that stops for the sloop included Perth Amboy on August 29 and Fort Hancock, Sandy Hook, on August 31 and September 1. Though Seeger didn't take part in the voyage or the events, both locations celebrated the arrival of the sloop with music and folk arts festivals.

Bob Killian, a folk revival musician from Little Silver, organized the Sandy Hook event. The New Jersey Friends of Clearwater, a nonprofit organization founded in 1974 and previously known as the Monmouth County Friends of Clearwater, sponsored the Sandy Hook gathering. In the following years, the group ran Clearwater festivals in Asbury Park. The event in Perth Amboy, led by Palieri and the Central Jersey Friends of Clearwater, turned into an annual music celebration that came to be known as the "Festival of Blueberries."

Killian remained active in music and Clearwater events, worked as an artist in residence at Brookdale Community College–Lincroft and moved to Florida in the late 1990s. The New Jersey Friends of Clearwater group celebrated its fortieth-annual festival on September 12, 2015, at Brookdale Community College. Killian performed at the festival and also organized a

separate concert honoring Seeger ("Pete's Gang"), which was held the next day at the Unitarian Universalist Congregation of Monmouth County in Lincroft. Promoter Bob Kelley said the positive feedback from that event inspired the creation of the bimonthly "Earth Room" acoustic music concert series, which began on April 23, 2016, at the Lincroft Unitarian church.

On the Banks of the Old Raritan

In mid-1979, the New Brunswick Tercentennial Executive Committee, led by Professor MacLean Babcock of Douglass College, reached out to Palieri to help the committee develop an event to celebrate the city's 300th anniversary. After nearly a year of preparation, the first Raritan River Festival in New Brunswick was held in Elmer B. Boyd Park, a greenspace along the Raritan River, on August 16, 1980. The event included performances by Seeger, Palieri, Bob McGrath, the New Jersey Pineconers and Elaine Silver. The *Home News*, in its August 17, 1980 edition, reported that the festival, an eight-hour extravaganza, attracted eight thousand people and "featured continuous folk music, craft exhibitions and a parade of thirty aquatic floats. As musicians strummed out chords on guitars and banjos and the sound of Old Time music filled the air, grandfathers took their grandchildren for a look at the one-hundred-and-forty-eight-year canal that once served as a main shipping route between New York and Philadelphia." A third installment of the festival was held on July 10, 1982, once again at Boyd Park, with music by Palieri, Seeger and the Highland Watch Bagpipe Band of Pennsylvania.

Following the 1982 festival, Palieri decided it was time for him to move on as a musician. He established a residence in Vermont and pursued a career that, quite literally, has taken him around the world. In the early 1990s, he received a fellowship grant to live in Poland and study the Polish bagpipes. In the summer of 2013, lured by his "mistress," Palieri and his guitar-playing buddy George Mann set off on a road trip to re-create the 1941 tour of the Almanac Singers. The cross-country excursion was a marathon effort—twenty-eight shows over a five-week trek—and music from the tour was released as a CD.

Today the mustachioed Palieri continues to travel and perform. Looking back, he was philosophical when assessing the effect of the New Jersey festivals he organized, acknowledging that the events were more than just a day of entertainment. "I think, in a small way, the festivals changed some

Rik Palieri. *Courtesy of Rik Palieri.*

people's lives. They got people thinking in a different way. As a young person, you discover this music, it inspires you, and then you want to share your love of the music with others. I wasn't even thinking about a career in music when I became involved with Clearwater. It became a way of life, almost like a religion. When I was in the middle of it, I thought that scene would go on forever."

Part III
Jersey Boys (and Girls)

LISTENING TO DAD ON THE RADIO

Throughout the twentieth century, while influential folk revival artists were performing in the Garden State, there was a parallel track of regional New Jersey musicians creating dulcet sounds in urban, suburban and rural settings. These homegrown artists were pioneers in their own right, establishing community organizations, concerts and festivals; regional jamband scenes; radio station programs; and coffeehouse venues.

Acoustic music could be heard in every corner of New Jersey, especially the bucolic Pine Barrens. In 1940, Plainfield folklorist and author Dorothea Dix Lawrence (1899–1979) was meandering through the Pine Barrens, in search of indigenous musicians. She was on a quest to find authentic talent to represent the Garden State at the 1941 National Folk Festival in Washington, D.C. As the story goes, she stopped in at the local post office near Forked River, seeking a friendly tip, and the postmaster told her to "find the Bamber boys." Bamber, a hamlet west of Forked River, was home to a popular trio who performed on local radio broadcasts and at dances, taverns and community events. Dorothea connected with guitarist, vocalist and singer/songwriter Merce Ridgway Sr. and two cousins, banjo player Walt Britton and fiddler Bill Britton. These Bamber boys would come to be known as the Pinehawkers.

Dorothea made the arrangements, and the Pinehawkers appeared at the National Folk Festival, held on May 1–3, 1941. The *Asbury Park Evening*

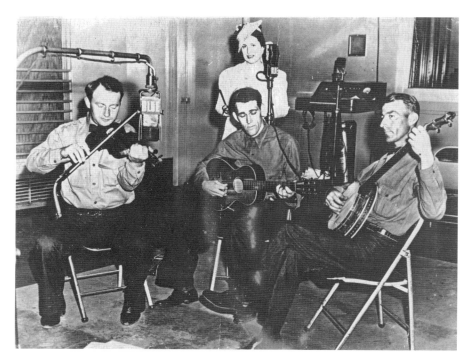

The original Pinehawkers—*(left to right)* Bill Britton on the fiddle, Merce Ridgway Sr. on guitar and Walt Britton on the banjo—perform during a *Blue Network* radio broadcast in New York City, circa 1941. Folklorist Dorothea Dix Lawrence is standing in the background. *Courtesy of Merce Ridgway Jr.*

Press, in its May 3, 1941 edition, reported that the "three clam diggers" from the Pine Barrens went to the National "and won rounds of applause for their quaint music. The trio presented two unfaltering, professional-like entertainments before thousands packed into Constitution Hall." They performed a tune that they described as handed down from Pine Barrens pirates during pre–Revolutionary War days and "Mount Holly Jail," said to be New Jersey's oldest traditional folk song.

According to an article by Angus Kress Gillespie and Tom Ayres in the 1979 winter edition of *New Jersey History*, the trio performed at spots on the New Jersey shore during the summer of 1941, with appearances at places like the Island Heights Yacht Club in Toms River and the Berkeley/Carteret Hotel in Asbury Park. The Pinehawkers also took part in live performances on radio stations in New Jersey and New York such as WJZ, WOR, WNYC and the Blue Network. "Virtually all of these radio appearances were emceed by Dorothea Dix Lawrence, who seemed to have taken the three musicians

The Ridgway and Britton families are pictured in the village of Bamber, located in the Pine Barrens, circa 1940. *Courtesy of Merce Ridgway Jr.*

under her wing," the Gillespie/Ayres article stated. The trio reunited briefly following World War II but then discontinued its musical association.

Merce Ridgway Jr. said his dad and the two Brittons, in addition to their music, worked as baymen, boat builders, carpenters and machinists and supplied regional merchants with Pine Barrens charcoal and moss. In his autobiographical book, *The Bayman: A Life on Barnegat Bay*, Merce Jr. wrote that his father's musical talents were an inspiration and a nostalgic part of his life growing up in the Pine Barrens.

> *My father played guitar and sang, and I knew that he went away to play on the radio station. In the late afternoon there was a train that passed through a field across from Taylor Lane, the road in Forked River that we lived on. When that train came by, I knew it marked the time for me to go in the house and listen to my father. We had a radio that operated off a car battery. I remember peering through the holes in the radio at the glowing tubes inside. It seemed to me that, if I looked hard enough, I certainly ought*

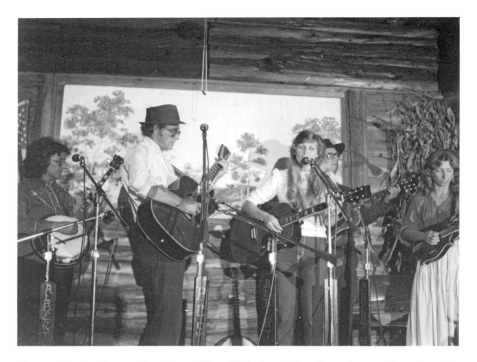

The new Pinehawkers performing at Albert Hall, circa 1995; pictured second from the right is Merce Ridgway Jr. (with hat, glasses and guitar). *Courtesy of Merce Ridgway Jr.*

to be able to see him. I was always sad when the program ended. I loved the music and felt strongly that I wanted to play.

Emulating his dad, Merce Jr. learned to play guitar and banjo and was taught how to clam, crab and fish in Barnegat Bay while absorbing the traditions and culture of the Pine Barrens. On December 29, 1959, his eighteenth birthday, he drove to Atlantic City and enlisted in the marines.

Born in Barnegat in 1915, Merce Sr. died in July 1980 of a heart attack while driving along a Pines Barren road. One year before Merce Sr. passed away, Merce Jr. received his dad's blessings to resurrect the name of the old trio and form a new generation of Pinehawkers, and he did so, creating an ensemble that had a revolving assortment of musicians during the 1980s and 1990s. The new Pinehawkers performed at the 1995 New Jersey Folk Festival, and Merce Jr. received a special achievement award, Distinguished Contribution to the Folk Music of New Jersey.

WHAT HAVE THEY DONE TO THE OLD HOMEPLACE?

In the mid-1920s, two brothers from Sayreville, George and Joe Albert, were frequent visitors to the Waretown area in the Pine Barrens, making the trek in their Model T Ford. According to story panels on the wall of Albert Hall, they were avid hunters and quickly became enamored of the region. They met a teenager named Sammy Hunt who served as a faithful hunting guide. By 1933, the Albert brothers had decided to purchase fifty-six acres of land in the Waretown Pine Barrens, with plans to build a rustic hunting lodge in the woods. Joe Albert worked at the old Sayre-Fisher Brick Company and was a mason and carpenter. Together with friends, the brothers transported brick, wood and other building materials from Sayreville and cleared a site in the Pine Barrens, just off Route 532.

George Albert, the Homeplace, circa 1965. *Courtesy of Phil Grant.*

The Albert brothers, through their hospitality and George's apple pies, quickly became popular with the Waretown locals. The cabin had no electricity, so during the evening hours, after a long day of hunting, the brothers entertained themselves by inviting friends to play music. George was a fiddler, and Joe played the gut-bucket bass. Their young guide, Sammy, was a banjo player. Other amateur musicians from the Waretown area became frequent guests for Saturday night jam sessions, with music that included original compositions, popular songs from the Great Depression era, old time folk tunes and traditional Irish and Scottish melodies.

Through these musical get-togethers, the cabin affectionately became known as "the Homeplace." The Pineconers emerged from these informal

Sammy Hunt, the Homeplace, circa 1965. *Courtesy of Phil Grant.*

sessions, a band led by the Albert brothers, along with Bill Vath, Bill Britton of Pinehawker fame and Sammy Hunt. Other participants included Gladys Eayre, Janice Sherwood, Kurt Kievel, Jim "Tinker" Stackhouse, John Peich, Dave Renier, Pete Curry, Russell Horner, Jim Camburn and Joe King. In addition to music at the Homeplace, the Pineconers performed at Waretown-area events and dances, the folk festival at Whitesbog in Lebanon State Forest and the first New Jersey Folk Festival. Janice and Gladys received

Right: Merce Ridgway Jr., the Homeplace, circa 1965. *Courtesy of Phil Grant.*

Below: Saturday night jam session at the Homeplace, circa 1965. *Courtesy of Phil Grant.*

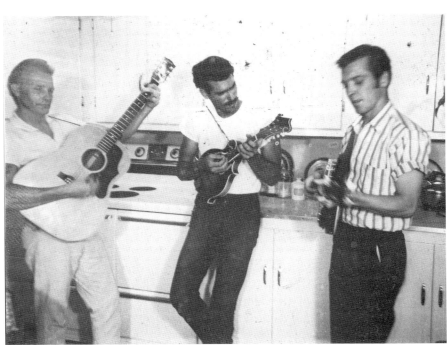

the New Jersey Folk Festival 1994 Distinguished Contribution to the Folk Music of New Jersey Award.

Merce Jr. was discharged from the marines in 1963 and returned to the Pine Barrens. Eager to bond with local musicians, he and his cousin Phil Grant were invited to join the Saturday night jamborees at the Homeplace. It was the spring of 1964, the year Merce Jr. married his wife, Arlene. He described jam sessions at the Homeplace as "kitchen music. Some of it was good, some of it not so good, but it was all fun."

By the late 1960s, the Homeplace Saturday night scene, via word of mouth, had started drawing young musicians from throughout the Garden State. At first the mixture of young and old musicians was collegial, but it soon turned into a wave of party crashers, as alcohol, drugs and rowdy behavior sullied the good vibrations. Merce Jr. recalled that in the spring of 1973, Joe Albert took him aside and said it was time to end the Homeplace music gatherings—a sad turn of events. George Albert died on October 31, 1973, and the Homeplace era in the Pine Barrens came to a close. The Waretown-area musicians turned to Merce Jr. as a leader of the community, and he worked with others to establish a new music hall to rekindle the Homeplace spirit. He rented space at the Waretown Auction Shopping Center on Route 9 as a spot for weekly music sessions, and it was christened "Albert Hall." This was the beginning of the weekly "Sounds of the Jersey Pines" music series, which kicked off in November 1974.

Larger plans began to emerge. On April 20, 1975, the Pinelands Cultural Society executive board was formed and incorporated as a nonprofit organization, with Merce Jr. tapped as president. Fundraising efforts were discussed, with the goal of establishing a permanent structure to preserve Pinelands culture. The dream was to build a formal concert venue, which would be known as Albert Hall. Pinelands Cultural Society members reached out to Pete Seeger, who performed a benefit concert at the auction center Albert Hall on May 21, 1976. Seeger returned for a second concert on August 17, 1980, and this time, he was accompanied on stage by the Pineconers.

This hopeful period was tested by a series of tragic events. Joe Albert passed away on April 14, 1987. One year later, the Homeplace cabin was torched by vandals and destroyed. On July 24, 1992, the Waretown Auction Center building also was decimated by fire. Despite these setbacks, the Waretown faithful remained resilient. Following the auction center blaze, arrangements were made for weekly concerts at the nearby Frederic Priff School to sustain a source of income for the cultural society. The fundraising efforts also included personal donations.

Inside Albert Hall, Waretown, June 2015. *Photo by M. Gabriele.*

On May 18, 1996, groundbreaking ceremonies were held to begin construction of the new Albert Music Hall, located at 131 Wells Mill Road, adjacent to the Priff School. The final weekend performance at the Priff School was held on December 14, 1996. On January 5, 1997, the new Albert Music Hall was dedicated, and the dream was realized. Since then Albert Hall has thrived as a popular music venue. According to information posted on its website, as of June 2016, Albert Music Hall had welcomed nearly 300,000 visitors. Merce Jr. ended his association with the Pinelands Cultural Society due to health problems. He and Arlene relocated to Shirley, West Virginia.

That "Down Jersey" Guy

Radio host, folklorist, musician and one heck of a nice guy, Jim Albertson possesses an abundant wisdom of Garden State roots music. And it's the "sand in his shoes" that keeps him grounded and gives him his sense of place: "Down Jersey." A member of the Atlantic City High School class of 1961, he grew up listening to big-band music while working as an usher on Atlantic City's Steel Pier.

117

Jim Albertson, playing the dulcimer at his home in Millville, June 2015. *Photo by M. Gabriele.*

He journeyed north and graduated from Montclair State College (University) in 1965 as a speech and theater major. His wife, Nancy McCullough, also a member of the class of 1965, was a home economics major.

During the early 1960s, Albertson tuned into the Greenwich Village scene and the music circulating throughout the Pine Barrens. As a student in the Montclair State Speech and Theater Department, Albertson became immersed in musical productions and worked as a member of the stage crew. After graduating, Albertson felt a gravitational pull that drew him back to the Atlantic City area, but two years later, he and Nancy returned to northern New Jersey when he was hired as a speech and theater teacher at Madison High School.

Once in Madison, he learned that Drew University was looking for someone to run a coffeehouse for students at the Hayes House facility, located on campus. Albertson made a connection with the Drew administration through one of his students and landed the job, which included free living quarters on the second floor of Hayes House. Through Albertson's outreach efforts, word spread fast about the coffeehouse, which hosted live acoustic music on Friday and Saturday nights. Soon the joint was presenting "name" artists like singer/songwriters Kate McGarrigle, Dave Van Ronk, David Bromberg and Reverend Gary Davis.

The former Drew University Hayes House, today the site of Grace Counseling Center, Madison. *Photo by M. Gabriele.*

In 1972, Albertson received an invitation to a backyard barbecue in Madison where he met Benjamin Franklin ("Tex") Logan Jr., the famous bluegrass long-bow fiddler from Texas. In addition to his musical prowess, Logan was a genius in electronic communications, with degrees from MIT and Columbia. He arrived in New Jersey in 1956 to work as a research mathematician at AT&T Bell Laboratories. Albertson and Logan hit it off quite well at the barbecue, and the subject of the Hayes House coffeehouse came up during the conversation. "Well, I'd like to come to this coffeehouse of yours, and I'll bring a few friends with me," Logan told Albertson. Albertson assured Logan he would be more than welcome to visit "any time." In successive weeks, Logan showed up at Hayes House to perform with his friends—two guys named Doc Watson and Bill Monroe.

By the late 1970s, Albertson had returned to southern New Jersey. He and Nancy relocated to Mauricetown on the Maurice River in Cumberland County, and they settled in Millville in the mid-1990s. Albertson phased out his teaching career and became involved in the New Jersey Folklore Society, serving as its president from 1980 to 1982. It was also during this time that he invited North Carolina folk and

Jim Albertson, surrounded by his extensive collection of records and CDs. *Photo by M. Gabriele.*

country singer Ola Belle Reed (1916–2002) to perform at the New Jersey Folk Festival. They became good friends, and Reed contacted producer Moses Asch of Folkways Records to explore the possibility of recording Albertson. After meeting with Asch in New York City, Albertson signed a contract and recorded the album *Down Jersey: Songs and Stories of Southern New Jersey*, which was issued in 1985.

Citing Albertson's years of dedication to music and the folk arts, the New Jersey Folk Festival, in 1979, honored him with its Distinguished Contribution to Folk Music of New Jersey Award. Albertson has worked at radio stations in Ocean City and Cape May Courthouse. He got a job as a deejay at WSNJ in Bridgeton, which turned into a ten-year run. In 2010, he began hosting and producing his *Down Jersey* program (www.wvlt.com/downjersey) at WVLT FM ("Crusin'" 92.1) in Vineland, broadcast on Thursdays at 9:00 p.m. He also produces live weekend music programs at Cumberland County College, also located in Vineland.

IVY LEAGUE HARMONIES

Music teacher and pottery studio owner Yvonne J. Aronson, in the spring of 1964, organized informal "sings" at the Princeton YMCA/YWCA. Jim Floyd Jr., an early participant, recalled that the friendly gatherings typically drew fifteen to twenty people. (Floyd's father, James Floyd Sr., was the first African American mayor of Princeton, elected in 1970.) These get-togethers slowly grew in popularity and then became happenings that branched out to musical receptions and house concerts. Floyd, a 1969 graduate of Princeton University, said "out of all that, Yvonne joined with others and founded the Princeton Folk Music Society in the fall of 1965."

Floyd said one mission of the new organization was to bring top-flight folk revival musicians to the Princeton community. Prior to its "official" formation, one of the society's early efforts was to book a concert featuring Greenwich Village recording artist Dave Van Ronk. The performance was held on Saturday, January 9, 1965 at Princeton University's Alexander Hall, but there were anxious moments leading up to the event. Floyd said that after tickets went on sale, word reached town that Van Ronk suffered an accident and hurt his arm and hand, leaving him unable to play guitar. Van Ronk arranged for Danny Kalb—a guitarist and founding member of the

Princeton YMCA/YWCA. *Photo by M. Gabriele.*

Blues Project—to come to his aid. Kalb, playing guitar, joined the injured Van Ronk on stage, and the show was a hit.

The society attracted an impressive lineup of musicians during the 1960s. On January 8, 1966, Doc Watson performed at Alexander Hall. The Muddy Waters Blues Band appeared on February 10, 1967, while Kentucky-bred Appalachian dulcimer player Jean Ritchie, singer/songwriter Malvina Reynolds, blues master Reverend Gary Davis and the New Lost City Ramblers also appeared in Princeton. The organization continued to sponsor house sings and concerts on a regular basis and maintained connections with the Catacombs Coffeehouse, which operated from the basement of Princeton's Trinity Church. Founder Yvonne Aronson died on May 9, 1990.

The Princeton Folk Music Society remains active, and in recent years, Susan White, treasurer, and Justin Kodner, member at large, have handled the concert bookings. "We're very eclectic," Kodner said. "We seek out traditional folk and folk revival musicians. We also host international performers from Ireland, England, Scotland, Canada and Australia."

BRING THE FAMILY TO BODMAN PARK

The first Middletown Folk Festival was held on June 22, 1968, and the last was held on June 9, 1984. In between, festival organizers Marlene and Dick Levine supplied a truckload of memories for those who attended the yearly event. Writing in the 1978 program booklet, festival organizers took stock of the event with a look back and a look ahead. "Last year, our tenth [festival] was a milestone year…a time of reflection and assessment for us, and as we looked back on our original goals and accomplishments, we felt proud and satisfied. Now this is the first year of our second decade, and we find that our goals are no different than they were in 1968. We still want this to be a small, informal, community-oriented festival with a definite family atmosphere."

Lifelong music fans and practitioners (Dick plays guitar, concertina and Celtic harp; Marlene performs on autoharp and washtub bass), the Levines were inspired to establish a folk festival in Middletown because of their experiences attending the Newport and Fox Hollow (Petersburg, New York) folk festivals during the mid-1960s. They networked with friends, raised money, organized musicians and inaugurated the festival in Bodman Park. They also established a nonprofit organization in order to gain state funding.

An original poster of the first Middletown Folk Festival, which was held on June 22, 1968. *Courtesy of Dick and Marlene Levine. Photo by M. Gabriele.*

Dick and Marlene Levine, Middletown, April 2016. *Photo by M. Gabriele.*

The festival grew rapidly and attracted thousands of people. In addition to local volunteers, the four Levine sons were an integral part of the operations. As indicated in festival program booklets, in addition to the music, there were craft and dance workshops, education programs and activities designed to engage children. Musical performances included traditional folk, folk revival and blues. By the early 1980s, attendance had begun to sag, and funding became problematic. There were more complexities and red tape associated

with booking performers. "The money and the crowd ran out," Dick Levine said with no regrets. "I think the music and the audience started going in different directions. Our enthusiasm never faded, but organizing the festival each year became more work and less fun." The enthusiasm continues as the Levines host "sings" at their Monmouth County home, a musical tradition they've led for more than fifty years. In 1988, the New Jersey Folk Festival lauded Dick and Marlene for their Distinguished Contributions to the Folk Music of New Jersey.

WE STARTED BIG, WE'VE STAYED BIG

It was raining all week in New Brunswick in late April 1975. Angus Kress Gillespie, at the time an instructor of American studies at Douglass College, was worried. He quaffed a few stiff drinks on Friday night and went to bed. Early the next morning, he awoke to blue skies and dazzling sunshine. It was Saturday, April 26, 1975—the day of the first New Jersey Folk Festival. "God was kind to us that day," Gillespie acknowledged. "The sun shone and the ground was muddy, but people turned out for the festival."

Douglass College dedicated its 1974–75 school year "a year of the arts," following the completion of a four-building, integrated complex that housed a theater, art gallery, performance hall and classrooms. While plans were being made for art exhibits, musical concerts and dance recitals, Gillespie—an author and folklorist—told his colleagues that, to be fair, the proposed celebration also needed a folk festival on campus. His suggestion was approved, and he was appointed faculty adviser and executive director of the project (two titles he has retained during the last four decades) and received a $1,300 grant to launch the event. Gillespie's strategic allies at the time were Margery Somers Foster, the dean of Douglass College; Kathy DeAngelo, who, as music director, booked musicians for the festival; and artisan Barbara Irwin, who assembled crafters and food vendors. He described Foster, who died on September 22, 2007, as "our patron saint who continues to look over the festival."

The festival was held on the lawn of Rutgers' Eagleton Institute of Politics and has returned there each year. "We had an enormous turnout at the first festival," Gillespie recalled. "We started big and we've stayed big." Part of that success he attributed to the synergistic relationship with "Ag Field Day," sponsored by Cook College of Rutgers. "People attended Ag

Program cover for the first New Jersey Folk Festival, 1975. *Courtesy of Angus Gillespie.*

[Agriculture] Field Day and then they stumbled upon the music." From the beginning, the festival, which each year attracts upward of ten thousand people, has maintained an educational aspect—that being the separation and balance between traditional folk music and modern folk revival music. "We're a hybrid. We straddle the fence and provide both," he said. "We

Reverend Marion C. Hannah (*left*), pastor of Antioch Christian Church, New Brunswick, with Angus Gillespie at the 2015 New Jersey Folk Festival. Born in 1934 in Beckley, West Virginia, Reverend Hannah joined the Famous Original Soul Seekers Spiritual Singers of New Orleans in 1953 and came to New Jersey in 1954. He met the great pop and jazz musician Nat "King" Cole in 1957 at a concert at the Apollo Theater in Harlem, New York City. After the show, Cole took him aside and said, "My friend, you're the best gospel singer I've ever heard." *Photo by M. Gabriele.*

acknowledge the differences. The festival is an honest product, and we have an honest story to tell." Gillespie, who began his teaching career at Douglass/Rutgers on July 1, 1973, takes great pride in the fact that today, the festival is run by a committee of undergraduate students.

Gillespie traced his inspiration for proposing the folk festival to his days as a student at the University of Pennsylvania in Philadelphia during the mid-1960s and a professor of folk-life studies named Don Yoder, PhD, a scholar who helped to establish the American Folklife Center at the Library of Congress. In 1950, Yoder and two other professors (Dr. Alfred J. Shoemaker and Dr. J. William Fry) at Franklin and Marshall College in Lancaster, Pennsylvania, founded the Pennsylvania Dutch Folk Festival, the predecessor to the Keystone State's Kutztown Folk Festival—the oldest continuously operating annual folk-life festival in the United States.

Yoder encouraged his students to go to the Kutztown festival. Gillespie attended several times and acknowledged he was charmed by the experience. "The festival emphasized rural farm arts and folklife. I was intrigued with the notion that you could study everyday things [like farm tools, clothing, food and furniture] and extract cultural meaning." Folk music was part of the mix, but it was secondary to the farm arts displays, he said. Captivated by all that he saw, Gillespie filed away an idea in the back of his mind: "to someday create a folk festival myself. It was a highly speculative thought. But then in 1975, the opportunity fell into my lap."

In 2006, Gillespie proudly hosted his professor at the New Jersey Folk Festival. Yoder strolled the grounds for thirty minutes and then offered an assessment to his former student: "I had no idea it was going to be this big!" Yoder died on August 11, 2015, at the age of ninety-three, according to an online obituary from the *Reading Eagle* newspaper.

Author and music journalist Stephanie Ledgin served as director and adjunct faculty for the New Jersey Folk Festival from 1994 to 2003. During these years, she reached out to more vendors and music organizations to create a "folk" marketplace; expanded the scope of the workshops to educate and enrich festival attendees; and implemented four simultaneous stages resulting in more than twenty-four hours of music, dance and workshops. She also emphasized the value of effective publicity and marketing campaigns to promote the festival.

Ledgin said there's always a need to support the aspirations of emerging musicians. "Music should be a bridge," she said during a July 2015 interview. "Music will always reflect the times and the combined experiences of younger and older generations. Bridge building is needed, as many folk revival veterans of the twentieth century have retired or passed away. We've lost a lot of the old guard, but their music will continue to stand the test of time." Ledgin graduated from Livingston College of Rutgers in 1974. Her father, Norm Ledgin, was the *Targum* reporter who interviewed Paul

Hoot and Holler—the duo of Amy Alvey and Mark Kilianski—at the 2015 New Jersey Folk Festival. Graduates of the Berklee College of Music in Boston, they have an extensive bluegrass/folk revival repertoire and perform together and individually at music festivals throughout the country. Kilianski is a former Nutley resident, and Alvey hails from California. *Photo by M. Gabriele.*

Robeson at his final Rutgers performance in 1947. She is the author of three books: *Discovering Folk Music*; *From Every Stage: Images of America's Roots Music*; and *Homegrown Music: Discovering Bluegrass*.

THE SWEETER THE TUNE

New Year's Day 1977 was a sad occasion for musician Kathy DeAngelo. It was, she confessed, a turning point in her life, for on that day, DeAngelo's mentor and musical confidant, Irish fiddler Ed McDermott, died at the age of eighty-one. Born in Ballinamore, County Leitrim, Ireland, McDermott came to the United States in 1915 and went on to become a respected interpreter of traditional Irish music. On October 4, 1970, McDermott recorded nineteen tunes for the American Folk Life Center in Washington, D.C., a session that was part of the center's Archive of Folk Culture.

DeAngelo became acquainted with McDermott in the early 1970s through her involvement with the Middletown Folk Festival. DeAngelo and McDermott both resided in Keyport. McDermott, an elder statesman of the fiddle, and DeAngelo, a young musician, became friends, and he taught her the joys of Irish music. As mentioned, DeAngelo served as the musical

Ed McDermott and Kathy DeAngelo, circa 1975. *Courtesy of Kathy DeAngelo.*

director of the first New Jersey Folk Festival in 1975, and McDermott performed at the inaugural event.

In 1977, New Jersey Folk Festival organizers asked DeAngelo to assemble a musical tribute to commemorate McDermott. She gathered several musicians who performed that year at the festival as a group she dubbed "McDermott's Handy." A "handy," she explained, is a select set of tunes put together to honor someone. DeAngelo has since maintained a band known as McDermott's Handy, which performs traditional Irish music at venues throughout the Northeast.

A 1971 graduate of Keyport High School, DeAngelo enrolled as a freshman at Douglass College and heard about musical happenings at New Brunswick's Second Reformed Church, located at the corner of Mine Street and College Avenue. Since the late 1960s, the church basement had been a gathering spot for Rutgers students. "It was a place to hang out," DeAngelo recalled. "Sometimes people would show up and bring guitars. It was nothing formal; just fun, impromptu jam sessions." DeAngelo also frequented the "Tuesday Night Fifty Cent" series at the Rutgers student center, an acoustic, live-music venue directed by Rutgers student Jon Pushkin, which presented up-and-coming professional musicians, such as Bonnie Raitt and Leon Redbone.

THE SUBTERRANEANS

Leaders of the Second Reformed Church in New Brunswick asked DeAngelo if she would be interested in running a folk music coffeehouse in the church basement. Her answer was yes. Church seminarians painted and cleaned up the space; tables, chairs and coffee-making capabilities were added; and the Mine Street Coffeehouse opened in October 1973. (For the record, Mine Street, the actual boulevard in New Brunswick, is named after an old copper mine at that location. The first shaft "was sunk" in 1751, according to the 1944 New Jersey Geological Survey *Copper Mines and Mining in New Jersey*.)

Mine Street presented live music on Friday and Saturday nights, and word about the venue spread quickly among Rutgers students. What was the vibe like? DeAngelo said there was a wide range of acoustic music, dim lighting and a crowd dominated by long-haired young women and men. Music lasted until 2:00 a.m. There was no cover charge. Seating capacity was thirty people. Coffee was fifteen cents a cup, and musicians were paid

by "pass-the-hat" proceeds from the audience. She ran the Mine Street coffeehouse for two years.

The *New York Times*, in its March 14, 1985 Metropolitan Report, published an article on the Mine Street Coffeehouse, topped off with a four-column photo of Jim Albertson playing the dulcimer, pictured in the basement of the Second Reformed Church. The story portrayed Mine Street as a nostalgic haven from the 1960s, a time when "people talked about commitment and were enchanted by the sound of a lone guitar." As for the place itself, Mine Street was described as "a dirty subterranean haunt that on weekends is filled with folk music and sentimental echoes of the past. Here is vintage counterculture; three cramped rooms with low, narrow-planked ceilings and concrete floors. The plaster skin on the walls is crumbling and, for long stretches, the red brick shows through."

DeAngelo and Dennis Gormley, a talented musician, were married in June 1979, and together they have gone on to become proficient on many instruments and have achieved a vast command of Irish music traditions.

Kathy DeAngelo and Dennis Gormley. *Courtesy of Kathy DeAngelo.*

In addition to performing, DeAngelo and Gormley have dedicated their lives to teaching young musicians. DeAngelo said they have pursued their calling as educators, inspired by the legacy of McDermott. "Ed was always involved in supporting the next generation of musicians," DeAngelo said. "That's what he did for us, and that's what keeps us going." Gormley and DeAngelo were recognized for their dedication as music educators. They were inducted into the Mid-Atlantic Chapter of Comhaltas Ceoltoiri Eireann Hall of Fame in April 2014 and the Delaware Valley Irish Hall of Fame in November 2015. Their favorite student is daughter Emma, a skillful Irish

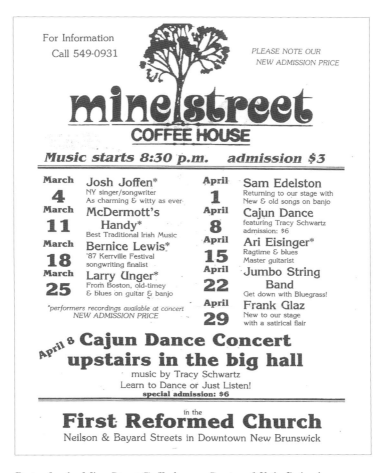

Poster for the Mine Street Coffeehouse. *Courtesy of Kathy DeAngelo.*

fiddle player who performs with an all-female South Jersey traditional Irish music trio called the Peacock's Feathers.

Not long after the March 14, 1985 *Times* article was published, the Second Reformed Church decided to close the coffeehouse. Undaunted, a group of Mine Street aficionados formed a search committee to select a new location. They chose the First Reformed Church, located at Neilson and Bayard Streets in downtown New Brunswick. Sondra Flite, who served as an emcee and was part of the management staff, made an entry in her diary on Saturday, January 18, 1986, writing that she and her associates did repair work on the facility to make preparations for the new venue. She said the relocated Mine Street Coffeehouse opened in early February of that year.

Ted Toskos booked musicians and ran the new Mine Street location for a number of years, and then Bob Yahn, a staff photographer for the National Folk Alliance Conference who has documented music events throughout North America, became the director in the fall of 1995. Because of his work as a photographer, Yahn knew many New Jersey musicians and had experience in organizing other folk revival music events.

"We had a sense of community at the coffeehouse," Yahn recalled, saying Mine Street served as an inviting alternative to the bar scene and Rutgers frat houses. "I volunteered to run the place because I felt the need to provide this kind of music to people. Our audience always had respect for the music and the performers." Despite his best efforts, Yahn said the new Mine Street had mixed results. "After twelve years, the coffeehouse had run its course, and we had trouble maintaining our audience." Mine Street closed in May 2007.

Coffeehouse activities at the First Reformed Church were dormant until September 2008, when the Second Saturday Music Café opened. Musician, impresario and songwriter Frank Glaz founded and ran the café. Following some initial success, Glaz said the audience for the café began to thin out, much like the audience for Mine Street. A performance by Christine Lavin, on June 13, 2009, was the final show at the Second Saturday Music Café.

THE COFFEEHOUSE BLUES

The coffeehouse, as an iconic social institution, is closely associated with the rise of folk revival music. It's the hip café that serves as a haven for poets, musicians, artists and the local intelligentsia. Coffeehouses were first established in cities of the Middle East in the sixteenth century. By the mid-1600s, the concept had spread to England and from there throughout Europe. In the United States during the mid-twentieth century, coffeehouses in New York, San Francisco and Boston gained a reputation as alluring, after-hours spots and served as springboards to launch the careers of legendary folk revival artists.

Nancy Groce, senior folk-life specialist at the Library of Congress American Folklife Center, penned an essay ("Coffeehouses: Folk Music, Culture and Counterculture") that described the early days of the modern coffeehouse era. She wrote that American coffeehouses cultivated "a slightly edgy atmosphere that encouraged progressive political conversations. In the postwar years, this proved an ideal match for guitar-playing soloists, idealistic singer/songwriters,

and the unamplified rural- and ethnic-inspired ensembles of the early folk music revival." She continued by describing the coffeehouse atmosphere:

> *Like in the earlier jazz and Beat* [generation] *poetry clubs, patrons* [at coffeehouses] *were expected to listen to the performers—not talk over them or dance around them. The connection between folk music and progressive "message music," which was already present in urban folk revival circles during the 1930s and 1940s, found a welcome home in the coffeehouses of the 1950s. Coffeehouses have served as "nexus venues"—places that brought together people, things, and ideas that otherwise might not have crossed each other's paths. Coffeehouses encouraged the mixing of audiences and artists. There was literally no backstage for performers to retreat to, so they were usually accessible to the members of the audience who wanted to meet them. This might not sound like a big thing, but it was—especially since it allowed audience members and artists to circumvent many of the race and class boundaries that prevailed in the 1950s and early 1960s.*

Groce, in an April 2016 phone interview, pointed out that it was the urban coffeehouse crowd that initially propelled early folk revival hits heard

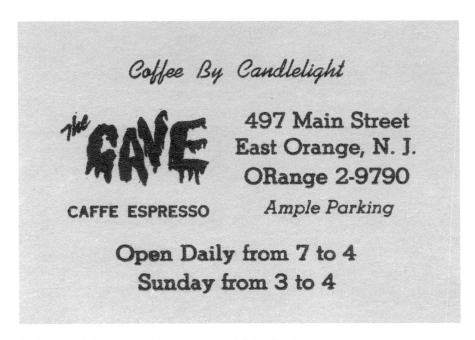

Back cover of the Cave café menu. *Courtesy of Robert Costello.*

on the radio. The songs of the Kingston Trio, Peter Paul and Mary, the Brothers Four and the Highwaymen were a clarion call to coffeehouse devotees. They showed their support by purchasing records and concert tickets. This was their music.

Some New Jersey coffeehouses, like the previously mentioned Mine Street and Hayes House, enjoyed extended runs and had loyal followings. For others, even though they were transient, their legend quietly lives on. One such place was the Cave, which opened in the early winter months of 1960 at 497 Main Street in East Orange. The site selection was a strategic business decision, according to Morristown attorney Robert Costello, one of a trio of twenty-something friends who opened the joint. Costello, interviewed at his office in March 2015, said the café was adjacent to the old Ormont Theater, a cinema showcase for foreign films. This was the sophisticated, late-night clientele that the Cave sought to attract. In addition, the targeted customer demographic included adventurous students from nearby Seton Hall University and Upsala College.

Attorney Robert Costello at his office in Morristown. *Photo by M. Gabriele.*

Costello said that while he and his partners—Frank Battaglia and Amon Goldstein—tried to promote a bohemian image for the Cave, music was an afterthought. "We wanted people to come in to drink coffee, have dessert and play chess," he recalled. Chess? "Chess was a big fad in the early '60s," he explained. The three cronies also were smitten by the Greenwich Village music scene. Costello, for a short time, worked at Café Bizarre. He and his partners borrowed money, dipped into their meager savings, bought a serious Italian espresso machine, hired six waitresses, painted the walls pink and black and opened for business.

"We did it on a shoestring," Costello said. "People donated

furnishings to us. Once we started, the place ran itself. The waitresses knew what to do." Interior appointments included wrought-iron chairs and Chinese lanterns. He said the Cave opened at 7:00 p.m. and closed at 4:00 a.m., after which he, his partners and the waitresses grabbed an early breakfast at the East Orange Diner. A vintage copy of the Cave's menu ("Coffee by Candlelight"), provided by Costello, documents an ambitious listing of European-style café fare. Along with espresso, cappuccino, teas and chocolate drinks, patrons feasted on seasonal fruit, cakes, pastries, cheese, ice cream, sandwiches and, yes, Russian caviar with sour cream.

An article in the March 20, 1960 edition of the *Newark Evening News* conveyed the atmosphere in the Cave, reporting that lighting was provided "almost exclusively by candles on the walls and tables." Battaglia, quoted in the story, outlined the business objectives of the three young owners. "We are looking for people in the 25 to 30 age group who appreciate something a little different. If people want chess tournaments, all-Beethoven nights or poetry reading sessions, we'll provide it." People posting comments on an East Orange Facebook forum recalled that the Cave "was a beatnik hangout."

Musicians gravitated to the Cave via word of mouth. Costello said that, initially, musical performances were occasional, spontaneous happenings. Newark jazz musicians would drop in, unannounced, and play on the café's upright piano. Soon, acoustic guitar players started showing up, and folk revival music became a fixture at the Cave. After two years, Costello and his partners decided to sell the Cave to an entrepreneur named Jerry Schoenkopf. According to online sources, legend has it that Bob Dylan performed at the Cave. A Stockton School blog post by Jeff Smith, "Bob Dylan in East Orange," dated August 11, 2012, cites this. Considering Dylan's aforementioned trips to East Orange to visit Woody Guthrie, the tales of Dylan appearing at the Cave certainly are plausible.

THE BLUEGRASS STATE

There was more than just a touch of honey-sweet nostalgia in his voice as Carl Goldstein, a retired judge of the Delaware Superior Court, began to reminisce about the origins of the Delaware Valley Bluegrass Festival, held at the Salem County Fairgrounds on Route 40, east of Woodstown, which marked its forty-fifth consecutive year in 2016. During his high school days in the mid-1950s, Goldstein was a fan of radio stations out of

Philadelphia that broadcast rhythm and blues, bluegrass and country music. As a young acoustic guitar player, Goldstein was able to appreciate the similarities found in these different genres. "Even when I was a teenager, I saw a connection in those forms of music," he said. "They each are grounded in a deep emotional connection with the lives of everyday people. That's what drew me to bluegrass music."

Goldstein attended law school and traveled throughout North Carolina and Virginia, where his love of bluegrass music grew stronger. By the mid-

Ivan Sexton, performing at the 2006 Delaware Valley Bluegrass Festival. *Courtesy of Priscilla Warnock, vice-president of the Brandywine Friends of Old Time Music.*

1960s, he had settled in Hockessin, Delaware, and had hooked up with two friends, Sheldon Sandler and Michael Hudak. Like Goldstein, Sandler and Hudak were musicians and bluegrass fans. One day, the three friends had a brilliant idea: "Let's put on a concert." They staged several events in Delaware in 1971, which motivated the trio to form the Brandywine Valley Friends of Old Time Music—the group that organizes and operates today's annual bluegrass festival.

While the 1971 concerts represent the start of the Delaware Valley bluegrass tradition, the first "formal" festival took place in 1972 at the KOA Campground south of Wilmington, Delaware. Working through a network of friends, Goldstein and his buddies connected with bluegrass pioneers Bill Monroe and Ralph Stanley. "Ralph asked us if we would host a bluegrass festival," Goldstein said. "Our answer was 'of course!' So they provided the talent [including Lester Flatt], and we provided the venue. After three years, we began to produce the festivals ourselves."

The 1972 festival attracted about five hundred people. The next year, the festival moved to Gloryland Park in Bear, Delaware, where it ran each year through 1989. As the festival's popularity expanded, Goldstein and his colleagues realized they were outgrowing their Gloryland Park accommodations. Ivan Sexton, a Garden State bluegrass musician from Alloway Township, approached members of the Brandywine Valley Friends with a proposal to move the festival to New Jersey's Salem County Fairgrounds. The event was held there in 1990, and it remains the home of the festival, each year attracting more than six thousand fans—some from as far away as Europe.

Today, Goldstein continues to serve as the chair of the Brandywine Valley Friends of Old Time Music. He said the festival's audience demographic has become more diverse, and in turn, it embodies a more eclectic mix of musical styles—folk revival, old time, country music, Cajun, blues and western swing—while continuing to feature traditional and progressive bluegrass music. "Bluegrass and folk revival music go hand in hand," Goldstein said.

Englishtown Impresario

The Englishtown Music Hall, established in August 1975 by promoter and musician Geoff Berne and his family, was a lively, short-lived hub for bluegrass music in central New Jersey. Built in 1891, the building originally

was known as Columbia Hall of the Knights of Pythias. Bluegrass shows were held on Friday and Saturday nights and filled the two-hundred-seat house. In addition to weekly shows, the October 16, 1976 edition of *Billboard* magazine reported that the music hall held a two-day festival on October 9 and 10, 1976. The Monmouth County hall housed a second two-day festival on April 27 and 28, 1977. New Jersey Public TV taped performances during that event, segments of which were first aired on November 6 and 12 of that year, according to an article in the December 3, 1977 edition of *Billboard*.

The *Daily Register* reported that a fire that broke out in the building just before midnight on June 15, 1977, damaged the kitchen and stage, and the hall remained closed for the remainder of the season. It reopened with a weekend festival on April 28–30, 1978, with twenty-one bands from New Jersey and other states, as reported in the March 17, 1978 edition of the *Daily Register*. The Sunday show featured stellar fiddler Tex Logan, and Urban Swampgrass, a Bergen County jug band, performed during a Saturday matinee geared toward children. Along with productions in Englishtown, Berne organized two bluegrass festivals, in 1977 and 1978, at the Quaker Bridge Mall in Lawrenceville, as reported by the *New York Times*, in an April 23, 1978 feature article on Garden State bluegrass music. The two festivals attracted thousands of people each year. The *Times* story quoted Berne, who defined bluegrass as "county folk music that has evolved into a cross between country music and jazz."

A story in the November 10, 1977 edition of the *Asbury Park Press* reported that Berne, as a college Shakespeare professor in California in the late 1960s, fell in love with the music at Paul's Saloon, a bluegrass dive located in San Francisco's Marina District. "I realized the appeal of bluegrass as bona fide entertainment," Berne stated in the article. A year before he opened the Englishtown Music Hall, he was a bluegrass impresario at the Spare Room, a New Brunswick music club. On November 13, 1977, while the Englishtown hall was undergoing repair work from the June 15 blaze, Berne staged a six-hour bluegrass festival at a theater in Hightstown.

The January 7, 1979 *Red Bank Sunday Register* reported that the Englishtown Music Hall had ceased operations. The story quoted Berne, who said that despite the venue's popularity, he was forced to close the hall due to mounting economic pressures. Following that setback, in 1979 and the early 1980s, Berne went on to produce bluegrass reviews at summer festivals staged at Monmouth Battlefield State Park, Manalapan, which were sponsored by the Battleground Arts Center, as reported in various editions of the *Asbury Park Press* and the *Daily Register*. Geoffrey Ethan Berne relocated to Hamilton,

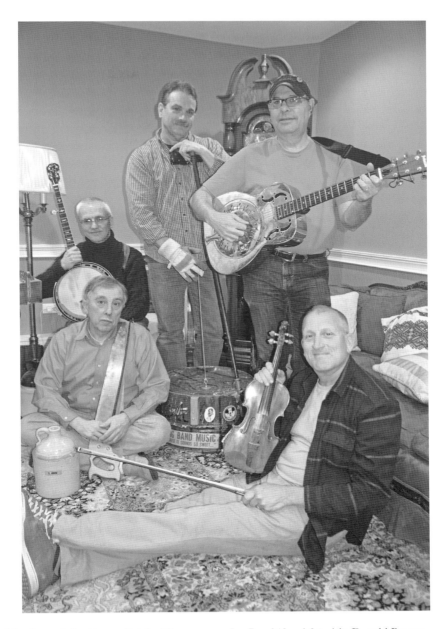

Members of the Almost Original Swampgrass Jug Band (*from left to right*: Donald Bowen, Doug Bowen, Jim Vasconcellos, Dave Rubin and Jeff Tyler) have performed throughout New Jersey ever since their first rehearsal in November 1970, when they were preparing for a talent show at Pascack Hills High School. They remain active today and have an extensive roots-music repertoire. The affable crew, under an alter-ego band name (Urban Swampgrass), appeared at Englishtown Music Hall in 1978. *Photo by M. Gabriele.*

Ohio, where he died on September 18, 2012, at the age of seventy-three, according to his obituary in the September 20, 2012 edition of the Butler County, Ohio–based *Journal-News*.

A FRIENDLY PARTY OF PICKERS

Dolly and Wayne Farmer hosted a convivial bluegrass jam session at their Old Bridge residence to celebrate New Year's Eve 1977. Like Dolly and Wayne, those who attended the festivities were big fans of Englishtown Music Hall. Not long after the clock struck midnight, the two hosts, along with Harold and Dot Buckelew, Bill and Bev Hoffman, George and Joyce Burrows and Steve Hammond, decided to move forward on a plan to create the Bluegrass and Old Time Music Association of New Jersey.

The nine friends had mulled over the idea for several months, usually during Friday night "pickin' parties" at the Farmers' home. "The musicians we saw at Englishtown inspired us to learn about bluegrass," Dolly recalled. "It was a recreational thing and we enjoyed it." They felt that forming an association would enable them to share their love of the music with others. They sought legal advice, applied to the state for nonprofit status, selected officers and trustees and founded the organization. M&M Hall on Texas Road in Old Bridge initially served as the association's home for concerts, workshops and jam sessions. The organization went on to establish its "Pickin' in the Park" summer gatherings at Thompson County Park in Lincroft and currently meets at Embury United Methodist Church in Little Silver.

Dolly and Wayne moved to Pennsylvania in 2014 and are no longer active with the group. They recalled that bluegrass was a New Jersey "subculture" in the 1970s, with loosely connected pockets of fans scattered throughout the state. "Bluegrass is feel-good music," Dolly said. "It speaks to you." Wayne said that, for him, the authentic, free-spirited sound of bluegrass is a grass-roots "rebellion" against the commercial pop/rock formats that dominate the airwaves.

Musician Heidi Olsen, a 1978 graduate of Wall High School, conducts workshops and serves as vice-president for the Bluegrass and Old Time Music Association. Her connection with bluegrass began in the late 1970s with a single banjo that hung on the wall of the Music Man store in Sea Girt, where she worked. "A guy named Rusty used to come in and play that banjo, and I fell in love with the sound," she reminisced. She purchased the banjo and

Tony Trischka, New Jersey Folk Festival, 2016. *Photo by M. Gabriele.*

attempted to play it, but she soon lost interest and stashed it in her closet, where it sat for ten years.

Olsen became enthralled with bluegrass bands that performed at the Monmouth County Fair during the late 1980s, reawakening her interest in the hidden banjo. In 1990, she began taking lessons with banjo virtuoso Tony Trischka, who had relocated to Fair Lawn during this period. "Tony is the best of the best. He was a great teacher and welcomed me as his student." According to biographical information on his website, Trischka's career dates

back to the mid-1960s. Originally from Syracuse, New York, Trischka has performed throughout the world and recorded more than twenty albums. In October 2007, the International Bluegrass Music Association, located in Nashville, Tennessee, honored Trischka as its Banjo Player of the Year.

Encouraged by Trischka, the music quickly became a central part of Olsen's life, and she attended bluegrass festivals along the East Coast, where she networked with players from other regions and expanded her knowledge of the music. Olsen gained a reputation as a friendly organizer of "slow-jam" banjo workshops, "for players at my speed," she explained. She and bass player Randy Bailey cohosted a bluegrass program at the Brookdale Community College radio station, a show created in 1980 by Tom Gamberzky. Olsen joined Bailey in 2000, and the program ran until 2012. In April 2015, Olsen became a bluegrass deejay at radio station WBZC FM, Rowan College at Burlington County. She also leads her band, Heidi Olsen & the Night, and confirmed there is an extensive "underground infrastructure" for bluegrass in the Garden State—"people who care about the music and want to pass it on to the next generation."

New Sound, Grass Fed

The Garden State, over the last four decades, has been home to new grass, a vibrant subset of the more established bluegrass sound. The Bottle Hill Band, founded by Jim Albertson, was an early proponent of New Grass music. Albertson said Hayes House in Madison in early 1970 was the "cradle" of the ensemble, the place where original members first gathered and rehearsed. (Bottle Hill was a district in Madison during the colonial era.) Original members of the band included Albertson as lead singer and guitarist; vocalist, guitarist, fiddle and banjo player Lew London (Albertson's friend from Philadelphia); hammer dulcimer player and vocalist Walt Michael, a student at Drew; and upright bass player Mike DelaGarza, a student at Madison High School. Albertson said a harmonica player named Davey Burkitt occasionally would sit in on sessions.

The band performed at Hayes House and developed a following. Initially the group's repertoire was built around folk revival tunes but slowly gravitated into the realm of "progressive bluegrass." Albertson credited Michael with guiding the group's move toward bluegrass/new grass, developing compositions with a greater emphasis on improvised solos. Bottle Hill's full

new grass concept blossomed when Albertson brought mandolin player Barry Mitterhoff into the fold. After two years, as the band was gaining traction and establishing its identity, members decided it was time to move to a farmhouse in Bernardsville, which served as their living quarters and rehearsal studio. Albertson, as the only married man of the bunch, had more pressing responsibilities, and there was an amicable parting of ways. Various band members came and left following Albertson's departure. Bottle Hill recorded two albums and continued performing until the mid-1970s.

Albertson expressed pride that the band helped to pioneer new grass and lauded the careers of his friends. London, a recording artist, studio

Barry Mitterhoff, 2016 New Jersey Folk Festival. *Photo by M. Gabriele.*

engineer and composer, serves as a teacher and artistic coordinator at CharterTech High School for the Performing Arts in Somers Point. Michael is a teacher, performer and director of the Common Ground on the Hill music program in Westminster, Maryland. DelaGarza became a California filmmaker. Mitterhoff is best known for his recordings with Hot Tuna and Tony Trischka and Skyline. Mitterhoff and Trischka performed together at the April 30, 2016 New Jersey Folk Festival, where Mitterhoff received the Lifetime Achievement Award.

Mitterhoff was born in Newark in 1952, when his family resided in Irvington. He developed an interest and aptitude for music as a teenager, recalling that his Aunt Silvia gave him his first mandolin. He studied with musician and family friend Bob Applebaum, joined Bottle Hill prior to graduating from Livingston College at Rutgers University and then went on to tour with Tex Logan and the Green Grass Gringos. Mitterhoff affectionately described Logan as his mentor. The bluegrass master fiddler from Coahoma, Texas, died in Morristown on April 24, 2015, at the age of eighty-seven, as reported in a *New York Times* obituary.

During the 1980s, Mitterhoff began his long musical association with Trischka and later formed his own band, Silk City. Interviewed at the 2016 New Jersey Folk Festival, Mitterhoff recalled how Bottle Hill formulated its new grass sound through experimental jam sessions. "We were responding to the music that was around us," he said, referring to early 1970s rock. "We developed a more adventurous sound. The bluegrass we played had a harder edge."

Hackensack native and mandolinist David Grisman, who remains active on the national touring scene and is known for his collaborations with the late Jerry Garcia of the Grateful Dead, is another new grass luminary. Grisman, in the early 1960s, was influenced by Passaic folklorist, mandolin player and music scholar Ralph Rinzler (1934–1994). Rinzler, according to online biographical material, is a cofounder of the Smithsonian Folklife Festival. To honor his contributions, the Smithsonian Institute created the Ralph Rinzler Folklife Archives and Collections at the Center for Folklife and Cultural Heritage. Rinzler also participated in the late 1950s/early 1960s folk revival movement as a member of the aforementioned Greenbriar Boys.

Bluegrass revivals took shape during the 1970s and 1990s in northwestern New Jersey, which sparked new grass offshoots. Stillwater Township was one region drawing musicians to this spirited acoustic scene. Young players took the familiar strains of traditional bluegrass music—fiddle, banjo, mandolin and acoustic guitar—and grafted elements of rock, blues and jazz to broaden the sound spectrum. The instrumentation expanded to include

Railroad Earth prepares songs for a performance at the Hangtown Ball's annual Halloween festival, located in Placerville, California, October 2015. *Photo by Dylan Langille.*

electric guitars, bass, drums, keyboards and reed instruments. Taverns in the area became venues that presented new grass to an engaged audience, much like Jersey Shore bars promoted rock music. Even the Rockaway Townsquare shopping mall, which opened in 1977, had a stage to host lunchtime bluegrass performances. The bluegrass festivals of Waterloo Village, sponsored by Denville-based *Pickin' Magazine*, were a focal point for the music. The first festival in the nineteenth-century Morris Canal port/ village located in Byram Township was held in 1977 on the weekend of August 26, 27 and 28 and included noteworthy performers, such as Ralph Stanley and the Maryland-based Seldom Scene band. Online articles by *River Dell Patch* ("Waterloo Village, Part 2: The Game of Musical Chairs," by Kevin Wright) and *The Hackettstown Forum* ("Bluegrass Festival Scheduled at Village") document the 1977 festival.

The band Railroad Earth emerged in early 2001 from this thriving bluegrass jam-band corner of New Jersey. One founding member, Andy Goessling, said that "from the beginning, we knew exactly what our sound was going to be," indicating there was a musical chemistry that came together quickly through extended jam sessions. "We also knew there was an audience for this music." Railroad Earth put together a demo session and

Railroad Earth is pictured performing at the Boulder Theatre in Boulder, Colorado, September 2015. *Photo by Dylan Langille.*

sent a CD to the Telluride Bluegrass Festival in Colorado. Lightning struck, and they were invited to perform at the twenty-eighth annual installment of the festival series, held from June 21 to 24, 2001. The group returned to the Rocky Mountain festival in 2002, 2004, 2009 and 2011. Railroad Earth maintains an ambitious national touring schedule and has released seven CDs, along with a *Live at Red Rocks* DVD and music videos. Railroad Earth band members include Goessling, Todd Sheaffer, Tim Carbone, John Skehan, Carey Harmon and Andrew Altman. The group's instrumentation arsenal features acoustic and electric guitars, fiddle, mandolin, bouzouki, saxophones, flute, drums, dobro, keyboards and bass, along with lead vocals by Sheaffer. The band draws its name from a frenetic Jack Kerouac short story, "October in the Railroad Earth," published in *Evergreen Review* ("…till the time of evening supper in homes of the railroad earth, when high in the sky the magic stars ride above the following hotshot freight trains—it's all in California, it's all a sea…").

THIRSTY EARS FOR FORTY YEARS

As the Folk Project was preparing to celebrate its fortieth anniversary series of events in July 2015, Mike Agranoff—the program chairman for the

Morristown-based organization's Minstrel Acoustic Concert Series—recalled the origins of the group and the early leadership of Laurie Brownscombe. "She was our champion," Agranoff said. "She was the one willing to do the work. That's how things get done." He said Brownscombe was the central character of a loosely organized group of musical friends and volunteers called Project 21. She published the organization's newsletter, made phone calls and scheduled monthly music parties known as "Evenings of Music."

An item posted in the Folk Project's February 2015 online newsletter told the story of a coffeehouse located on Williams Street in Morristown called the Thirsty Ear, which was formed in 1966 by Granville Miller as a Presbyterian Church youth-outreach program. (The name of the establishment was a take on the Hungry i, a popular 1950s and 1960s music club in San Francisco.) A parallel effort in Morristown during the mid-1960s was the annual Tricorn Hootenanny, which was held at Morristown High School, according to the newsletter.

Music lovers from throughout Morris County adopted the Thirsty Ear as their regular haunt. Agranoff said he fell in with this circle in the early 1970s. The Ear closed, but those associated with the coffeehouse decided to keep the music flowing and established Project 21—the precursor to the Folk Project. Brownscombe emerged as the leader of Project 21 (named to spread good music to all twenty-one counties of the Garden State) and found a new venue for music—the basement room of a French restaurant in Chester, L' Auberge Provincale. Agranoff attended the opening night for the new coffeehouse (on July 25, 1975—his thirtieth birthday), paid the dollar admission fee at the door and sat in the crowded room. This event marked the start of what was to become the current Minstrel Acoustic Concert Series. Agranoff said the restaurant's basement venue usually featured performances by Project 21 members. One year later, the series relocated to an eighteenth-century inn on Parker Road in Chester, changing its name to the Minstrel Show Coffeehouse.

In early 1976, Brownscombe moved to Colorado and later settled in the Pacific Northwest. In the wake of her absence, Project 21 members met to determine how best to move forward. Agranoff suggested establishing a nonprofit group with trustees, officers and bylaws to coordinate programs and schedule activities. He recalled that the initial reaction by his associates to this idea was: "Are you crazy?" Enlightened discussions continued, Project 21 was dissolved and, on June 7, 1976, the Folk Project was founded—a volunteer cultural organization that sponsors weekly music programs, weekend "Getaways," concerts, dances and community outreach efforts. In 1977, Agranoff volunteered to be chair of the group's weekly music program and continues today in that role. Getaways, he noted, are gatherings (more

Singer/songwriter Christine DeLeon, who grew up in Glen Rock, performs throughout the New Jersey/New York area and has been an active member of the Folk Project since 2005. She released her debut CD, *January Hiding*, in 2007. *Photo by M. Gabriele.*

intimate than festivals) held during the spring and fall seasons and feature concerts, music workshops and outdoor activities.

Today, the Minstrel Acoustic Concert Series performances are held at the Morristown Unitarian Fellowship. Agranoff admitted that "none of us thought this would last for forty years." In honor of its four decades of

Mike Agranoff, program chairman for the Minstrel Acoustic Concert Series of the Folk Project. *Courtesy of Mike Agranoff.*

community service, the Folk Project received the 2015 Outstanding Arts Organization Award from the Morris Arts Council. The Folk Project has over 550 members and is one of the oldest organizations of its kind in the United States.

An accomplished musician (guitar, concertina and banjo), Agranoff performs throughout the Northeast, with occasional trips abroad. He studied classical piano during his high school years and graduated from New York Polytechnic Institute of Brooklyn in 1968 with an engineering degree. He originally moved to New Jersey to pursue a career in mechanical engineering.

Horses Sing None of It, a cable TV series hosted, produced and founded by Ralph Litwin, is part of the Folk Project's family of multimedia endeavors. Litwin, along with fiddle player Lew Gelfond, began the series on September 25, 1989, taping a half-hour segment with New Jersey musician Henry Nerenberg. The program originally was associated with Video on the Go studios of the Parsippany-Troy Hills school district. The show ran for two years and then went on an extended hiatus before being picked up by Dover-based Sammons Communications, which broadcast the program via public access out of Morristown. Cablevision acquired the Sammons operations, and today the show is taped at studios in Randolph.

Litwin applied for grant money and formed an alliance with the Folk Project, describing the TV show as "an activity" of the organization. Interviewed in November 2015, Litwin said he was rapidly approaching the program's 700th show. In addition to his work in broadcasting, Litwin is a skilled musician. According to his biography notes, he won first place in the New Jersey Old Style Banjo Championships in 1983 and 1986 and plays harmonic and guitar. Litwin toured the country for many years, but since 2010, he has curtailed his public performances due to physical disabilities. As for the offbeat title of his TV show, Litwin said it comes from a quote from blues singer and composer Big Bill Broonzy (1893–1958), who once was asked if he thought the blues was part of folk music. "Must be," Broonzy replied. "I never heard no horses sing none of it!"

EVERYBODY'S HEARD ABOUT THE BIRD

Doug Heacock and friends Artie Grimes, Don Flaherty, Jim Gartner and Lori Weiss Falco were enjoying a late night snack at the Golden Touch Diner in East Hanover in September 1983, when the conversation turned to their love of contra dancing. They lamented the fact that, aside from existing dance groups in Princeton and New York City, there was no place for them to contra dance locally. Heacock said he would be willing to help organize a dance program under the umbrella of the folk-art activities of the Folk Project.

A committee, composed of the original diner quintet along with Eddie Roffman and Jean Silver, began to draw up a proposal for the contra dance concept. They decided on a name for the series, playing off a pun from the "swing and turn" contra movements. "Oh, you mean those funky shore birds [terns]?" Heacock asked. Following a hearty chuckle, the name "Swingin' Tern Dances" was hatched. The Folk Project board approved the proposal, and the first Swingin' Tern dance debuted on January 7, 1984, at the College of Saint Elizabeth in Convent Station, drawing 112 participants. In year two, the dance moved to the Madison YMCA, and then the group found a nest for twenty-three years at Ogden Memorial Church in Chatham. In 2009, the terns flew to their current location, First Presbyterian Church in East Hanover. Throughout the year, dancers meet on the first and third Saturday of each month, along with their annual New Year's Eve Dance.

Contra dancing has its roots in sixteenth- and seventeenth-century English and French folk dance (with some Celtic musical undercurrents) and became

This page: Flocks of contra dancers joyfully sashay throughout the year at the Swingin' Tern Dances held in East Hanover. The group is part of the Folk Project. *Photos by M. Gabriele.*

a popular social activity in colonial America. Swingin' Tern male and female participants (or those assuming these roles) form parallel lines and follow the moves prompted by a caller, backed by a live band, to a tempo ranging from

lilting to driving. Couples swing their way through a sequence of formations (circles, stars, contra corners and "hey"). As the sequences continue, dancers interact with various partners as they move down the line. Some of the movements are similar to square dancing as participants "walk smoothly through" the dance formations. Heacock described contra dancing as "a joyful aerobic activity that's community oriented and flirtatious."

KINDRED SPIRITS

There are a handful of organizations that share a similar spirit with the Folk Project in terms of mission, music and outreach. One is the Hurdy Gurdy Folk Music Club, founded by Wally Koenig in Fair Lawn in 1981, which was mentioned in Part II. Outpost in the Burbs, established in Montclair in 1987, has hosted concerts by artists such as Judy Collins, Roger McGuinn and Dave Van Ronk and supports community food banks in East Orange and Montclair. Barbara and Gordon Roehrer founded the Acoustic Café in Park Ridge, which held its first show on March 11, 2006. The Ethical Brew Coffeehouse, organized by Beth and Perry Stein and located at the Ethical Cultural Society of Bergen County in Teaneck, staged its first concert on January 12, 2013.

In March 2005, a group of friends that included Joe and Linda Ribaudo, Jill Fenske, Martin Williams, Bob Tully and Linda Waddington-Tully created the Hillside Café, held at Franklin Reformed Church in Nutley. An ensemble of versatile singers and musicians known as "doorjam" has been performing on behalf of the Nutley church for more than twenty years. Sanctuary Concerts, held in the sanctuary of the Presbyterian church of Chatham Township, began in September 2001. Mike Del Vecchio, host, sound engineer and producer of the sanctuary series, said his organization offers a colorful assortment of acoustic music. Renowned musicians such as Arlo Guthrie and Rosanne Cash have graced the sanctuary stage, but Del Vecchio pointed out that the concert series also puts a special emphasis on emerging singer/songwriters.

In 1969, enthusiasts participating in house sings at the Millburn home of Evelyn Simpson established the Folk Music Society of Northern New Jersey. The now-defunct organization remained active through the mid-1990s. Musician Roger Deitz, who served as a trustee, said founding members included Simpson, Jules Schneider and Panos and Ronnie Lambrou. Bill Palius and Bennet Zurofsky were among the key participants in the early

days. The group is best remembered for its annual June Days folk festivals, most of which were held at Eagle Rock Reservation in West Orange, and the monthly Closing Circle Coffeehouse, at the Essex County Environmental Center in Roseland. Along with these two enterprises, Deitz said the society held monthly house sings/song circles at the West Caldwell home of Dave Blumgart and Jean Gille.

The Folk Music Society organized concerts at the Ethical Cultural Center of Essex County in Maplewood and Upsala College in East Orange. The group staged the first June Days festival at Upsala in 1969 and then shifted it to Eagle Rock Reservation, with financial support from the New Jersey Council on the Arts. Responding to a request by Essex County officials, the society moved the June Days event to Livingston's Riker Hill Art Park in 1990 and then finally to Turtle Back Zoo in West Orange. Deitz served as a program director for June Days in the 1980s and led the Closing Circle Coffeehouse from 1983 to 1989. Debra Cohen, Ridge Kennedy and Glenn Bukowski also directed the coffeehouse.

Gonna Write a Little Letter, Gonna Mail It to My Local Deejay

John Weingart arrived at Princeton University in 1973 as a graduate student. Once on campus, he gravitated to the university's radio station, WPRB FM. He put together a radio program, remained associated with the station and, in the process, earned his degree in 1975. When Paul Robeson died in 1976, Weingart approached the station about doing a special memorial program on Robeson's life and career. The program aired in February of that year, and due to its success, the station offered Weingart the opportunity to host and produce an evening radio show, which it called *Music You Can't Hear on the Radio*. The show is broadcast every Sunday from September to June.

Weingart said the title of the show refers to music that's not well known. "It's about musicians that deserve recognition. I liked listening to Pete Seeger songs when I was nine years old, but he was hard to find on the radio." In creating the title for the program, Weingart said he purposely didn't use the word "folk" to avoid imposing restrictions on his selection of tunes.

He also spoke about his "advocacy" responsibilities as a deejay. "I put a ridiculous amount of thought and time into what I play and how I play it. I think about the order of the tunes I play and how they're connected."

John Weingart, deejay at Princeton University's WPRB FM. *Courtesy of John Weingart.*

Weingart said he develops sets of interconnected songs based on different themes—sometimes subtle, sometimes obvious. "I try to add value when I put together a set of songs. I want my listeners to know why this song follows that song. I look for combinations of songs that are amusing and instructive." He's drawn to performers who reinterpret older songs with different styles and new musical elements. "Today it's a more diverse mixture," he said. "The music is enriched, and there's no need for people to be restricted by barriers and definitions." In 2014, the New Jersey Folk Festival presented Weingart with the Lifetime Achievement Award.

As a freshman at the Teaneck campus of Fairleigh Dickinson University in the fall of 1975, Ron Olesko volunteered to join the university's radio station, WFDU FM. More than forty years later, he's still there, spinning tunes and interviewing guests involved in the Garden State's folk revival music scene. In his early years as a deejay, his taste for music spanned progressive rock and folk revival. In 1978, he hosted and produced a one-hour, in-studio interview with Marjorie Mazia Guthrie, the wife of Woody Guthrie—an experience that steered him to focus almost exclusively on folk revival music. (Marjorie died in Manhattan on March 13, 1983, at the age of sixty-five.)

After graduating from Fairleigh Dickinson, Olesko created a weekly music program, which he launched in 1980 as *Traditions*. Olesko cohosts the show with Bill Hahn, alternating Sunday afternoon broadcasts. Speaking from his vantage point as an experienced deejay, Olesko said New Jersey's folk revival audience has become an extended community. His career as a broadcaster, as well as his work as a writer for *Sing Out!* magazine and his involvement as president of the Hurdy Gurdy Folk Music Club in Fair Lawn, has helped to shape that community.

When he first began at WFDU FM, he acknowledged that the emphasis was on presenting music, especially

Ron Olesko, deejay at Fairleigh Dickinson University's WFDU FM. *Courtesy of Ron Olesko.*

albums from independent record labels. "Over the years, I've become more of a program host," Olesko said. "Today, I try to get to know the performers as artists and have a more in-depth exploration of their music." Much like Weingart, Olesko said he's particularly interested in young artists who rediscover and transform old tunes, giving these songs a new life. "We try to show the progression of a song. This is music that's a living tradition." Olesko also observed that in recent years, an evolution has occurred, in that a majority of recordings he plays are now self-produced by the singer/songwriters. He said this is largely due to structural changes in the music industry, along with the preferences of folk revival fans.

Requiem for a Luthier

To tally the full measure of talent and accomplishment in the lifetime of David E. Field, a good place to start is with the number of instruments he built and sold over a span of fifty years: more than 400 mountain/Appalachian dulcimers; 180 Celtic harps; 36 hammer dulcimers; and 1 guitar.

A master luthier, Field died on January 26, 2015, at the age of eighty-three. As reported in a February 11, 2015 philly.com online obituary, Field was a member of the Greater Pinelands Dulcimer Society, the South Jersey Acoustic Roots Music Society and the Philadelphia Folksong Society. In 2010, he received the Lifetime Achievement Award from the New Jersey Folk Festival.

Interviewed in August 2014, he said woodworking was in his DNA, as his father and four uncles all were carpenters and his grandfather was a stone cutter. Though he had no formal background in music, Field briefly took guitar lessons at a Philadelphia music store and, by chance, became intrigued by the sound of a dulcimer. After studying the instrument and learning more about its history, he corresponded with the aforementioned dulcimer player and singer Jean Ritchie, who died on June 1, 2015, at the age of ninety-two. An obituary in the June 2, 2015 edition of the *New York Times* reported that Ritchie, originally from Viper, Kentucky, came to New York City in the 1940s and was an integral part of the Greenwich Village folk revival movement.

Field spent several years of tinkering in his basement workshop, teaching himself how to build the instrument. Through his research, he learned that in the early 1800s, Scottish and Irish immigrants in the southern Appalachian Mountains were fascinated with a string instrument known as a Scheitholz, which they most likely encountered through contact with Dutch and German settlers in Pennsylvania. Craftsmen in Kentucky and Virginia began experimenting with their own designs, which evolved into the modern dulcimer—a teardrop- or hourglass-shaped wooden body with four strings.

He began building dulcimers in 1964 and "started getting good at it" within four years. He learned the nuances of the craft, such as the best woods for the construction of the instrument—eastern white cedar for the top of the dulcimer body and applewood, walnut or rosewood for the bottom—and different types of hardwood for the fret board. "There's no such thing as a 'proper' dulcimer," he declared, saying that he liked the variety of darker and lighter sounds that one can get, depending on the type of wood selected to construct the instrument. "The real secret is the

Mountain dulcimers built by David E. Field, August 2014. *Photo by M. Gabriele.*

David Field's basement workshop. *Photo by M. Gabriele.*

thickness of the wood. That's critical." Field gradually became proficient at playing the dulcimer. Born in Philadelphia, he and his family moved to New Jersey in 1957 and settled in Collingswood in 1993.

A Singer/Songwriter Rolls Up His Sleeves

When John Gorka stepped onto the stage at the South Orange Performing Arts Center on February 25, 2016, it was a New Jersey homecoming, as well as another stop in his four-decade odyssey as a singer/songwriter and acoustic balladeer. Dressed in dark-gray jeans, a collarless burgundy shirt and a black sport jacket, Gorka quickly charmed the audience with his droll sense of humor and mischievous smile.

Born on July 27, 1958, Gorka lived on Wood Avenue in Colonia, just a stone's throw from the Garden State Parkway. As a teenager, he was attracted to the sound of the bluegrass banjo. "My older brother Cass had a very good record collection. He turned me on to other kinds of music that also had banjos. This led me into the acoustic singer/songwriter world." He graduated from Colonia High School in 1976 and four years later earned his undergraduate degree in history and philosophy at Moravian College in Bethlehem, Pennsylvania. During his college days, he performed at coffeehouses in New Jersey. He also gravitated to Godfrey Daniels, a contemporary folk revival music club, which opened in Bethlehem, Pennsylvania, on March 17, 1976, and became a volunteer usher, sound man, emcee and occasionally served as the opening act for musicians passing through town.

The turning point for Gorka as a young singer/songwriter came when he met Jack Hardy at Godfrey Daniels in June 1979. Hardy, an influential musician, impresario and publisher of the New York–based *Fast Folk Musical Magazine*, challenged Gorka to improve his game. "Jack wrote songs on a schedule, averaging one per week," Gorka said. "This was a revelation to me." By contrast, Gorka confessed that his approach was to "wait for inspiration to strike" in order to write a song. "Jack said that was a cop out. He told me that I would write more and better songs if I worked at it. The next time Jack came to Godfrey Daniels, I opened the show and performed some of my own songs. He invited me to be a part of the *Fast Folk Musical Magazine*'s songwriter cooperative and live shows at the Bottom Line in New York." Hardy died in Manhattan on March 11, 2011, at the age of sixty-three. His magazine was in print from 1982 to 1997.

John Gorka. *Photo by Joe del Tufo, Moonloop; courtesy of Red House Records.*

Armed with a new sense of discipline, Gorka set out on his journey as a musician. He performed at the 1981 Winnipeg Folk Festival, and in 1984, he won the New Folk Award at the Kerrville Folk Festival in Kerryville, Texas. Three years later, he released his first studio album, *I Know*, on Red House Records, an independent label based in St. Paul, Minnesota—the first of more than fifteen recordings. *Rolling Stone* magazine, in its August 8, 1991 edition, cited Gorka as a leading voice in what was then called the "New Folk" movement. The Roches—sisters Maggie, Terre and Suzzy from Park Ridge—were among the early pioneers of that era, as they blended contemporary elements of folk revival, pop, rock and punk. With their crystal-clear, three-part harmonies and eccentric, original compositions, the three sisters performed in concert at Carnegie Hall on November 19, 1982; played various shows at New York City's Bottom Line during the early 1980s; appeared at the Capitol Theatre in Passaic on October 21, 1978; and have recorded more than ten albums and CDs.

Today, Gorka resides in Minnesota and balances his professional music career with family life (he's married with two children). He tours throughout Europe and North America, playing medium-sized clubs and halls that typically seat up to three hundred patrons. As an independent artist, he concentrates on the relationship he has cultivated with his audience. Though

John Gorka. *Photo by Joe del Tufo, Moonloop; courtesy of Red House Records.*

Gorka rose through the ranks of folk revival music, he admitted that his current song writing defies labels. "I don't know if what I do [today] is considered folk revival music," he said. "I feel like I'm a part of a tradition of people writing about their lives and the world around them."

A Jersey Girl's Moment of Truth

It was a Saturday afternoon in the winter of 1974, and Elaine Silver sat on the sofa in the basement of her Montville home, all alone, quietly staring across the room at her guitar. This was "the moment." Silver, a gifted singer, was becoming more aware of her musical talents. "I said to myself, if I walk across the room and pick up my guitar, then that's it; I'm going to become a full-time musician." Silver rose, methodically strode toward the instrument, lifted it and hasn't looked back since.

Born in November 1954, Silver grew up in Whippany. At age fifteen, she and her family moved to Montville. Her home was a supportive musical environment. Her dad, Arthur Silver, was a concert violinist who hailed from East Orange. Her mom, Catherine, was a nursery school teacher who

Elaine Silver, circa 1990. *Courtesy of Elaine Silver.*

played piano and composed songs for the children. Elaine recalled the musical highlights of her formative years. At age three, she and her four-year-old sister, Catherine, performed as the Baby Dolly Sisters at home for family and friends. At age ten, she and Catherine sang for neighbors, with the family driveway as their venue and the garage door as the stage curtain. She performed in an octet and as a soloist as a freshman at Villa Walsh Academy in Morristown, where Sister Judy encouraged Elaine to improve on the guitar. Silver was selected for the New Jersey All State Chorus as a student at Montville Township High School, where she graduated in 1973.

Silver enrolled as a music major at Montclair State in the fall of 1973 but left after two semesters, enticed by opportunities to sing off campus and inspired by the careers of Joni Mitchell and Judy Collins. In the summer of 1974, she got her first regular performance date at a club called Lou's Worry in Martha's Vineyard, Massachusetts. She returned to New Jersey and was invited to perform at schools, museums, libraries, parks, wedding ceremonies and rehab centers. In 1977, she enrolled in a jazz vocal performance course at William Paterson University but once again left after two semesters, as she was fielding offers to perform, with her reputation as musician on the upswing.

Throughout the 1980s and 1990s, Silver was in demand to appear at coffeehouses and folk revival events throughout the state, including the New

Jersey Folk Festival, the Middletown Folk Festival and the Raritan River Folk Festival. In May 1990, she received the Garden State music award for Outstanding Folk Performer during a ceremony at the State Theater in New Brunswick. Silver has toured throughout North America, Europe and Mexico. She said her artistic legacy is "music with a message: truth principles through song." In 2000, she relocated to Florida. These days, Silver visits New Jersey during the summer months, focuses on a metaphysical music ministry at progressive churches and spiritual centers, serves as a board member at Mount Eden Retreat in Washington (Warren County) and continues to perform. "I'm a Jersey girl. Life is good."

CARRYING THE TORCH

With guitar in hand, Spook Handy waited patiently for his cue as he was about to go onstage to perform at the 2015 New Jersey Folk Festival. He was introduced to the audience as a "torch bearer." It's a description that Handy readily embraces because it captures an important part of his mission as a musician. "Yes, I am a torch bearer," he confirmed during an interview in July 2015. "And I'm looking for as many people as possible to join me in bearing that torch." According to Handy, the torch is the symbolic light "that shows us the way. The torch is how we navigate that path. I see music as a tool to build community and connect ideas on history, culture and human values. Music, for me, is more than entertainment."

Pete Seeger was a source of Handy's inspiration for the higher purposes of music. An opponent of the 2003 U.S. invasion of Iraq, Handy, in May 2003, performed at the Somerset Voices for Peace concert. Sharleen Leahey, a musical colleague, suggested that Handy send his song ("Vote") to Pete Seeger. Handy did just that, and several weeks later, he received a letter from Seeger, who offered a positive critique. Seeger then invited Handy to perform with him at the Pumpkin Festival in Beacon, New York, a music event held in October 2003. After that, Handy "adopted" Seeger as a mentor and performed with him more than fifty times.

Handy was a member of the Phi Beta Kappa Honors Society and graduated from Rutgers University in 1982. He was a math and business administration major and landed a job as an actuary with a company in Newark, but on his first day at work, Handy had a sobering epiphany: the corporate business world wasn't for him. He quit the job and fell in

Spook Handy with trombone player Emily Brady, 2015 New Jersey Folk Festival. *Photo by M. Gabriele.*

with friends in the music field, redeploying his mathematical skills to run the sound boards for various bands. Absorbing various musical influences, Handy gained confidence as a vocalist and guitarist and began playing at coffeehouses. On September 16, 1985, he began hosting a live music series at the Corner Tavern in New Brunswick. Commonly referred to by regulars as the "Spook Handy Show," the series ran for twenty years, culminating with the 1,000th and final show on September 13, 2005. Handy marks June 10, 1989, as the date that he officially began his solo career as a folk revival musician with a performance at the Mine Street Coffeehouse.

KEEP YOUR EYE ON THE OPENER

It's all about the audience, so sayeth the noble bard, author and raconteur Roger Deitz. A folk revival champion and experienced performer, in 2012, Deitz received the New Jersey Folk Festival's Lifetime Achievement Award. Deitz, a sturdy banjo and guitar player and a most gracious man, has been a music journalist for more than forty years. A 1971 graduate of Fairleigh Dickinson University, he has written books, essays, reviews, humor columns and commentary pieces for publications such as *Sing Out!*

Deitz began his music career in the early 1980s by playing at college coffeehouses in northern New Jersey. On February 17, 1985, he opened for singer and storyteller Gamble Rogers at the Speakeasy in Greenwich Village. Four years later, he performed on the main stage of the Philadelphia Folk Festival and continues to appear at that venue. He also participated in the Fast Folk songwriter cooperative in New York. As mentioned, Deitz previously served as a program director for the June Days Folk Festival and ran the Closing Circle Coffeehouse.

He said the most important lesson he's learned during his travels is to keep eyes and ears fixed on the loyal fans that turn out to support the performers. "The real music scene is the audience," Deitz opined. "Out of those people come the new ideas in music." He said audience members draw from the melodic energy they hear performed on stage and then translate that passion into their own lives. "This is music that catalyzes people. It's music that enriches lives and inspires people to go out, buy guitars and sing on their front porches with their family and friends."

With years of musical miles under his fingers, he's long been encouraged by the caliber of talent found in opening acts for established performers.

Above: The audience at the Folk Project's Minstrel Acoustic Concert Series in Morristown, March 2016. *Photo by M. Gabriele.*

Right: Roger Deitz, 2015 New Jersey Folk Festival. *Photo by M. Gabriele.*

For Deitz, this is a reassuring sign that the folk revival tradition is alive and well. "The 'opener' spot—that's what makes the future happen. When I was booking acts, I always thought the opener was extremely important. That's how young musicians become main acts. If you have a 'voice,' you figure out a way to be heard. New musicians open our eyes and blaze new trails. Young singer/songwriters have an edge to their material. They're cutting new ground."

Drawing on the practical lessons of his own career, Deitz said new singer/songwriters typically learn the craft of performance via osmosis from experienced musicians. "It takes time for young performers to learn the nuances of how to connect with an audience. You need to make the music meaningful and entertaining. It's more than just playing 'another song' for people. You're fulfilling a mission for the community."

Epilogue

THE FOOTPRINTS OF COLLECTIVE MEMORY

It was an overcast June afternoon when I walked the sugar sand trails of the Waretown-area Pine Barrens with Ed Ahearn as my steadfast guide. Deep in the woods, he led me to an opening where the Homeplace cabin, built by the Albert brothers, once stood. Today, it's a nondescript vestige—scattered bricks and broken slabs of concrete.

There was nothing haunted about the site; no paranormal occurrences, no supernatural voices echoing in the distance. The only sound was the sweet, dry whisper of the late spring breeze.

The serenity of the Pine Barrens preserves the memories of the Homeplace. It was one stop on New Jersey's vast musical roadmap. Those who were there years ago for Saturday night jam sessions went on to share music and stories in other places with other friends. And so it continued.

Folklorist Mary Hufford, a senior research scientist with the Appalachian Studies Program at Virginia Polytechnic Institute and State University in Blacksburg, Virginia, in a March 2016 phone interview, defined the concept of collective memory as "recollection reconstituted through shared experience. The means of reconstitution is collective artistic practice." Hufford said collective memory interacts with a landscape—embracing remembrances "tethered to the recurring seasonal changes of the environment," like music making at the Homeplace.

Remnants of the Homeplace cabin, June 2015. *Photo by M. Gabriele.*

Pine Barrens, June 2015. *Photo by M. Gabriele.*

The Garden State, in all its regional and cultural diversity, has infused its language, imagery, personality and rhythm into songs that make up an important chapter in the folk revival canon. Historian Leonard DeGraaf said that landscape defines what people are capable of doing, as it dictates proximity to creative talent, metropolitan centers and, for the musician, a receptive audience. "History is more than just a sequence of random events," DeGraaf stated. "People in the past made decisions about their lives and work based on a number of factors. Geography sometimes gets taken out of the analysis of history. Place is important. It's hard to understand unless you read the landscape."

New Jersey's geography as a fertile corridor and crossroads has shaped its musical traditions. Tavern music flourished along colonial stagecoach routes. Celebrated artists were drawn to Camden to make landmark recordings. Bob Dylan traveled to East Orange to find his hero Woody Guthrie and then set off on his legendary career. A gathering of civic-minded individuals in the Morristown area established the Folk Project. Salem County, Stillwater Township, Englishtown and Madison became magnets for bluegrass music. The annual New Jersey Folk Festival on the campus of Rutgers University has entertained and educated thousands of fans. A comprehensive reading of the Garden State's landscape reveals these milestones and many others, the sum of which forms an interconnected score, an intricate musical saga.

Contemplating the bittersweet passage of time, singer/songwriters create poetry that speaks to the quiet dignity of everyday life. The music becomes a performer's on-stage "confession" to an audience. Hufford explained that this is part of what Ralph Waldo Emerson described as an "immense intelligence"; a profound, heartfelt truth that possesses us through collective memory. "Music, as one expression of that immense intelligence, accumulated over generations of shared experience in a place, renews the collective experience of belonging to a larger whole that is much older than we are, and also, at the same time, thinking of future generations, much younger," she said.

The unbridled flow of collective memory carries with it the remnants of salient traditions. Some are sustained, some lost. According to Hufford, tangible artifacts, like the time-worn remains of an old cabin in a pine forest, are only the "footprints" of collective memory—the telltale evidence of a deeper, abiding spirit. She said this spirit endures not only by embracing remembrances but also by moving forward. "It's through collective artistic forms of communication that the past becomes the head of the trail to the newly imagined future."

In her 1986 book, *One Space, Many Places: Folklife and Land Use in New Jersey's Pinelands National Reserve*, Hufford wrote:

> *Like* [an] *aquifer, collective memory must filter itself. People may have stopped making sails and singing shanties, but they still know how to move a garvey* [a small fishing boat] *through a particular bay. They know how to harmonize within a given musical tradition, whether accompanied by electric or acoustic instruments. The losses of particular aspects of tradition may sadden us in retrospect, but we must not forget that fishermen, boat builders and musicians are still with us and that, in the words of Robert Ames, a menhaden fisherman and shanty singer from Port Norris, the songs are in the fishermen, not in the boats.*

Bibliography

BOOKS

Barnum, Frederick O., III. *His Master's Voice in America: Ninety Years of Communications Pioneering and Progress: Victor Talking Machine Company; Radio Corporation of America; General Electric Company*. Camden, NJ: General Electric Co., 1991.

Beck, Henry Carlton. *More Forgotten Towns of Southern New Jersey*. New Brunswick, NJ: Rutgers University Press, 1963.

Bonnell, Arthur Franklin. *The Genealogy of the Bonnell Family*. N.p.: privately published, late 1880s.

Boyer, Charles S. *Old Inns and Taverns in West Jersey*. Camden, NJ: Camden County Historical Society, 1962.

Buehler, Phillip. *Woody Guthrie's Wardy Forty, Greystone Park State Hospital Revisited*. Mount Kisco, NY: Woody Guthrie Publications Inc., 2013.

Cohen, David Steven, PhD. *The Folklore and Folklife of New Jersey*. New Brunswick, NJ: Rutgers University Press, 1983.

Cohen, Ronald D. *Rainbow Quest: The Folk Music Revival and American Society, 1940–1970*. Amherst: University of Massachusetts Press, 2002.

Cray, Ed. *Ramblin' Man: The Life and Times of Woody Guthrie*. New York: W.W. Norton & Company Inc., 2004.

Denning, Michael. *The Cultural Front: The Laboring of American Culture in the Twentieth Century*. New York: Verso, 1997.

Duberman, Martin Bauml. *Paul Robeson*. New York: Alfred A. Knopf, 1989.

Fowler, David J., PhD. *Egregious Villains, Wood Rangers and London Traders: The Pine Robber Phenomenon in New Jersey During the Revolutionary War*. New Brunswick, NJ: Rutgers University Press, 1987.

Gura, Philip F. *C.F. Martin and His Guitars, 1796–1873*. Chapel Hill: University of North Carolina Press, 2003.

Helm, Levon, with Stephen Davis. *This Wheel's on Fire: Levon Helm and the Story of the Band*. New York: William Morrow & Company, 1993. Reprint, Chicago: A Cappella Books, 2000.

Hufford, Mary. *One Space, Many Places: Folklife and Land Use in New Jersey's Pinelands National Reserve; Report and Recommendations to the New Jersey Pinelands Commission for Cultural Conservation in the Pinelands National Reserve*. Washington, D.C.: Library of Congress, American Folklife Center, 1986.

Ian, Janis. *Society's Child: My Autobiography*. New York: Jeremy P. Tarcher, 2008.

Kaufman, Charles H. *Music in New Jersey, 1655–1860*. Cranbury, NJ: Associated University Presses Inc., 1981.

Kaufman, Will. *Woody Guthrie: American Radical*. Chicago: University of Illinois Press, 2011.

Klein, Joe. *Woody Guthrie: A Life*. New York: Alfred A. Knopf, 1980.

Ledgin, Stephanie P. *Discovering Folk Music*. Santa Barbara, CA: Praeger, 2010.

Mazor, Barry. *Meeting Jimmie Rodgers: How America's Original Roots Music Hero Changed the Pop Sounds of a Century*. New York: Oxford University Press, 2009.

———. *Ralph Peer and the Making of Popular Roots Music*. Chicago: Chicago Review Press Inc., 2015.

McGillian, Patrick, and Paul Buhle. *Tender Comrades—The Backstory of the Hollywood Blacklist*. New York: St. Martin's Press, 1997.

McPhee, John. *The Pine Barrens*. New York: Farrar, Straus and Giroux, 1967.

Nelson, Scott Reynolds. *Steel Drivin' Man: John Henry, the Untold Story of an American Legend*. New York: Oxford University Press, 2006.

Newman, Katharine D. *Never Without a Song: The Years and Songs of Jennie Devlin, 1865–1952*. Chicago: University of Illinois Press, 1995.

Palieri, Rik. *The Road Is My Mistress: Tales of a Roustabout Songster*. Hinesburg, VT: Koza Productions, 2003.

Ridgway, Merce, Jr. *The Bayman: A Life on Barnegat Bay*. West Creek, NJ: Down the Shore Publishing, 2000.

Rosenthal, Rob, and Sam Rosenthal, eds. *Pete Seeger—In His Own Words*. Boulder, CO: Paradigm Publishers, 2012.

Salinger, Sharon V. *Taverns and Drinking in Early America*. Baltimore, MD: Johns Hopkins University Press, 2002.

Tappert, Theodore G., and John W. Doberstein, trans. and eds. *The Journals of Henry Melchior Muhlenberg*. Vol. 1. Philadelphia: Evangelical Lutheran Ministerium of Pennsylvania and Adjacent States and the Muhlenberg Press, 1942.

Thompson, Peter. *Rum, Punch & Revolution: Taverngoing & Public Life in Eighteenth-Century Philadelphia*. Philadelphia: University of Pennsylvania Press, 1999.

Van Hoesen, Walter H. *Early Taverns and Stagecoach Days in New Jersey.* Cranbury, NJ: Associated University Presses Inc., 1976.

Van Winkle Keller, Kate. *Dance and Its Music in America, 1528–1789.* Hillsdale, NY: Pendragon Press, 2007.

Wald, Elijah. *Josh White, Society Blues.* New York: Routledge (published by arrangement with the University of Massachusetts Press), 2002.

Widdowson, John D.A., ed. *Folk Tales, Tall Tales, Trickster Tales and Legends of the Supernatural for the Pinelands of New Jersey.* Recorded between 1936 and 1951 and annotated by Herbert Halpert (the Estate of Herbert Halpert). Lampeter, UK: Edwin Mellen Press Ltd., 2010.

Wilentz, Sean. *Bob Dylan in America.* New York: Doubleday, 2010.

Willens, Doris. *Lonesome Traveler: The Life of Lee Hays.* New York: W.W. Norton & Company, 1988.

ONLINE VERSIONS OF BOOKS

Dietz, Dan. *The Complete Book of 1940s Broadway Musicals.* Lanham, MD: Rowman & Littlefield Publishing Group, 2015.

Filene, Benjamin. *Romancing the Folk: Public Memory and American Roots Music.* Chapel Hill: University of North Carolina, 2000.

Foner, Philip Sheldon, ed. *Paul Robeson Speaks: Writings Speeches Interviews 1918–1974.* New York: Brunner/Mazel, 1978.

Gregory, E. David. *Victorian Songhunters: The Recovery and Editing of English Vernacular Ballads and Folk Lyrics, 1820–1883.* Lanham, MD: Scarecrow Press, 2006.

Jamison, Phil. *Hoedowns, Reels and Frolics: Roots and Branches of Southern Appalachian Dance.* Chicago: University of Illinois Press, 2015.

Karpeles, Maud. *Cecil Sharp: His Life and Work.* London: Faber Finds, 2008.

Krohn, Ernst C., completed and edited by Clark, J. Bunker. *Music Publishing in St. Louis.* Warren, MI: Harmonie Park Press, 1988.

McMahon, William. *Pine Barrens Legends and Lore.* Moorestown, NJ: Middle Atlantic Press, 1980.

McNeil, W.K., ed. *Encyclopedia of American Gospel Music.* New York: Routledge, 2005.

Nielsen, Erica M. *Folk Dancing.* Santa Barbara, CA: Greenwood, 2011.

Sandburg, Carl A. *The American Songbag.* New York: Harcourt, Brace & Co., 1927.

Tyler, Don. *Hit Songs, 1900–1955: American Popular Music of the Pre-Rock Era.* Jefferson, NC: McFarland & Company, 2007.

Wondrich, David. *Stomp and Swerve: American Music Gets Hot, 1843–1924.* Chicago: Chicago Press Review, 2003.

MAGAZINES

Billboard Magazine. Articles on Englishtown Music Hall, October 16, 1976; December 3, 1977.

———. Articles on Joan Baez, July 27, 1963; August 31, 1963.

Cadenza. Review of William Foden concert at Carnegie Hall, New York. February 1904.

Crews, Ed. "Rattle-Skull, Stonewall, Bogus, Blackstrap, Bombo, Mimbo, Whistle Belly, Syllabub, Sling, Toddy, and Flip; Drinking in Colonial America." *Colonial Williamsburg Journal*, holiday edition, 2007.

Friedrich, Carl Joachim. "The Poison in Our System," *Atlantic Monthly* 167, no. 6 (June 1941).

Gillespie, Angus Kress, and Tom Ayres. "Folklore in the Pine Barrens: The Pinelands Cultural Society." *New Jersey History*, Winter 1979.

Hentoff, Nat. "The Odyssey of Woody Guthrie." *Pageant*, March 1964.

Kerouac, Jack. "October in the Railroad Earth." *Evergreen Review*, no. 2 (1957).

Lampell, Millard. "What Makes Good Songs?" *New Republic*, July 14, 1942.

McPhee, John. "The People of New Jersey's Pine Barrens." *National Geographic*, January 1974.

New York Magazine. Listing of Peter Seeger/Arlo Guthrie concert at Wollman Rink, Central Park, July 25, 1975.

Rolling Stone, August 24, 1968; July 9, 1970, August 8, 1991.

Time Magazine, June 16, 1941; November 23, 1962.

Wald, Elijah. "Josh White and the Protest Blues." *Living Blues*, no. 158 (July/August 2001).

NEWSPAPERS

Asbury Park Evening Press, May 3, 1941

Asbury Park Press, August 12, 1963; September 1, 1976; July 19, 1979; July 8 and August 2, 1979; July 28, 1980; July 8, 1982.

Associated Press newswire stories, April 15, 1963; December 19, 2007.

Daily Princetonian, October 31, 1963.

Daily Register, August 25, 1976; June 16, 1977; March 17, 1978; January 7, 1979 (online version of newspaper).

Daily Targum, January 10, 1947; April 15, 1963; April 18, 1963; February 8, 1965.

Daily Worker, March 1, 1940; April 30, 1948.

Dreier, Peter. "Remembering Bess Lomax Hawes." *Huffington Post*, March 18, 2010. www.huffingtonpost.com/peter-dreier/bess-lomax-hawes-1921-200_b_373423.html.

Drew Acorn, October 2, 1970; October 9, 1970; April 10, 1970.

Hackettstown Forum. "Bluegrass Festival Scheduled at Village." June/July 1977.

Home News, July 30, 1964; August 17, 1980.

Jersey Journal, April 25 1898; September 28, 1901; November 22, 1906; June 18, 1907.

Jewish News, October 21, 1949.

Journal-News, Butler County, Ohio, September 20, 2012.

Newark Evening News, June 4, 1941; October 24, 1949; March 20, 1960; November 24, 1962; November 27, 1963.

New Jersey Gazette, August, 8, 1781.

New York Times, numerous articles.

Paterson Evening News, May 23, 1966.

Philadelphia Enquirer, second annual New Jersey music awards, May 31, 1990.

Reading Eagle, August 12, 2015.

Red Bank Sunday Register, August 27, 1978; January 7, 1979.

Setonian, April 30, 1971.

Star-Ledger, December 18, 1965, March 30, 2006, January 28, 2014.

Town Topics. "Dave Van Ronk Concert, Saturday, January 9, at Alexander Hall." Thursday, January 7, 1965. https://archive.org/stream/towntopicsprince1944unse/towntopicsprince1944unse_djvu.txt.

———. "Princeton, Honorary Degree for Bob Dylan." June 11, 1970. http://www.mocavo.com/Town-Topics-Princeton-June-4-1970-Volume-Volume-25-Number-14/988535/8.

FESTIVAL BOOKLETS

Middletown Folk Festival, 1978, 1984.

New Jersey Folk Festival, 1975.

WEBSITES

Albert Music Hall. Presented by the Pinelands Cultural Society. www.alberthall.org.

Banjo History. www.banjohistory.com.

Bluegrass and Old Time Music Association of New Jersey. www.newjerseybluegrass.org.

Channel 47 WNJU-TV. www.wnjutv47.com.

Classic-Banjo. http://classic-banjo.ning.com.

Classic Banjo Resource. http://www.classicbanjo.com

The Digital Heritage Project. http://digitalheritage.org.

Digital Guitar Archive. www.digitalguitararchive.com.

Discography of American Historical Recordings (DAHR). Part of the American Discography Project (ADP), an initiative of the University of California–Santa Barbara and the Packard Humanities Institute. http://adp.library.ucsb.edu.

The Folk Project. www.folkproject.org.

Godfrey Daniel's. www.godfreydaniels.org/home.aspx.

The Hootenanny Chronicles. http://abchootenanny.blogspot.com.

Hudson River Sloop Clearwater. www.clearwater.org.

Martin Guitar. www.martinguitar.com.

Muddy Water Magazine. http://www.muddywatermagazine.com.

The New Jersey Friends of Clearwater. www.mcclearwater.org.

Old Barracks Museum, Trenton. www.barracks.org.

Railroad Earth. www.railroadearth.com.

St. John Terrell's Music Circus. www.lambertville-music-circus.org.

Telluride Bluegrass Festival, Colorado. www.bluegrass.com/telluride.

Tony Trischka. www.tonytrischka.com.

Woody Guthrie, Dust Bowl Ballads. http://www.woodyguthrie.de/dbball.html.

YouTube Recordings, Online Videos

Almanac Singers. "C for Conscription." *Songs for John Doe*. www.youtube.com/watch?v=jKxtF0CGA-M.

Carter Family. "Keep on the Sunny Side of Life." www.youtube.com/watch?v=ZbmQQ4RfzVE.

Jimmie Rodgers. *Blue Yodel No. 1 (T For Texas)*. www.youtube.com/watch?v=qEIBmGZxAhg.

Josh White. "Uncle Sam Says." https://www.youtube.com/watch?v=hRDAxnnHcCo.

Rainbow Quest. First episode, November 13, 1965. https://archive.org/details/RainbowQuest01.

Blogs

Brown, Peter Stone. "Bob Dylan—A Young Man with an Old Man's Voice." April 27, 2012. http://blog.peterstonebrown.com/bob-dylan-a-young-man-with-an-old-mans-voice.

———. "Reviving a Memory." February 24, 2014. http://blog.peterstonebrown.com/reviving-a-memory.

———. "Songs of Freedom at the White House…Well, Sort Of." April 25, 2012. http://www.muddywatermagazine.com/Peter-Stone-Brown-Songs-of-Freedom.html.

Carnegie Hall Blog. "Live from Carnegie Hall: Paul Robeson." www.carnegiehall.org/BlogPost.aspx?id=4294979264.

Mudd Manuscript Library Blog. "Bob Dylan Receives an Honorary Doctorate of Music from Princeton University." June 9, 1970. https://blogs.princeton.edu/mudd/2015/06/this-week-in-princeton-history-for-june-8-14.

Smith, Jeff. "Bob Dylan in East Orange." *Stockton School.* August 11, 2012. http://stocktonschool.blogspot.com/2012/08/bob-dylan-in-east-orange.html.

NETWORK TELEVISION SHOWS

American Experience: The Carter Family; Will the Circle Be Unbroken. http://www.pbs.org/wgbh/amex/carterfamily.

American Masters: Pete Seeger; The Power of Song. http://www.pbs.org/wnet/americanmasters/pete-seeger-the-power-of-song/50.

ONLINE ARTICLES, ESSAYS, REPORTS, RESOURCES

Aguilan, Arda. "Inventory to the Records of the Rutgers University Office of the President (Lewis Webster Jones); RG 04/A15/02; Academic Freedom Cases, 1942–1958." December 1994. Special Collections and University Archives, Rutgers University Libraries. http://www2.scc.rutgers.edu/ead/uarchives/jones2f.html.

AllMusic. "Various Artists: *The Bristol Sessions; The Big Bang of Country Music 1927–1928.*" www.allmusic.com/album/the-bristol-sessions-the-big-bang-of-country-music-1927-1928-mw0002100595.

———. "Woody Guthrie: *Dust Bowl Ballads.*" www.allmusic.com/album/dust-bowl-ballads-buddha-mw0000652784.

Banjo Hangout. "Alfred A. Farland." http://www.banjohangout.org/photo/154805.

The Bottomline Archive. "Chronology: 1980." See May 11–12, 1980, and November 5, 1980. http://bottomlinearchive.com/chronology_1980.

———. "Chronology: 1981." See September 25–26, 1981. http://bottomlinearchive.com/chronology_1981.

———. "Chronology: 1982." See May 14–15, 1982, and May 25–26, 1982. http://bottomlinearchive.com/chronology_1982.

Carnegie Hall. "C.L. Partee's Mandolin, Guitar and Banjo Concert" program. Friday, January 29, 1904, 8:00 p.m. Main Hall. https://www.carnegiehall.org/widgets/opas/concert.aspx?id=31151.

———. Programs of Paul Robeson's performances. http://www.carnegiehall.org/PerformanceHistorySearch/#!search=Paul%20Robeson.

Coia, Gabe. "Mulliner the Mariner: The Man Beyond the Myth." njpinebarrens.com, January 23, 2015.

Coldwell, Robert, ed. *William Foden (1860–1947) Grand Sonata*. https://books.google.com/books/about/Grand_sonata.html?id=nhn6kghh5-0C.

Creating Digital History. "The Almanac Singers and the Revival in the Village." New York University. Last modified November 25, 2011. http://creatingdigitalhistory.wikidot.com/the-almanac-singers-and-the-early-folk-revival-in-greenwich.

The David Sarnoff Library. "The Victor Talking Machine Company." Chapter Five, 1901–1905. http://www.davidsarnoff.org/vtm-chapter5.html.

Digital Heritage. "Cecil J. Sharp." http://digitalheritage.org/2014/02/cecil-sharp-2.

Eder, Bruce. "Millard Lampell: Artist Biography." AllMusic.com. www.allmusic.com/artist/millard-lampell-mn0001798653.

Fischer, Paul D. "The Sooy Dynasty of Camden, New Jersey: Victor's First Family of Recording." *Journal on the Art of Record Production*, issue 7 (November 2012). http://arpjournal.com/the-sooy-dynasty-of-camden-new-jersey-victor's-first-family-of-recording.

Gardner's Dulcimer Shop. "History of the Dulcimer." http://www.gardnersdulcimer.com/Page.aspx?id=129.

Gibson, George R. "Gourd Banjos: From Africa to the Appalachians." BanjoHistory.com, October 1, 2001. http://www.banjohistory.com/article/detail/1_gourd_banjos_from_africa_to_the_appalachians.

Groce, Nancy. "Coffeehouses: Folk Music, Culture and Counterculture." Library of Congress American Folklife Center.

Hayde, Michael J. "Hootenanny: The Original 'Unplugged.'" TVParty.com. www.tvparty.com/rechootenany.html.

Huey, Steve. "David Grisman: Artist Biography." AllMusic.com. www.allmusic.com/artist/david-grisman-mn0000809396/biography.

"Investigation of Communist Activities, New York Area; Part VII (Entertainment); Hearings before the Committee on Un-American Activities, House of Representatives, Eighty-Fourth Congress, First Session, August 17 and 18, 1955." Harvard College Library online text. https://archive.org/stream/investigationofc557unit/investigationofc557unit_djvu.txt.

Joyce, Jennifer Rita Collins, Madeline Esposito and Daria Mamluk, comps. "New Jersey Collections in the Archive of Folk Culture." American Folklife Center. Library of Congress. http://www.loc.gov/folklife/guides/newjersey.html.

Kragting, Ben, Jr., and Harry Coster. "Victor's Church Studio, Camden (1918–1935): Lost and Found?" Vintage Jazz Mart: The Magazine for Collectors of Jazz and Blues 78s and LPs. http://www.vjm.biz/new_page_25.htm.

Lankford, Ronnie D., Jr. "Bottle Hill: Artist Biography." AllMusic.com. www.allmusic.com/artist/bottle-hill-mn0001668518.

Leitch, Alexander. "Biography of William Paterson (1745–1806)." In *A Princeton Companion*. Princeton, NJ: Princeton University Press, 1978. http://etcweb.princeton.edu/CampusWWW/Companion/paterson_william.html.

Long, Lucy M. "A History of the Mountain Dulcimer." http://www.bearmeadow.com/smi/histof.htm.

Mandozine. "Barry Mitterhoff." www.mandozine.com/media/CGOW/mitterhoff.html.

New World Encyclopedia. "Jimmie Rodgers." http://www.newworldencyclopedia.org/entry/Jimmie_Rodgers.

———. "Pete Seeger." http://www.newworldencyclopedia.org/entry/Pete_Seeger.

Obituary of Ralph Rinzler. *Journal of American Folklore* 108, no. 429 (Summer 1995). http://www.jstor.org/stable/541887?seq=1#page_scan_tab_contents.

Period Records (SPL 1209). *Josh White Comes A-Visiting*. Album notes. www.discogs.com.

Philly.com. Obituary on David Field, February 11, 2015. http://articles.philly.com/2015-02-11/news/59010237_1_south-philadelphia-daughter-hammered-dulcimer.

Public Television from Indiana University. "A Guide to UHF Television Reception." http://www.indiana.edu/~radiotv/wtiu/uhf.shtml.

"Ralph Rinzler." Smithsonian Center for Folklife and Cultural Heritage. www.folklife.si.edu/legacy-honorees/ralph-rinzler/smithsonian.

Reese, Bill. "Thumbnail History of the Banjo." Banjo Tablatures and Bluegrass Information. http://bluegrassbanjo.org/banhist.html.

Sing Out! Ron Olesko's folk music notebook. December 1, 2014. http://singout.org/2014/12/01/celebrating-josh-white-father-son.

Sovietskaia Muzyka (Soviet Music), No. 7. "Song of My People." July 1949, translated by Paul A. Russo, reprinted in *Paul Robeson Speaks; Writings Speeches Interviews 1918–1974*, 1978.

The Stokowski Legacy. "Victor Talking Machine Company, Eldridge Johnson and the Development of the Acoustic Recording Process." http://www.stokowski.org/Victor_Eldridge_Johnson_Acoustic_Recording.htm.

Sutton, Allan. "A Camden Chronology: The Evolution of the Victor Talking Machine, Company Complex (1899–1929)." Based on Harry Sooy's memoirs. The Victor Record Pages. Mainspring Press: Resources for Collectors of Historic Sound Records. www.mainspringpress.com/vic-camden.html.

Van Winkle Keller, Kate. "Fiddle, Dance, and Sing with George Bush: A New Source of Eighteenth-Century Popular Music." The Sonneck

Society for American Music Bulletin 18, no. 2 (Summer 1992): 47–49. http://american-music.org/publications/bulletin/Volume%20XVIII,%20No.%202%20(Summer%201992).pdf.

Vaughan Williams Memorial Library. "Cecil J. Sharp's Appalachian Diaries: 1915–1918." http://www.vwml.org/vwml-projects/vwml-cecil-sharp-diaries.

Wikipedia. "Biography of David Grisman." https://en.wikipedia.org/wiki/David_Grisman.

William Paterson University. "Who Was William Paterson." http://www.wpunj.edu/university/history/WilliamPaterson_Bio.dot.

Woodward, Herbert P. *Copper Mines and Mining in New Jersey*. Bulletin 57, New Jersey Geological Survey. Trenton, NJ: Department of Conservation and Development, State of New Jersey, 1944. http://www.state.nj.us/dep/njgs/enviroed/oldpubs/bulletin57.pdf.

Wright, Kevin. "Waterloo Village, Part 2: The Game of Musical Chairs; The Continuing Story of an Old New Jersey Canal Port Reborn as a Performing Arts Center, 1968–1985." River Dell Patch, December 30, 2011. http://patch.com/new-jersey/riverdell/bp--waterloo-village-part-2-the-game-of-musical-chairs.

Miscellaneous

"Artists Letter Agreement." Woody Guthrie with RCA Manufacturing Company Inc., dated April 24, 1940. From the archives at the Library of Congress, Washington D.C.

Bertland, Dennis N. "For Citizens and Strangers, New Jersey Taverns During the Early American Period." Unpublished manuscript for the Merchants and Drovers Tavern Museum Association.

Delaware Historical Society, Wilmington, Delaware, archival documents on George Bush.

Grapes of Wrath concert program, March 3, 1940. Forrest Theater, New York. From the archives of the Woody Guthrie Center, Tulsa, Oklahoma.

Halpert, Herbert Norman. "Folktales and Legends from the New Jersey Pines: A Collection and Study." Submitted to the Faculty of the Graduate School in partial fulfillment of the requirements for the degree of Doctor of Philosophy in the Department of English, Indiana University, 1947.

Heacock, Doug. Essay on the history of the Swingin' Tern dances.

The Live Wire, Woodie Guthrie. CD Booklet. Mount Kisco, NY: Woody Guthrie Publications Inc., 2007.

Lutz, Anne. Booklet. *Everett Pitt, Up Agin the Mountain: Traditional Ballads and Songs from the Eastern Ramapos*. Little Ferry, NJ: Marimac Recordings, 1987.

Merchants and Drovers Tavern Museum, Rahway, New Jersey. Information transcribed from various poster displays and exhibits at the museum.

Missouri History Museum Archives, St. Louis, Missouri. Archival material on William Foden, including program for "Grand Festival Concert" at Witherspoon Hall, Philadelphia, on April 25, 1911, the American Guild of Banjoists, Mandolinists and Guitarists.

New Jersey Directory of the Oranges, including Orange, East Orange, South Orange, and Maplewood, 1959, 1961, 1963 and 1965 editions.

New Jersey Historical Society research library, Newark, New Jersey. Archival information on Paul Robeson.

HISTORICAL SOCIETIES, LIBRARIES, MUSEUMS, ORGANIZATIONS

Albert Hall, Waretown, New Jersey.

American Folk Life Center, Library of Congress, Washington D.C.

Archibald S. Alexander Library, Rutgers University, New Brunswick, New Jersey.

C.F. Martin & Co. Inc., Museum and Archives, Nazareth, Pennsylvania.

Clifton Memorial Public Library, Clifton, New Jersey.

Delaware Historical Society, Wilmington, Delaware.

Douglas A. Yeager Productions, New York.

East Orange Public Library, East Orange, New Jersey.

Hoboken Historical Society, Hoboken, New Jersey.

Jersey City Free Public Library, Jersey City, New Jersey.

Jewish Historical Society of New Jersey, Whippany, New Jersey.

Long Island Museum, Stony Brook, New York.

Lutheran Theological Seminary, Lutheran Archives Center, Philadelphia, Pennsylvania.

Merchants and Drovers Tavern Museum, Rahway, New Jersey.

Missouri History Museum Archives, St. Louis, Missouri.

Monmouth County Public Library, Eastern Branch, Shrewsbury, New Jersey.

Newark Public Library, Newark, New Jersey.

New Jersey Historical Society research library, Newark, New Jersey.

New York University, Department of History, Margaret Sanger Papers Project, New York.

Nutley Public Library, Nutley, New Jersey.

Ocean County Library, Toms River, New Jersey, and Plumsted Branch, New Egypt, New Jersey.

Paterson Public Library, Paterson, New Jersey.

Pinelands Cultural & Historical Preservation Society (associated with Albert Hall), Waretown, New Jersey.

Princeton Public Library, Princeton, New Jersey.

Tamiment Library and Robert F. Wagner Labor Archives at New York University, New York.

Vaughan Williams Memorial Library, London, England.

Wisconsin Historical Society, Madison, Wisconsin.

Woody Guthrie Center, Tulsa, Oklahoma.

Woody Guthrie Publications Inc., Mount Kisco, New York.

Index

About the Author

This is Michael C. Gabriele's third book on New Jersey history published by The History Press/ Arcadia Publishing. A lifelong Garden State resident, Gabriele is a 1975 graduate of Montclair State University and has worked as a journalist and freelance writer for more than forty years. He is a member of the executive board of the Nutley Historical Society and serves on the advisory board of the Clifton Arts Center.

Photo by Laura LaBadia.